Between Spring and Summer

D1309348

Between Spring and Summer

Soviet
Conceptual
Art
in the
Era
of
Late
Communism

Edited by David A. Ross
Curators:
David A. Ross
Elisabeth Sussman
Margarita Tupitsyn
Joseph Bakshtein

Tacoma Art Museum, Tacoma, Washington
The Institute of Contemporary Art, Boston, Massachusetts,
The MIT Press, Cambridge, Massachusetts and London, England

First MIT Press edition

© 1990 The Institute of Contemporary Art,
Boston, Massachusetts

Dates of Exhibition:

June 15 — September 9, 1990
Tacoma Art Museum
Tacoma, Washington

November 1, 1990 — January 6, 1991
The Institute of Contemporary Art
Boston, Massachusetts

February 16 — March 31, 1991
Des Moines Art Center
Des Moines, Iowa

ISBN: 0-262-68065-3

Library of Congress Catalog Card Number: 90-082363

Distributed by The MIT Press,
Cambridge, Massachusetts

**Library of Congress
Cataloging-in-Publication Data**

Between spring and summer: Soviet conceptual art
in the era of late communism / edited by David A.
Ross; curators, David A. Ross . . . (et al.).—1st
MIT Press ed.

 p. cm.

 Catalogue of an exhibition held June 15 — September
9, 1990 at the Tacoma Art Museum; Nov. 1, 1990 —
January 6, 1991 at the Institute of Contemporary
Art, Boston; Feb. 16 — March 31, 1991 at the Des
Moines Art Center

 Includes bibliographical references.
 ISBN 0-262-68065-3
 1. Conceptual art—Soviet Union—Exhibitions.
2. Art, Soviet—Exhibitions. 3. Art, Modern—20th
century—Soviet Union—Exhibitions. I. Ross,
David A., 1949- . II. Tacoma Art Museum.
III. Institute of Contemporary Art (Boston, Mass.)
IV. Des Moines Art Center.

N6988.5.C62B48 1990 90-44305
709′.47′07473—dc20 CIP

Contents

Preface

"The history of art is the history of the purpose of art directly related to the bases of the social forms. "

John Graham
System and Dialectic of Art

The history of the art of the Soviet Union, like the art history of any nation, is a reflection of not only its soul but of its mood and direction. This exhibition, *Between Spring and Summer: Soviet Conceptual Art in the Era of Late Communism,* is an attempt to assess the temper and purpose of recent Soviet art at a time during which such assessments are vitally important. It is necessarily a complex exhibition, and is the result of an extraordinary team effort between the Tacoma Art Museum (TAM) and The Institute of Contemporary Art (ICA).

The exhibition's origins, which I set out in detail in my contribution to this catalogue, are properly located in the desire of people in the Seattle-Tacoma region who decided to organize a cultural festival surrounding the athletic competitions known as the Goodwill Games.™ The notion that exhibitions, concerts and other educational and cultural exchanges might foster genuine goodwill between Soviets and Americans is part of the invisible substructure that has helped our two nations move closer together than at any point since we fought as allies during the Second World War.

Of the four museum exhibitions in the Goodwill Arts Festival,™ this is the only to focus on contemporary Soviet artistic activity, and as such we feel honored by our selection and a bit awestruck by the responsibility it entails. On behalf of The

Institute of Contemporary Art we would first like to express our gratitude to the Trustees and Staff of the Tacoma Art Museum and to the Organizing Committee of the Goodwill Festival for the invitation to produce this exhibition. As usual The Institute's Trustees have been supportive at every stage of the project.

At the Tacoma Art Museum, I am particularly grateful to its Director Wendell Ott who stood by us during this complex and somewhat risky project. The project would have been completely impossible without the help of Exhibition Coordinator Karin Hirschfeld, who not only coordinated all the research and travel, but played a critical role in the organization and execution of the exhibition and its tour. To the TAM Trustees, and especially Bill and Bobby Street, we are grateful for the way in which they steadfastly approached the considerable fund-raising challenge presented by the exhibition.

Jarlath Hume and his staff at the Goodwill Games and Arts Festival went out of their way to be helpful from the project's outset, and for this we are thankful. Jarlath is the model of a great community organizer and a visionary organizational leader.

My colleagues at The ICA have performed magnificently throughout this project. ICA Deputy Director Elisabeth Sussman has once again helped create an exhibition of real significance through her relentless concern for clarity and her astounding ability to find great work and help others find it as well. We were helped in the formative stages of the project by ICA Curator David Joselit, who returned to graduate school before the completion of the exhibition. The exhibition shows traces of his intelligence and humor.

Matthew Siegal, The Institute's Exhibition Manager has once again wrestled with the complex logistics of an international exhibition with grace and extraordinary skill.

Assistant Curator Leslie Nolen has carefully edited the catalogue manuscript and working with Special Curatorial Coordinator Leigh Raben has supervised the translation of all of the Russian material for this book and for the exhibition itself. Her experienced eye and unflappable spirit have been of great value. Once again we are fortunate to have Sylvia Steiner skillfully oversee the design and production of this catalogue. We thank ICA Curator Matthew Teitelbaum for his insight and advice in the editorial process.

We are grateful for and proud of the contribution of the writers who have provided essays for this catalogue. Besides those authored by the curatorial team, I would like to thank Ilya Kabakov, Richard Lourie, Dmitri Prigov, Alexander Rappaport, Mikhail Ryklin, and Victor Tupitsyn. We are also grateful to Clark Troy and Kim Thomas for their translations of the Russian essays into English.

Margarita and Victor Tupitsyn have played a central role in the conception and execution of this exhibition. If not for their pioneering work, and especially

Margarita's previous exhibitions and her long-standing commitment to the careful exploration of this particular field, we would surely have lost our way. Victor's patience and intelligent fine-tuning of the Russian essays into English proved invaluable.

Our Soviet curatorial associate Joseph Bakshtein has been a great guiding force for us. His brilliant exhibitions in Moscow set the pattern for our understanding of this complex scene.

We would have literally been lost if it had not been for our extraordinary translator and guide Layla Hagen. Layla not only anticipated our every need, she was (and remains) a thoughtful and considerate intermediary for us, making our visits not only productive but rather pleasant as well. The value of her counsel and government liaison work is impossible to fully calculate.

Finally we acknowledge our debt of gratitude to all the Soviet artists we met, and especially to those who will participate in this exhibition and publication. We all learned in ways we never expected to learn and delighted in the spirit and energy of these great people. I would especially like to acknowledge and thank the artist Misha Roshal, who though not in this exhibition, left an indelible mark on me, and in turn on this exhibition as well.

We are extremely grateful to the collectors who agreed to part with their work for the extended period of this exhibition; they are listed on page xiii.

The ICA would also like to formally acknowledge those people who assisted this project with their advice and support:

Tatiana Abalova	Layla Hagen	Anne Livet
Richard Andrews	Rustam Khamdamov	Pavel Lungin
Evgeni Barabanov	Barbara Herbich	Jean Hubert Martin
Tod Bludeau	Pavel Khoroshilov	Irina Mikheyeva
Philip Brown	David Juda	Elena Olikheyo
Nadia Burova	Alyona Kirtsova	Peter Pakesch
Douglas Davis	Naum Kleman	Irina Porudominskaya
Svetlana Dshafarova	Uri Klemenko	Dima Popov
Ronald Feldman	Vikka Kabakov	Ned Rifkin
Jamey Gambrell	Milena Kalinovshka	Gary Smith
Marshall Goldman	Phyllis Kind	Susan Stirn
Nikolai Gubenko	Allyona Kirtsova	Julia Turrell

David A. Ross

Director
The Institute of Contemporary Art

This exhibition represents a tremendous step for the Tacoma Art Museum and I would like to thank the Board of Trustees for their support, confidence and patience. Of equal importance was the effort of *Between Spring and Summer*'s Steering Committee headed by Bill Street; they were instrumental in achieving our ambitious fund raising goal. I am grateful for the hard work and dedication of our exhibition and development staff: Molly Gazecki, Jim McDonald, Laura Thayer, Penny Loucas, Bill Rietveldt, Heather Cooper and especially to Karin Hirschfeld.

Our gratitude and appreciation go to David Ross, Director of The ICA for undertaking the project with us and for his expert direction of the curatorial effort.

Ultimately many individuals lent their time and expertise to this project. The following are just a few:

Dan Baty	Stuart Grover	Robert D. O'Brian
Greg Bell	Dick and Betty Hedreen	Marschel Paul
Cathy Brewis	Kathleen Henwood	Ginny Perkins
Randy Coplen	Ray Highsmith	Bill Philip
Sonya Christianson	Jarlath Hume	Ron Rubin
Representative Norman Dicks	Peggy Kaplan	Paul Schell
Elgin Olrogg	Norm Langell	Hal Schuyler
Linda Farris	Janine Lavoie	Bobby Street
Anne Focke	Linda Martin	Michael Sullivan
Frank Frannich	Dorothy McCuistion	Frank Underwood
Leith Gaines	Marcia Moe	Jane Zalutsky
Katya Garrow	Erik Mott	Ellen Ziegler
David Gogol	Barbara McKnight	James Wiborg
Jim Griffin	Scott Morris	Jane Williams

Wendell Ott

Director

Tacoma Art Museum

Between Spring and Summer: Soviet Conceptual Art in the Era of Late Communism was organized with generous support from the National Endowment for the Arts and the following foundations, corporations and agencies: The Boeing Company, Ben B. Cheney Foundation, Grantmakers Consultant, Inc., Morning News Tribune, Printing Control, Puget Sound Bank, Frank Russell Company, Nalley's Fine Foods, Sea-Land Service, Inc., Tacoma Arts Commission and Univar Foundation. Additional funding for the catalogue has been provided by the Lila Wallace-Reader's Digest Fund.

The Institute of Contemporary Art

Tacoma Art Museum

Lender List

Sergei Anufriev
Avantgarde Galerie, Berlin
Yuri Avvakumov
Elena Elagina
Ronald Feldman Fine Arts, Inc.
Andrei Filippov
Galerie Folker Skulima, Berlin
Paul Judelson Arts, New York
Galerie Krings-Ernst, Cologne
Yurii Leiderman
Dr. Georg Ludwig, Germany
Igor Makarevich
Andrei Monastyrsky
Timur Novikov
Pavel Peppershtein
Raab Galerie, Berlin
Andrei Roiter
Maria Serebriakova
Galerie Sophia Ungars, Cologne
Konstantin Zvezdochetov
Larisa Zvezdochetova

Provisional Reading: Notes for an Exhibition

David A. Ross

The class struggle, which is always present to a historian influenced by Marx, is a fight for the crude and material things without which no refined and spiritual thing could exist. Nevertheless, it is not in the form of the spoils which fall to the victor that the latter make their presence felt in the class struggle. They manifest themselves in this struggle as courage, humor, cunning and fortitude. They have a retroactive force and will constantly call in question every victory, past and present, of the rulers. As flowers turn toward the sun, by dint of a secret heliotropism the past strives to turn toward that sun which is rising in the sky of history.

Walter Benjamin
Theses on the Philosophy of History

We live in a spoiled moral environment. We have become morally ill because we are used to saying one thing and thinking another. We have learned not to believe in anything, not to care about each other, to worry only about ourselves. The concepts of love, friendship, mercy, humility or forgiveness have lost their depths and dimension, and for many of us they represent only some sort of psychological curiosity or they appear as long-lost wanderers from a faraway time.

Vaclav Havel
in his inaugural speech as
President of Czechoslovakia

I

It is February, 1990, and the pace of change in the Soviet Union increases exponentially. As I write this, reports from the meetings of the Party Congress indicate that, as in nearly all of eastern Europe, the Communist Party of the Soviet Union will relinquish its monopoly on power, and may provide, in an indirect response to a Red Square demonstration of over 200,000 people, for open competition between opposing political parties. Stalin's totalitarian vision appears as dead as the czarist vision of Holy Moscow as the Third Rome.

This is the age of Gorbachev. Communism has entered a new era in response to the global social and economic pressures which have transformed both East and West since the end of the second World War. Like Capitalism, Communism is in its "late" phase as well. The struggle for what Walter Benjamin termed the "crude and material things" is fueling the engines of change. An important result of these changes, however, is found in those deeply immaterial aspects of life; those reflections of the strength, intelligence, and soul found in the art and literature of a nation.

The Gorbachev policies of reform generally summarized under the two watchwords *perestroika* and *glasnost* have not only brought the promise of radical social and economic change but have presented the real hope for ideological and moral transition as well. People within the Soviet Union are as thrilled and confused as are the legions of amateur and professional Sovietologists here and abroad. No one predicted that such a wholesale reconsideration of the operating basis for The Union of Soviet Socialist Republics would occur, and at this point, few dare predict where it will lead.[1] The election of the poet Jaclav Havel as President of Czechoslovakia gave proof to the extent of this transformation, and to the need for the healing and re-orientation that can be guided, in part, by a nation's artists.

Between Spring and Summer has been organized during this unpredictable time, and as such both mirrors and is part of the attempt to better understand the nature of the dynamic changes taking place throughout all sectors of the USSR. Not only is the direction of democratization unclear, but many skeptical observers doubt the ability of the reformers to survive in the face of numerous obstacles: from the overwhelming power of a rampant and corrupt bureaucracy to the nationalist fervor which threatens the concept of a Soviet Union; from civil war on northern and southern fronts (including a deeply imbedded anti-semitism apparently still flourishing throughout the USSR), to the ruling coalition of right-wing ideologues and indigenous organized crime syndicates whose power is threatened by the broad range of Gorbachev's proposed reforms.

Other observers believe that a new Soviet Union may emerge from this period, refreshed and re-vitalized, and prepared to evolve a reconstructed socialist model based on changed times and the new economic and social realities. Ready to compete with the soon-to-be united European community of 1992, Gorbachev hopes

that he can use an essentially radical centrist position to control both sides of the competing forces within his nation.

Among the most skeptical are the artists and writers whose lives have been completely transformed by a new social order whose tolerance of free speech, for the past fifty years, would have resulted in severe punishment. To many of the more radical of these artists, this period is simultaneously joyous and frightening, its state of mind conflicted. Nevertheless many artists feel it is a time to be savored and lived as fully as possible, despite its contingent quality.

In this exhibition, we have set out to explore this period — this moment between spring and summer — through a consideration of Soviet artists working primarily in Moscow. It is an exhibition which presents the voices of artists who have previously been denied speech within their culture — a culture that suppressed truth for the sake of pragmatism, and that glorified a now seeming obsolete utopian model. And yet it is also an exhibition that traces the challenges to art not only in *late communist,* but in *late capitalist* societies as well. The underlying theme of the exhibition, though difficult to distinguish, is framed by the living-death of a particularly dysfunctional modern culture stripped of its soul by decades of cultural engineering.

No position of Western moral superiority is intended here. One only needs to consider, for example, the pathetic yet horrifying situation in which several powerful conservative members of the U.S. Congress allied themselves with right wing press to intimidate the American arts community. Congressmen alleged that federal funds were improperly used for exhibitions and theater productions they consider morally offensive. It is clear that governments East and West are similarly caught in a crisis of legitimization. A crisis in which a reactionary "morals" debate is promoted by ideological zealots in order to distract the general populace from government's inability to address tangible social problems. A crisis in which the function of art is not only called into question, but its power is thrown into high relief. A crisis that makes it clear that we have as much to learn from the changes rocking the Soviet world as they have from observing the fragile nature of our freedoms. And finally, a crisis which clarifies the changing conditions by which the U.S. and the USSR seem to be colonizing each other's territories of culture.

II

The contemporary arts are a significant site for social studies. Few would argue that an understanding of the art of one's time can illuminate the formative forces of a culture, and help define a truly personal critical perspective. To develop my understanding of the relations between shifts in American and Soviet contemporary culture, I first visited Moscow in the summer of 1979. As Chief Curator at the University Art Museum at Berkeley at the time, I accompanied the filmmaker Francis

Ford Coppola for the presentation of *Apocalypse Now* at the Moscow Film Festival, representing our film department, the Pacific Film Archive. Since I was coincidentally working as a videographer/correspondent for the pilot of a public television broadcast arts magazine I found myself with the enviable opportunity of producing a video documentary segment on the reception of Coppola's film by Eastern bloc filmmakers and critics.[2]

The initial jolt of actually being in Moscow wore off quite quickly. Life in the 5000-room Rossiya Hotel is a perfectly Soviet experience: tiny rooms, bare necessities, lots of people sitting around watching you come and go, no element of comfort in the entire sleeping factory, and no notion of service whatsoever. After several days of attending screenings and serious drinking, followed by interviewing stars, critics and filmmakers I began to feel somewhat let down. Even my visit with the poet/actor Evgenii Yevtushenko was a bit anti-climactic. Exalting in his starring role as Konstantin Tsiolkovsky, "father of Soviet astronautics," the great poet saw himself as a major international movie star. While interviewing him at his dacha, the kitchen phone rang. I sat in stunned silence while he turned down the role of Lenin in Warren Beatty's epic production of *Reds*. As he hung up, he turned and in mock-disgust said that "from now on I will play only leading roles. John Reed or nothing." Returning to Moscow that evening Red Square seemed grand and imposing, but cold and alien at the same time; an empty theater of surveillance waiting for a parade.

Like many Westerners, I wanted to confront my fears and expectations about life in the Soviet Union. My simple plan was to seek out the Moscow underground art world; a world that didn't officially exist. I quietly drifted away from the festival (my colleagues and my assignment) and sought out "unofficial" artists to interview. I had taken several lists of names of so-called unofficial artists with me, with the hope that I might find time to do this unsponsored research on my own time. Among these artists were several whom I assumed were conceptualists, as they had been students of Vitaly Komar and Alexander Melamid. As the most well-known Soviet emigré conceptual artists working in the West, Komar and Melamid quickly developed a strong reputation for their own anti-modernism called Sots art, a term they had earlier invented in 1972.[3]

I'm not sure why I had such a strong desire to get a direct experience of a real underground. It occurred to me that perhaps this represented a certain kind of voyeuristic exoticism; a kind of perverse anti-recreation. I wanted to see if the experience of the Soviet avant-garde could expand my limited understanding of radical art. Perhaps it would foster a fuller appreciation of my increasingly grim sense of the realities of advanced Western art.

At that time I believed that American counter-culture heroes and the popular media created the sense of *undergroundness* necessary to define a critical space outside of the benign neglect of mainstream culture. Our present notion of underground

remains a polite social convention, a sort of off-Broadway art world where ideas could be readied for the marketplace free from critical tampering, while simultaneously developing the saleable American veneer of absolute independence. In the West, underground art was not necessarily radical or avant-garde.

During times of serious widespread activism, such as the period defined by the anti-war movement or the struggle for black civil rights, many American artists defined a more direct political link between the condition of the cultural underground, and the real political underground such as the Black Panther Party or the Weather Underground. And though there were, and continue to be, genuinely committed radical American artist/activists whose lives and careers are linked to primarily political motivations, the American art underground remained essentially an artificial oppositional force.

American radical art, as I have experienced it, has often oscillated between prescribing progressive social change — a sort of super-utilitarian art, and an art which demands space for pure aesthetic invention linked to formal issues. Some of this radical art has been conceptual in nature, that is to say, it functions as a philosophical exploration of art, its purpose and its ontological capacities. While other types of radical art insists upon a quite pure engagement in the extension of art's own language and structure. Conversely, some radical artists reject this kind of formal avant-gardism, using instead the techniques and strategies of more traditional artmaking practices to directly invoke social issues. These artists often show little interest in a philosophical questioning of art, or in the mythology of a distinct and singular avant-garde within what they see as a range of advanced positions.

I have long felt that such splintering divides the intellectual aspirations of the Western avant-garde from the more populist notions of the radical American cultural underground. Things get confusing in those areas in which these two worlds overlap or compete for the mantle of true radicality. And the competition within this American "underground" is transformed into bitter factionalism when either approach runs up against official attempts to constrain the presentation or support of art deemed oppositional. Questions are raised: is one approach more radical than another? can any claim a truly avant-garde position? are any in need of a real underground? Responses to the recent Robert Mapplethorpe/ Andres Serrano controversy, or the destruction of Richard Serra's "Tilted Arc," are instructive in this regard.[4] Ultimately, the American idea of "radicality" functions in a climate of repressive tolerance, not one of direct repression. Or as the cultural historian Andreas Huyssen notes,

> [t]he American post-modernist avant–garde. . .is not only the endgame of avant-gardism (it) also represents the fragmentation and the decline of the avant–garde as a genuinely critical and adversary culture.[5]

But the avant-garde underground one encountered as an American in Moscow in the late seventies was an underground in the grip of direct repression, and as such,

I naively expected things to be a great deal more straightforward. Good guys on the left, bad guys on the right.

III

I traveled to Moscow for the second time in the full-tilt *glasnost* summer of 1988. Since my initial trip in 1979, I was known as harboring a serious ongoing interest in returning to Moscow to continue my research, and was asked by the Tacoma Art Museum to organize an exhibition of contemporary Soviet Art as part of a cultural festival surrounding the Seattle-Tacoma based Goodwill Games. I was willing to explore the possibilities of an exhibition, but, pragmatically, was unsure if I would be allowed back. Much of my activity in 1979 had been monitored by Soviet authorities.[6] It was evident that they were not pleased with my contact with underground artists. Further, I was skeptical of my ability to organize an exhibition that the Soviets would allow as a representation of their contemporary scene. To allay my fears, prior to leaving, I traveled to Washington D.C. to meet with a formal representative of the Soviet Ministry of Culture. I was amazed when he stated that I would be free to organize whatever exhibition I liked, and could expect their official support as long as at least one artist was a member of the Artist Union. This new openness, he told me proudly, was part of the changing condition of their nation. Since I had heard that official/unofficial hierarchies had been formally eliminated by the state, and that some previously outsider-artists were now "officially" in the Union, I readily agreed to this single condition.

My July trip was timed to coincide with the official opening of the Soviet art world to the Western art market announced by a major Sotheby's auction that offered both contemporary work, and several gems of early Russian modernism. The fact that a heavily hyped Sotheby's auction would mark the opening of this world as a "market" was a symbolically perfect event to introduce Western collectors to the land of irony, and vice versa.

It had been nearly ten years since I had first visited Moscow, and though heartened by the developments of perestroika and the liberal leadership of Gorbachev, I still suspected that the opening of the art market was merely a ploy to attract hard currency while promoting the careers of sanctioned artists.

Moscow in July of 1988 had a smell of land-rush fever to it, as a literal horde of American and European art dealers, collectors, journalists and carpet-baggers descended on Moscow for the auction. On view in the Artist's Union wing of the "new" Tretiakov Gallery was an embarassing exhibition of Leroy Neiman's work sponsored by Armand Hammer. At Kuznetsky Most, the smaller somewhat junior gallery for younger artists in the Union, was an exhibition including work by many avant-gardists never before seen in an "official" exhibition.[7] In The Palace of Youth, a large

and ungainly exhibition of work by more than 200 young artists included only a handful of interesting works.

These events have been well documented in scores of reports in American and European art and news magazines, and a serious documentary film, but it is hard to communicate the mixture of hopefulness, confusion, anxiety and strangeness that hung heavy in the environment.[8]

The auction was center stage, and was the signature event for the impromptu festival. Like most observers, I was impressed by much of the work on view in what was more a benefit sale than an actual auction. Most of the work was directly from the artists or the Union, and as it had been picked carefully by a Sotheby's-Soviet team, it represented the first attempt to represent their newly expanded universe. I felt encouraged by what I saw, and even more encouraged by my talks with Pavel Khoroshilov, the then head of the All Union Artistic Production Association named for E. V. Vuchetich. As one of the auction's organizers, he was buoyant about the success of the auction, and was extremely optimistic about the future for Soviet art. He also agreed that we could have complete control over our selections for the Tacoma/ICA exhibition and that his organization would help in whatever way we would like.

Their rules were changing so quickly that Ministry and Union bureaucrats were clearly reluctant to do or say anything that would dilute the sense of openness they too were enjoying. Though there was pressure to deal with the potential hard currency implications of this new export market, they were circumspect and politically cautious. They were concerned, for example, with the sensitive issue of nationalist politics, and warned against confusing Soviet art with Russian or that of other nationalities, and hoped that our show would provide an overview of the best creative work from across the entire USSR. And, because they were co-curating the *"10 + 10"* exhibition, which was already being organized and would be the first to be seen in the U.S., they felt in control of the extent to which they could design the inaugural American exposure of art from their *perestroika*. Excitement aside, however, I was left with the question: what did the auction portend?

IV

Prior to the auction, the critic Joseph Bakshtein had organized a group of about 100 artists (all current and former undergrounders), to assemble for a boat ride and picnic on the Volga on the day following the sale. About a dozen or so foreigners (including journalists) eagerly joined the Muscovites for the trip. It seemed an important thing to do, as there was much to consider and discuss concerning not only the extraordinary prices which some of the work brought[9] but the nature of the changes that seemed to be transforming their community. Changes that could as easily be dismissed and forgotten if the mood of the state shifted away from the theater of *novostroika*.

With camera and recorders going, and reporters paying rapt attention, poet Dmitri Prigov held forth on the ship's foredeck and ran a floating press conference on board the day-liner. Like the auction, it was great theater. Conspiracy theorists in the group saw this moment as a mirror of the moment of *perestroika* itself. Formerly ignored and once "unofficial," Grisha Bruskin had sold a work for the sum of several hundred thousand pounds sterling; a record price for the work of a living Soviet artist. What did that mean? If this was theater, who was directing, and was it farce or drama? Was this time for a victory celebration? Many feared that this was merely an empty media moment — and worse, a moment not really radical enough to satisfy those hoping for more dramatic changes in their lives. To many, the changed art world — as with other aspects of *perestroika* — was far enough out of step with the mainstream that it could easily backfire, ending many of the minor reforms that were currently being enjoyed. Further, some suspected that during this period carefully constructed defenses born of generations of living underground lives would wither and the supportive close-knit communities — which if anything at all characterized the underground art scene — would be shattered by the lure of fame and material wealth. Would the new freedoms end with a return to the active repression they had all known so well? Cause to celebrate? Perhaps. A time between spring and summer? Quite possibly.

The avant-gardist's picnic provided me with the opportunity to begin to develop a focus for the exhibition. It seemed that what was necessary was a twofold attempt to look at one group within the formless scene (no longer underground, no longer unofficial, and disputably avant-garde), and to trace the formal and intellectual roots of Soviet conceptualism. In a conversation with the theologian and art critic Evgenii Barabanov we discussed this approach, particularly the enduring influences of a generation of conceptualists. While he traced the effort of a wide range of artists to replace a spiritual emptiness with a mix of Eastern and Western influences — and thus underscored the historic place that Russian culture has always held as a crossroads of occidental and oriental influence — I mentioned my concern that too much effort would be focused on the exotic novelty of things Soviet, and that our exhibition needed specific focus to succeed in communicating anything profound about the complex Soviet art world. Later, during a conversation with Joseph Bakshtein, we discussed how this new Soviet conceptualism *worked out of* the sustained repression modernism, *worked through* the official sanctioning of Soviet realism, and thus generated a particularly Soviet postmodern moment. Slowly, inevitably, it was the work of those artists whose access to the legacy of modernism was so severely constrained, the work of artists who nonetheless managed to forge a postmodern aesthetic strategy by induction, which became a focus for this exhibition.

V

I returned to Moscow with my curatorial colleagues in the fall of 1989, and found the pace of *glasnost* and *perestroika* increased tremendously. The airport was jammed with returning Soviets ladened with electronics and other Western consumer goods. Our hotel lobby was jammed with American, European and Japanese business-men; the Coke machine and the American Express cash dispenser always busy. Limos and gypsy cabs filled the drop-off area outside the hotel entrance. Even the expensive co-op restaurants were over-booked, and the hotel itself was straining to keep up with the crush of visitors.

To our disappointment, several of the artists we wanted to spend more time with were already traveling in Europe — Ilya Kabakov was on a DAAD fellowship in Berlin, and of the younger artists, Andrei Roiter was in Brussels, and Zakharov was visiting Cologne — a scene he fit into easily. By this time, we had a working list of artists we were interested in spending time with, and a long list of questions that were guiding our research, among them: must an avant-garde function as an opposi-tional force? what is the relationship of an art market to the dissolution of a community? will the Soviet scene generate its own critical press? is the diverse iden-tity crisis — between region and nation — reflected in art from Moscow? is the presence of an avant-garde a product of cosmopolitan thinking?

We agreed that the exhibition should contain no more than twenty artists in order to present each artist's work in sufficient depth. To accomplish this meant find-ing a curatorial focus that could open up at least one set of evident connections between members of a community formerly united by their outsider status, but now beginning to re-orient themselves in a manner more familiar to us. On the surface, this didn't seem too difficult a task, but the actual practice of working as foreigners in a volatile and necessarily hermetic environment made us aware that, finally, we would need to work with one or two non-government Muscovites to assure ourselves that we weren't wholly fabricating a portrayal of the situation.

We spent most of this second visit sharing our concerns with artists, filmmak-ers, and architects, and maintaining cordial working relationships with culture ministry functionaries. We began through an introduction to the world of the "paper archi-tects," architects who had not yet begun to realize their public buildings. We had particular help from one of its chief proponents, the young architect and independent curator Yuri Avvakumov. Late on the evening of our first day together, Avvakumov had taken us to the studio of Mikail Belov and his wife Katerina Belova. As is gener-ally the case in the West, we found conceptually oriented architects seriously engaged in issues of theory and the social consequence of their practice. They were eager to collaborate on a still amorphous art exhibition, and to build upon their critical relation-ship to the business of their profession. For Soviet architects, most particularly

Moscow architects, this critique was charged: it challenged professional control by the party *aparat,* it questioned the party's role in the stagnation of the state economy, and lamented the depressed state of life in a city that — at one time — had the charm and grace of Paris.

Leaving Belov's studio late that night, Avvakumov pointed out a typically nondescript fifteen-story apartment building of a discernible modern character. "Look at the eighth floor," he directed our small group, "see how it is several feet taller than all the other floors? This was built for Brezhnev's apartment, and they tried in vain to hide his privilege by burying it between two regular floors." This, he indicated, was a good example of the lack of respect for the popular intelligence, and the complete lack of architectural imagination. The insult to the intelligence of any observer was obvious, but that the nature of the lie lived day-to-day was evident in the details as well as in the more obvious shortages and inequities came as something of a revelation to all of us.

VI

If capitalist greed is considered the primary rationale for poor design, failed architecture and short-sighted urban planning in the West, the fear of lost bureaucratic privileges and the evolution of pluralist cultural enterprise is the Soviet equivalent.[10] It is widely agreed that the major problem confronting Gorbachev is the same problem that confronted all who have attempted to rule this vast nation: an entrenched, indispensable and completely intractable bureaucracy. This reality would be reflected time and again as we moved within the Moscow avant-garde. But it was as evident to any of us who walked the streets in the outer city apartment zones as it would be to those engaged in ongoing interactions with state functionaries.

Alexander Brodsky and Ilya Utkin are interested in reflecting the decay of Moscow, and the ways in which its glorious architectural heritage has been carelessly eliminated in the name of modernization. They showed us their work, in their shared studio, a great idiosyncratic space in the eaves of a thirties building that had belonged to Brodsky's late father, a well-respected illustrator. Their drawings, etchings, and sculptural installations are not simplistic pleas for preservation, but rather they are complex romantic fantasies which seem to meld the drawing style of Piranesi with visions of the bleak cyber-punk futurism of Western films like *Blade Runner.*

Of all the "paper architects," so called because their work exists almost exclusively as drawing, Brodsky and Utkin are among the only ones to have built a project within Moscow. Commissioned by a restaurant co–op (the co–op business functioning as one of the most significant pre-glasnost signs of progress), they produced a renovation for *The Atrium* in the basement of an apartment building on the broad avenue known as Leninsky Prospect. With images calling up the comic vision of modern Moscow as a repository of classical ruins, they have built a vaulted catacomb space

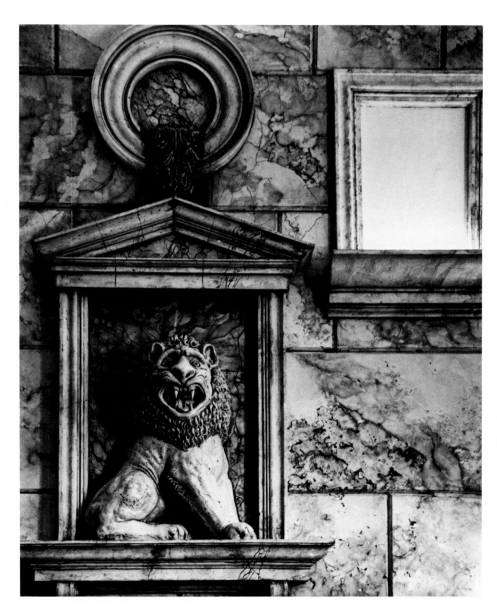

Brodsky and
Utkin, *Atrium
Restaurant,*
1988, Leninsky
Prospect,
Moscow
Installation

covered in marble-tinted plaster relief sculpture redolent of a restrained Red Grooms version of a Roman bath. It is the most perfectly finished contemporary space we will see in all of our visits, a quality achieved by the architects' willingness to not only design, but re-build the entire space themselves after the official workers had "concluded" the re-hab.

After dining with them in the space they designed, we asked if they would conduct a tour of Moscow on our next visit. It occurred to us that we might also need to experience the city from the perspective of an architect with a cooler vision, so we later asked Avvakumov if he would also show us *his* city.

During the next days, we spent time with the noted filmmaker Rustam Khamdamov. Though I was wary of the relative privilege and insulation of the film community that I experienced on my first visit to Moscow, we recognized that film was the most important indicator of popular taste and as such could not be ignored. In 1968, Khamdamov had made an underground classic version of the Saroyan short story *My Heart Is In The Highland.* As an Uzbek with no formal permission to live in Moscow, and as a gay filmmaker who had run afoul of the officially homophobic film bureaucracy, he has literally existed underground for more than twenty years. Supporting himself as a costume designer, he works and lives in a small studio built into what was at one time a secret escape tunnel from the palace of a member of the royal family.

Khamdamov was happy to meet with us, for as we would discover, the changes in the state-controlled film industry (in Moscow known as Gosfilm) had provided him with his first production opportunity since having his film *Slave of Love* taken away.[11] When we called he was in pre-production on a film based on his script "Anna Karamazov," a Stalinist fairy-tale melodrama functioning as a meditation on the moral endgame of contemporary Soviet life. To illuminate his sense of Russia, Khamdamov took us to visit Moscow's great decrepit Constructivist masterpiece — the Melnikov house — still inhabited by Melnikov's now elderly son. The clarity of Melnikov's vision still shines through the shamefully run-down building, confronting the visitor with a concrete example of the lost innocence that characterizes contemporary Soviet life. He insisted that we visit the studio of a great older painter, an artist named Mikhail Shvartsman whose paintings, in the modernist spiritual tradition that emerged from icon painting, were transformed by an exquisite painterly sensibility. It was clear what had been lost, and the poignancy of his work brought the intellectual urgency and rawness of the projects of younger conceptualists into high relief.

Khamdamov was, beyond the bitter outsider's humor of his own work, a true believer in the spiritual power of what survived of Russian culture. And yet, after a series of meals, talks, and some polite disagreements, we realized that there was a rift here between the outsider community that held on to their old status out of habit,

and those who needed to work out of that space for purely ideological reasons. We also recognized that there was virtually no connection between the independent feature film community — whose stars like Andrei Tarkovsky, Sergei Paradzhanov, Andron Konchalovsky, Nikita Mikhailkov and Khamdamov himself, were already well-known to serious film audiences in Europe and the U.S. — and the avant-garde art community in Moscow. The issues that were present in the newest films — the anti-Stalinist sentiment that few believed would be officially condoned, the pent-up desire for relief from their material and spiritual poverty — had long been present in the Sots art work. And yet according to Khamdamov, none of the filmmakers had first-hand knowledge of this work.

During this trip, we visited studios in the *Furmanny* Lane building - a completely dilapidated apartment house occupied quasi-legally by Zakharov and dozens of other artists of his generation. We became more certain that this was the work to concentrate on; primary patterns of influence were beginning to emerge. We saw, for example, Konstantin Zvezdochetov's quirky, ungainly, but powerful assemblage constructions with their focus on irony, poverty, madness and ambiguity. I had remembered, from my "auction" trip in 1988, a work of his consisting of a painted refrigerator door (produced for an Apt art exhibition) that Zakharov had shown me, but now could relate the work within the frame of Ilya Kabakov's assemblage approach. If Kabakov was allied with the American assemblage of the Robert Rauschenberg/Jasper Johns generation, Zvezdochetov (and Zakharov) were closer to sardonic hermeticism of younger artists like the American Mike Kelley or Germans like Georg Herold or Martin Kippenberger. Their shared anti-aestheticism emerges from an absolute refusal to recognize the reductive language of modernism as heroic. Zvezdochetov's is an angry hermeticisim, a response to a generational rage curiously symmetrical with that of post-Beuysian German art.[12]

Visits to Dmitri Prigov, Eric Bulatov, the Kopystanskys and Ivan Chuikov, followed, and we were impressed by their work. It was evident to us that they were all key artists in the formation of this new art. But our final studio visit of this trip proved to be extremely influential.

We met Andrei Monastyrsky at a party thrown by Vika Kabakov, the wife of Kabakov, and for many years an important figure in the Moscow scene. Unlike New York, parties in Moscow are not merely social adjuncts to the ongoing discourse, they are its center; they are the primary medium for a scene that has existed with support from *samizdat* international publications and no relevant internal art press.

Monastyrsky is the central figure in the group known as Collective Actions, a loosely-knit circle of artists whose primary activities have been actions presented as metaphors for social change, but also as meditations on their conflicted relationship to prevailing ideas of nature and social order and their place as a culture formed between the oriental and occidental worlds. These actions, presented as purely ephemeral

sculpture with no audience other than the participants, were part of an evolving discourse among the members of the group, and were documented with text and photographs.

Collective Actions rejects the idea of the work of art as either a discrete event or object, and in this sense theirs is an anti-modernist project. The works can be seen as para–Buddhistic reactions to the world they encountered. Simultaneously, the work reflects the hermetic Moscow intellectual environment, and represents collectivity as a metaphor for the sublime.

The group, which has included Kabakov, Igor Makarevich, Elena Elagina and several others as regular participants, injects Eastern thought (particularly Zen Buddhism) into the consideration of temporal and physical conditions. We were surprised to discover, in discussions with Monastyrsky, that a primary influence in their development had been the ideas of John Cage, whose work is widely recognized for having introduced Western artists and audiences to the Zen-influenced ideas of randomness and indeterminacy and a Buddhistic capitulation to natural order. It struck us as a wonderful irony that these ideas had traveled such a circuitous route to arrive at the century-old site of primary cultural contact between Eastern and Western cultures, one which was curiously passive and in a way very much allied to Kabakov's own anti-heroic attitudes.

Collective Actions have been actively exploring the limits of the modernist language of art, and its detachment from and inability to describe natural forces. Their work extends a notion of mystical and passive aestheticism. Their work, driven by its own logic, finds its American parallel in the work of the late American sculptor Robert Smithson. In the late 1960s, Smithson spoke directly for a complex aesthetic of the natural world. In "Art and Dialectics" an essay he wrote of the relationship between a work of art (or any phenomenon) and its context in the natural world (including its social dimensions) superceding the ideational dialectic of thesis and antithesis. He wrote:

> . . . a painting may be said to have the quality of 'openness' when in fact it is only representing openness. One might tell a prisoner facing a life sentence that he is free. The freedom is metaphysical, or in art critical terms, 'esthetic.' A shrewd esthete can turn a prison into a palace with the aid of word — one has only to read a Jean Genet novel to see that . . . Natural forces, like human nature, never fit into our ideas, philosophies, religions, etc . . . The old notion of 'man conquering nature' has in effect boomeranged. As it turns out the object or thing or word 'man' could be swept away like an isolated sea shell on a beach, then the ocean would make itself known. Dialectics could be viewed as the relationship between the shell and the ocean. Art critics and artists have for a long time considered the shell without the context of the ocean.[13]

VII

In November of 1988 we returned to Boston, and continued our planning and conversations. We agreed that in the final phase of our process we needed to expand our curatorial dialogue through the formal introduction of a Soviet voice. From our previous discussions with several specialists, Margarita Tupitsyn was clearly the right project partner for us. A Soviet-born American art historian specializing in twentieth-century Soviet art, her experience with both the Sots art and the Aptart exhibitions made her a natural resource for us. It was also apparent to us that she shared our desire to see an exhibition that might underline some of the theoretical underpinnings of the current Soviet scene. Her husband, Victor Tupitsyn, a respected Soviet-born mathematician was also well-known for his theoretically based writings and interviews with artists of this generation. We felt that with their help we could wrap up this phase of our work in Moscow and visit the two artists in Leningrad which for some time we had thought to include in the exhibition. We also knew that finally we had to test our shared intuition about the vast differences we would encounter in a non-Russian city like the Georgian capital, Tbilisi where the painter Giya Edzgveradze lived and worked. In this regard, we were concerned that our short list was almost exclusively composed of Muscovites (though many of the artists were born and educated in other regions.)

As planned, we began this visit with two architectural tours, the first led by Avvakumov and the latter by Brodsky. To our delight and amusement, Avvakumov began with a trip to the Permanent Exhibition of Agricultural and Industrial Achievements(or VDNKh), a classic example of high Stalinist architecture, glorifying a fully modern future as projected by what was supposed to be the world's most advanced and modern social system. The New York World's Fair of 1939 may have been more grand, and more technologically advanced, but this park , built in 1937 is a virtual catalogue of stolid workers' modernity. Each pavilion was initially devoted to the various republics that compose the Soviet Union, but as that approach failed, the pavilions were transformed into poorly designed trade and industry related exhibitions. Many buildings are now under extended periods of repair, lending a stately shabby air to the place. The generally faded feeling of this place aside, with the exception of the pavilion celebrating triumphs in Soviet space exploration, both the information and entertainment levels of the park are pretty low. That is not to say that it is not popular; to the contrary, on a hot sunny afternoon the park was packed with families on day trips complete with kids queuing for ice cream. The park exists as a grand but essentially empty signifier, valorizing workers sleepwalking through a faded dream. [14]

On the way to our next stop, Moscow University in the Lenin Hills, we passed through Dzerzhinsky Square, where Avvakumov noted the terrible irony of locating the infamous KGB headquarters directly adjacent to Moscow's major toy emporium.

To encounter fear and desire in such proximity, according to the architect/guide, was a terrific example of the completely unsubtle ways in which Soviet urban planning ceaselessly functions as narrative architecture. From the Lenin Hills, we could see how the city was organized, and how those circles within circles, so typical of the great medieval walled cities, had made Moscow virtually impenetrable.

Finally we visited the site of Moscow's still extant (and wondrous) first major cinema theater, originally fitted with a roof that could open to the starry evening sky. The constructivist masterpiece designed in 1930 by Boris Iofan remains, like the massive film industry itself, evidence of the role that film has always played in both projecting the nature of the state aesthetic, and how film conformed to the ongoing ideological needs of the state.

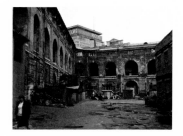

Brodsky's tour was — as we expected — quite different. He led us to three ruins, each symbolic of the spiritual core that remains at the center of this great city and great nation. After touring a vast decrepit building interior literally one block from the Kremlin, and the Hotel Ukraine (arguably the real monument to Stalin's cosmopolitan vision), he took us to the Donskoy Monestary an old graveyard located behind a de-sacrilized eighteenth-century church. The grounds, dotted with small sanctuaries, were the resting place of many important eighteenth, nineteenth and early twentieth-century Russian aristocrats, intellectuals and political leaders, and as such became known as a meeting ground for the organization known as *PAMAYAT* or Memory — a nationalist and virulently anti-semitic association which is evidence of the frightening re-emergence of a Russian racist sensibility. But for Brodsky, the place's true symbolic value lay in its function as an unofficial "museum" of lost architecture. The grounds are littered with architectural details from destroyed churches and public buildings, including ornate stone carvings from what was formerly the great Church of Jesus Christ, destroyed in the 1950s to produce the Soviet Union's largest outdoor swimming pool. The church itself contains the massive eighteenth–century model of Bajanou's visionary scheme for a new Kremlin. It is locked away in the frescoed space of the cathedral.

Seeing this place, I reflected upon *Columbarium Habitabile*, Brodsky and Utkin's homage to an architecture expressing the role of the individual in a technological world, as not just a humanistic plea for preservation, but rather an elegy for a nation's soul, a cautionary tale about what fills that vacuum. As we were leaving the cemetery, we were attracted to a small sanctuary with its door open. Venturing inside, we found an art restorer working beneath scaffolding, repairing the frescoed interior of the chapel. We asked permission to come in, and as we talked, our eyes eagerly searched the littered tables and surfaces resting on a familiar but strangely out-of-context icon — a small plaster bust of Stalin. The restorer admitted that he made them in his spare time, and sold them to visitors to the grounds.

On the way back to our hotel, we again passed KGB headquarters, and this time it generated a conversation about the courage and intelligence of Yuri Vlasov, the

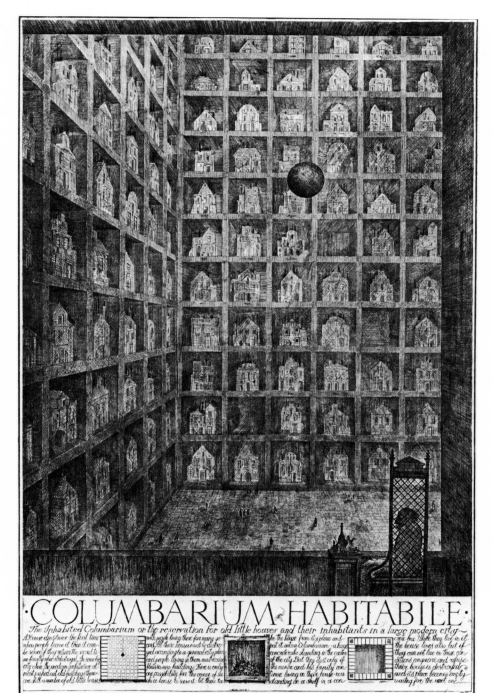

Brodsky and Utkin, *Columbarium Habitabile*, 1989–90, Etching

athlete/scientist/politician who had delivered a cogent analysis of the KGB building's architecture (and its symbolic status as a metaphor for Stalinist culture) in a major address to his peers in the Soviet Congress. We talked about the comparative level of the American Congressional arts discourse, the growing American distrust of intellectuals and lapsed into an uneasy silence for the rest of our ride.

The next days were spent looking at new work by Andrei Roiter, and Sergei Volkov, two artists whose work might be considered in relation to American New Image painters, but whose approach emerged from Roiter's participation in the "Kindergarten" group — so-called due to the abandoned school building they worked in, and also to their use of childhood and the mock innocence of an ideologically pure state of mind.

This notion of distanced nostalgia is a broadly shared reference. Larisa Zvezdochetova, whose parodic mixed-media works are attempts to construct a critique of the kitsch imagery of her native Odessa, explores the ways in which domestic (women's) materials provide the underlying framework for a systematic repression of women within the broader framework of an oppressive system of signs.[15] Her work speaks to the schizogenic effects of a culture that formally promotes women as co-equals within the context of a revolutionary society of workers, while it encourages and supports a violently anti-feminist patriarchal culture. Her work addresses the range of options that art must have.

If Zvezdochetova's work recalls that of the German artist Rosemarie Trockel, the young painter and collagist Maria (Masha) Serebriakova recalls American artist Annette Lemieux in her construction of fabricated family histories. Her small paste-ups evoke a melancholy of the disempowered, and though she was the only woman who would speak to the stirrings of a feminist discourse in Moscow, it seemed evident that the kind of women's community necessary to support that evolution was still in its early stages.

Our trip to Tbilisi was somewhat as we'd expected. We had been concerned that rioting in the southern Soviet republics, including a highly publicized anti-nationalist police action in Tbilisi several months before our planned visit, might make it impossible to obtain a visa extension permitting our travel to the Georgian capital. In the midst of extraordinary beauty, there was a continuing, palpable mood of political ferment, anger, fear and expectation. The filmmaker Sergei Paradzhanov, Tbilisi's most famous artist, was gravely ill, and unable to see us. Of the painters we saw — Giya Edzgveradze — whose work had been highlighted in the Sotheby's auction and had thus quickly developed a strong European following — literally lacked work to show us, choosing instead to share transparencies for an upcoming survey exhibition in southern France. A younger painter, Koka Ramishvili, drove us to a fourteenth-century monastery outside of the city and then took us to his group studio where we saw his work and paintings by several of his friends. Strong neo-expressionist work

though it was, there was little of the intellectual rigor or ambition we encountered regularly in Moscow.

Most memorable and disturbing was the discussion of the April Fifth military police action in which many people were injured and scores were killed. To these artists, there was no novostroika; perestroika was a Russian thing — essentially a smokescreen to cover the attempts by the state to crush national liberation movements throughout the USSR. To them, the postmodern debate is oddly irrelevant except perhaps as a sign of the broad cultural crisis gripping not only the USSR but all nations. That evening we met and spoke at length with people who feared an imminent Russian attack, and were preparing for civil war. The underground, in this context, was something unrelated to art.

Back in Moscow we were troubled by the problem posed by the reality of an exhibition which sought to explore some general characteristic of a nation as vast, diverse, and conflict-ridden as the USSR. We checked out an exhibition of Champions of the World, a group which Zvezdochetov had formerly belonged to and which had been influential for the past year. The show seemed witless and, with exceptions, pointless. Like many of the Moscow provisional groups, their function was changing rapidly as an individualist approach towards making art developed. Also, as the discourse broadened to engage external critical priorities the need for these circles has begun to fade. We found the group known as Medical Hermeneutics, consisting of Sergei Anufriev, Pavel Peppershtein and Yuri Leiderman, an extremely important exception to the dissolution of the collective mentality. Referring to themselves as "inspectors," and functioning as an aesthetic detective agency, Anufriev described the group as:

> inspector-erudites of schizophrenic China; specialists in the development of aesthetic categories; specialists in the allocation of meaning. [16]

The three artists look at everything, and generate complex, scholarly description and analysis of art, the art culture and the popular culture. The Med-Hermeneuts produce paintings (either collectively or individually signed) as well as installations and collage (primarily by Anufriev). They then collectively produce an analytical investigation of the work, which is meant to function within the work, not as a critical afterthought. Beyond the references to self-criticism and constant monitoring of ideological purity that this activity parodies, there is, in their work, an attempt to locate a discourse centered on the ontologic implausibility of art (or any form of abstraction).

Interestingly, the Med–Hermeneuts were Moscow outsiders who also came from Odessa. The strength of their work helped convince us not only that the exhibition we sought had to come out of Moscow, but, as Kabakov would later confirm, that Moscow's parochial cosmopolitanism was a fairly accurate reflection of the conflated Soviet identity of Moscow conceptualism. We reflected then, on the work of the artists of Tbilisi — intensely Christian, intensely spiritual, self-contextualized as Georgian

art: art of another world. We realized it was work that had a logic separate from our exhibition focus; it was art waiting for its own definition in its own exhibition.

We met up with Bakshtein at an exhibition entitled *Perspectives of Conceptualism* which he organized to be installed in a basement gallery space far from the center of Moscow. This small but brilliant exhibition made it immediately apparent that we should invite him to work with us in the final selection of the exhibition, and as a primary writer for this catalogue. *Perspectives of Conceptualism* included important work by the Peppers (Mila Skripkina and Oleg Petrenko, a wife and husband from Odessa) which used a mock scientific vocabulary of elemental signs, common domestic objects, foodstuffs, and reformulated illustrations. Allied to Kabakov's use of the banal, they brought to their work a strange sense of humor and sarcasm. We saw a "green" work entitled *Children's* by Collective Actions members Igor Makarevich and Elena Elagina,[17] as well as another jointly produced mixed-media work entitled *Pure,* a frightening metaphor for dystopic social hygiene.

We departed for a three-day stay in Leningrad before returning home.[18] Since meeting "Africa" (Sergei Bugaev) at the avant-gardist boat ride and picnic in July of 1988, I had wanted to locate those expressions of a Moscow-based conceptualism which flourished away from the center. I wanted to spend some time getting to know his work and the work of his friend the painter Timur Novikov.

Leningrad is home to the musical underground, and though more conservative in regard to the visual arts, is the site of the Soviet rock scene as well as its fledgling video community. Africa, an artist who took part in performances with the group *Popular Mechanics,* was an ideal guide to the city.

We knew Africa to be a situation-specific conceptual artist, so we expected that he might be willing to respond to our growing sense of the exhibition with a proposal which would be both an expression of late Communist Soviet culture and a response to our take on the same developments. Africa is fascinated by cultural mythology, and by the literal and figurative sign systems that any modern culture uses to generate and sustain a dominant cultural narrative.

Africa responds, like American artists Haim Steinbach and Ashley Bickerton, to the impossibility of working against the cultural history of a place choosing instead to work within it, using its intrinsic rules to bend its nature. While walking the streets of Leningrad, Africa pointed out signs and banners extolling the Soviet way and urging readers to lead a model socialist life. No ads urge the consumption of consumer goods, nor is there any promotional identification linking class mobility to brand consciousness. Taking its place, both on the streets and in public media is the broader coercion to live the correct life.

Africa proposed an American advertising campaign commodifying life as lived by his friend Sergei Anufriev, not in regard to Anufriev's investigatory spirit, but as

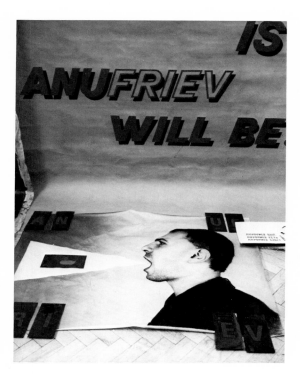

The Orthodox Totalitarian Altar in the Name of Anufriev, 1990, Mixed media

an unconsidered act of faith and allegiance. The post–Sots work, *The Orthodox Totalitarian Altar in the Name of Anufriev,* in a transgressive Koonsian spirit — both sees the growing fame of the new Soviets as a threat to the stability of their closed community, and critiques the commodification of personality. His anti-utopian art is a form of meta-investigation, an attack on notions of exemplary behavior as a correlate to exemplary art. The work is about desire, sexuality and the surrogate. As such, it functions both as a lament and a celebration.

VIII

I want, in conclusion, to relate some of my thinking about Soviet art to the underground, and the changes in the Soviet Union in the ten years since my first visit. Perhaps, in such a consideration of change, one focus of our exhibition may be found.

The basic condition of the Moscow art world had changed materially since the fall of Mayakovsky and Lunacharsky and the rise of the Stalinist state cultural apparatus. That is to say, what was known in the West as "unofficial" Soviet art was part of a *real underground* composed of artists fearful of the consequences of their dissidence and mindful that their underground status was imposed on them, not self-inflicted.

The unofficial Soviet art world was not merely a metaphor for a state of mind, but meant actually concealing your life's work from the public. These artists recognized that in choosing not to directly serve the interests of the state, they were acting quasi-criminally, and that they risked everything, including the modicum of creature comforts they may have managed to accumulate.

Though they were not working as counter-revolutionary insurgents, the seemingly innocent decision to work outside the confines of the state's explicit official aesthetic code was more than a style or badge of ideological difference, but rather part of an inescapable commitment to social and intellectual independence.[19] *Partiinost,* or loyalty to the party, was the expected norm; all other behavior was suspect at least.

The impression I registered in the late seventies was of a closed community experiencing direct repression. Despite their material poverty and lack of open and free public discourse, the Moscow underground art world gave shelter and support to several avant-garde communities engaged in energized discussions about art. These discussions addressed art's function both as an independent agent of individual expression and as part of a systematic investigation of broader social practices.

Because of the nature and extent of day-to-day repression, the Moscow underground was a natural environment for avant-garde conceptual art — that art which in the West evolved out of a broadly shared sense that the object and intention of artists' work needed to be continually re-considered free from art-historical or ideological presumptions. The basic philosophical problem of living in a culture where you could not refer to things and experiences by their real names, and in which fully contradictory experiences are the schizogenic way of life, created a condition for the emergence of a conceptual art that varied somewhat from its more academic sources in the West.

The scarcity of material resources in Moscow also encouraged the development of an anti-modernist conceptualism with pronounced parallels to the look of arte povera, yet expressing both the energy and ennui of a simultaneously timorous and alienated community.

As I was to discover in 1979, Moscow conceptual art bore only a passing relation to its Western analogue, and virtually none to the putative state-controlled contemporary art found around it. Within the "unofficial" Soviet underground most of the art had little, if anything, to do with conceptualism. What I eventually discovered — all government protestations to the contrary aside — was that the most distinguishing feature of most Soviet underground artists was that they were *unofficial.* That is to say not banned, but not officially sanctioned by the state-controlled artists' unions or the ultra-conservative academic certification process. One's approach to art-making was secondary in comparison to one's party status or more often than not, one's social or political status. Being a Jew, for instance, made it difficult if not impos-

sible to be considered an "official" artist. As far as the state was concerned, refusnik artists were persona non grata.

Like many before me (and as an American Jew) I found it confusing and distressing in 1979 to encounter underground art whose status emanated purely from the socio-political identity of the artist.[20] Many observers of the American scene would have to recognize some striking parallels in our supposedly ideologically value-neutral structure. Nonetheless, a great deal of the "underground" Soviet art bore more of a debt to fairly tame notions of Western European modernity than to any avant-garde aspirations on the part of the artists themselves.

The best of these artists, such as Mikhail Shvartsman, or Eduard Steinberg who produces beautiful but essentially lifeless academic modern variations on constructivist themes, or the clunky abstractions of Ernst Neizvestny, whose infamous 1963 confrontation with then Premier Khrushchev epitomized the way in which reformed modern art was first scorned by the state then later embraced when its safety was understood, are regarded as generally uninteresting when seen in the West. More commonly "state" artists made work which had the look and feel of tenured faculty work. It was intriguing to note that many of these "unofficial" traditional painters and sculptors bore an open hostility towards the "unofficial" avant-garde conceptualists in their midst.

Clearly, the Westerner's somewhat nostalgic and romanticized confusion of the terms underground and avant-garde, often have drawn links between the concrete, material process of artmaking and the revolutionary consequences of its reading. To those who have never directly experienced a shooting war or real revolution, the ironic use of the term "underground" implied a desire to consider art as a radical form of pro-social para-military activity: an effective abettor in a revolutionary struggle for social change. To those who have, the terms have always had an altogether different set of connotations.

In this respect it is extremely ironic that the role of the original Soviet avant-gardists in the construction of Russian revolutionary culture remains an ideal of the actual integration of the artist into a complex social order. This is especially so since the sad fate of this Russian avant-garde — its dissolution within the Stalinist state — denied art's ability to function as a continuing revolutionary agent.

After the end of the heroic period of the revolution, the Stalinist Soviet state made it virtually impossible for these artists and intellectuals to continue to play a role: the popular culture of Socialist Realism in art and literature not only left little room for the artist as privileged critic and independent producer, but established a false set of goals for the measure of artistic excellence. Worse, it generated a culture of silence and fear. Once the hard-won political conditions of the revolutionary Soviet State had been fought for and established, and the grind of building an economic and

social infra-structure has begun, the question remained: how could the artistic avant-garde remain productive, independent, critical of the new social order, and able to function with sufficient moral standing to engage the state in an open, and consequentially critical, discourse? Could artists be allowed to explore more complex notions of truth, if those truths were not in the interest of the state? As Lunacharsky asked in his 1920 manifesto *Revolution and Art*

> For a revolutionary state, such as the Soviet Union, the whole question of art is this: can revolution give anything to art, and can art give anything to revolution? It goes without saying that the state does not intend to impose revolutionary ideas and tastes on artists. From a coercive imposition of this kind only counterfeit revolutionary art can emerge, because the prime quality of true art is the artist's sincerity. [21]

Many factors contributed to the ongoing repression of unofficial avant-garde art in the Soviet Union. As such, mainstream Soviet (revisionist) art historians are extremely reluctant to link the heroic Russian avant-garde of the revolutionary period with those self-described avant-gardists working within the current period of change and struggle. Working as outsiders, rather than as part of the revolutionary government, the contemporary avant-garde plays a distinctly different set of roles than those of their predecessors. Yet in conversation, they appear confident that their critical stance is in the interest of the health of their nation, that their own sense of patriotism is part of their artistic aspirations. The question implied is familiar in both the East and the West: can an artist function in opposition to the state yet in the interests of the nation?

When measured against the realities of Western contemporary art, the ironies and frustrations of these differing visions of avant-garde and underground have been the source of a constant challenge to my understanding of avant-garde practices and their ramifications. I can say this now, looking back on my first trip to the Soviet Union, looking back, that is, from an experience of a "new" Soviet culture. Perhaps I feel it as I do because, during the eighties we witnessed, in Western art, the transformation and deeply disturbing depreciation of our notion of an avant-garde. Could it be, as the German literary scholar Peter Burger describes, that there can be no avant-garde in a culture in which the work of art and the artist bear no social significance or in which it does not serve as a critique of art's function in bourgeois society? Burger, a critic interested in understanding the institution of art, describes the problem in relation to the withering autonomy of the individual work of art in relation to art considered as a distinct social phenomenon. [22] Or was it that the inherent conflicts between artists and a public which has grown increasingly intolerant of forces (including art) which were not clearly directed towards making their lives less alienated?

To the general public, the popular press and politicians feeding at the trough of media-induced skepticism, this crisis has been the fodder for a continuing and increasingly hostile attack on that art, those artists, and those institutions which persist in the attempt to resolve a social role for art. In this construct, such a role acknowledges the simple fact that art reflects contemporary values while functioning as an essentially independent agent of individual empowerment and creativity. "Pure" art's demise — as the story goes — is the result of this unpleasant struggle, and those deemed guilty are too often charged with the murder of that which should simply provide pleasure and inspiration. This critical lacunae seems to unite both the Soviet and Western conceptual avant-garde.

Compounding the difficulty of understanding the *role* of the Western avant-garde, at this point in the early nineties, is the clear realization that within commodity culture an all-encompassing emphasis on material value threatens to replace nearly all other uses for art. The intrinsic values of art have indeed been transformed (if not lost) within the headlong rush to generate and demonstrate wealth. The auction spectacle defines art's identity as a uniquely profitable trading commodity, and nothing more. It is not as if ideas don't matter, in fact they matter a great deal. But more often than not, the consequence of ideas is only measurable as an index of a work's ability to maintain its market identity, or as acts of cultural resistance. In considering this dis-spiriting polarity, the question arose as to whether or not the transformation of the Communist economy by the very forces which had created an analogous set of crises in the West would create a comparable force on advanced art practices within the Soviet Union. It was, in fact, just such a question which this exhibition has sought to circle, if not to answer.

IX

We left Leningrad on the 15th of July. On the way back to Boston, I stopped briefly in Paris to see the exhibition *Magicians of the Earth* at the Beaubourg. Kabakov's monumental installation *The Man Who Flew Into Space From His Apartment*, was on view. It was a poignant postscript to our trip, indeed, for the exhibition as well. Its accompanying text read:

> The lonely inhabitant of the room, as becomes clear from the story his neighbor tells, was obsessed by a dream of a lonely flight into space, and in all probability he realized this dream of his, his "grant project."
>
> The entire cosmos, according to the thoughts of the inhabitant of this room, was permeated by streams of energy leading upward somewhere. His project was conceived in an effort to hook up with these streams and fly away with them. A catapult, hung from the corners of the room, would give this new "astronaut" who was sealed in a plastic sack, his initial velocity and further up

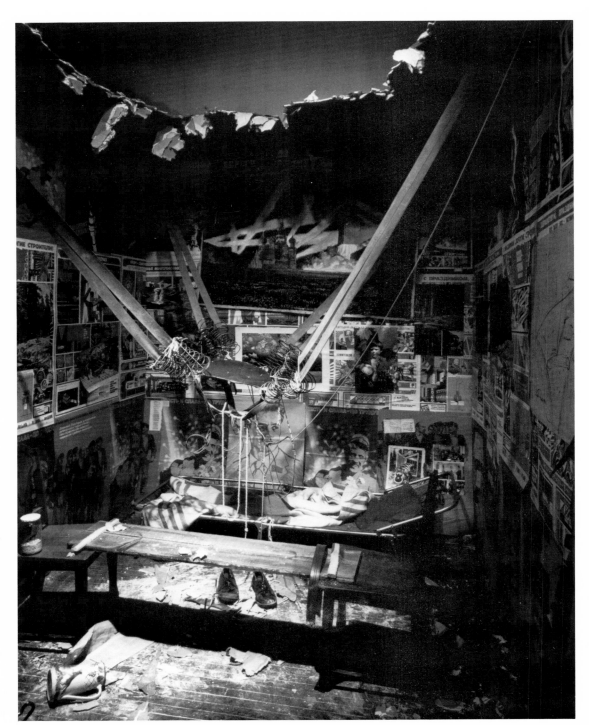

Ilya Kabakov,
*The Man Who
Flew Into Space
From His Apart-
ment*, 1981–88,
(From *Ten Char-
acters*), Mixed
media

at a height of 40 — 50 meters, he would land in a stream of energy through which the Earth was passing at that moment as it moved along its orbit. The astronaut had to pass through the ceiling and attic of the house with his vault. With this in mind, he installed powder charges and at the moment of his take-off from the catapult, the ceiling and roof would be wiped out by an explosion, and he would be carried away into the wide-open space. Everything was in place late at night, when all the other inhabitants of the communal apartment are sound asleep. One can imagine their horror, fright, and bewilderment. The local police are summoned, an investigation begins, and the tenants search everywhere — in the yard, on the street — but he is nowhere to be found. In all probability, the project, the general nature of which was known by the neighbor who told the investigator about it, was successfully realized."[23]

Notes

1. see Ernest Mandel, *Beyond Peristroika: The Future of Gorbachev's USSR,* translated by Gus Fagen, Verso, London and New York, 1989.

2. A pilot for a TV arts magazine was being produced in NY. Since I had done one-person video pieces before, I was asked to participate and suggested following Coppola and the controversial new film to Moscow in order to see if the Communist-bloc film community would receive this poetic treatment of the Viet Nam war substantially differently than American critics had. The film was warmly received by festival attending critics and filmmakers alike.

Unlike the film's stormy American reception, there was virtually no criticism of the film for its use of a white hero and white god/villain, its victimization of the black GIs. There was essentially no critique of the film's use of surrealist style to deal with the still quite palpable consequences of the American engagement, and only one instance of a Communist party-line critique of the film's message (a reporter from *Soviet Life* who challenged what she saw as the film's racism and revisionist portrayal of American involvement as a function of madness rather than criminality).

The truth of the matter is that Coppola remained a major star in the Soviet film world, and his reception was not unlike what he would have received anywhere within the industry at that time. People simply wanted to meet the legendary director of *The Godfather,* and were not up for either a theoretical debate or a critical cat fight. The message: Hollywood *uber alles.*

3. Defined as code for a deconstructive approach to Socialist Realist art, the term Sots art was coined by Komar and Melamid in 1972, and employed the cynicism of Pop art to the realities of Socialist Realism and the representation of Soviet life. For more on this subject and a thoughtful review of this period in Soviet art, the general reader may wish to see Margarita Tupitsyn's description and analysis of this history in her *Margins of Soviet Art,* Giancarlo Politi Editore, 1989. For further reading please consult the bibliography in the appendix to this catalogue.

4. Free speech advocates and those civil rights activists responding to the implied homophobia in the attack on Mapplethorpe's work demanded that the US government both stay out of the direct application of aesthetic and moral value judgments, and be willing to allow the First Amendment's guarantees of free speech and freedom from religious coercion to protect art deemed vile and morally offensive by spokesmen claiming to represent the majority taste. Many of the same defenders of Mapplethorpe's work were quick to join the derisive attacks on Serra's work claiming that the implied relationships governed by the rules of "public art" and the more abstract language of large-scale minimal sculpture mitigated the right of a "public" to effectively destroy a work with no serious moral or ethical problem.

5. Huyssen, Andreas, *After The Great Divide,* Indiana University Press, Bloomington, 1986, p. 170.

6. After several initial studio visits, on my 1979 trip I began to feel that I would never find my way into the underground scene I sought out. Unable to reach artists by phone, unwilling to trust my official translator, and still somewhat distracted by the film festival social agenda, I imagined myself facing an impossible task, and nearly gave up. There are no telephone directories in Moscow, nor are there any street maps. In Moscow information is the real currency of power. Even today, the lists you carry with you are the only information you are likely to get, until you manage to plug into a particular circle of friends.

One of the painters I visited was turning thirty that day, and invited me back to his apartment that evening to share in his birthday celebration. At the party, about thirty people were jammed into a small apartment literally filled by a make-shift dining table. In a turn of events that still seems unbelievable to me, I was seated next to a young English-speaking artist named Mikhail Roshal. We spoke of film and the festival (his grandfather had been a well-known film director), we talked a bit of video and performance art, and he told me that he was a conceptual artist. He told me that he worked with two other artists in a collaborative group called *Nest.* I was stunned, as I recalled that this was one of the artists whose name I had been given with what turned out to be an incorrect phone number.

An American art world visitor, though no longer unheard of, was still something of an event at that time, as it was the only way for most Russian artists to get any reasonably credible information about the progress of things in the West. For my part, I realized that I had finally stumbled into the community that I had been seeking.

During the course of our conversations, I mentioned that I had brought a video camera and recorder with me to produce my Coppola piece. Roshal's eyes lit up and he asked me if I would like to meet with him and his two co-workers at their studio the next day. At that meeting the three of them first showed me an original signed document which showed them to have purchased, for 100 rubles, the soul of Andy Warhol. I was impressed. Then the trio, which included Victor Skersis and

Gennadii Donskoy asked if I would help them produce a video performance work, purportedly the first to be made in the USSR since no artist at that time had access to video equipment. I agreed, and the next day showed up at the pre-arranged place which turned out to be Beljaevo Park on the outskirts of Moscow where an infamous exhibition of unofficial art had been closed and bull-dozed by the KGB exactly five years before in the fall of 1974. Joining the three of us there was Roshal's wife the painter Alyona Kirtsova.

The video/performance work, titled "Underground Art" involved the three of them buried in a mass grave, while covered with soil and sod, and speaking into a remote microphone about their lives as artists in Moscow and drawing with dirt and coal on a small stretched canvas covering their faces. Visually the 15-minute video is a slow pan of the bleak park-scape punctuated by the emergence of the three artists after what seems like an hour of choking and coughing, holding aloft the finished "underground" painting. The only line delivered in English was, "where is Chris Burden when we need him?" Since I only had but four days left before returning to Berkeley, Roshal and I talked late into the evening to meet again at his studio the next day.

This work, and our resulting friendship, opened the window for me into an avant-garde culture with an acutely different rationale and history. The next days passed quickly. I had barely enough time to explore the surface of that community before returning to encounter an increasingly hostile period in US-Soviet relations, indeed in my own relations with the Soviet government as well.

While in Moscow, I received a call from the director of the Coppola pilot informing me that the dancer Alexander Gudunov was attempting to defect and was negotiating for asylum in a jet being held on the tarmac of JFK in New York. Phoning direct to my room from his NY office, he asked me to go directly to the Bolshoi and interview dancers and Bolshoi officials to see how they reacted. I told him he was crazy to call me (my sense was that all hotel room phones were tapped), and hung up feeling my video adventures had probably been compromised.

When I returned to Berkeley with the tapes of the performance, and the painting produced during the piece, I also carried with

me tapes of the Coppola interviews, interviews with several other artists, and a video interview with Alexander Lerner, a well-known Jewish refusnik neighbor of Roshal's. I was notified rather directly that the Soviet authorities knew all about my video activities, and that if any of them saw the light of day, those involved in the USSR would pay the price. After a series of complex negotiations with the producers of the pilot (some of whom turned out be violently anti-Soviet and unconcerned with what they saw as a bluff to suppress this material they felt would be at least mildly embarrassing to Soviet authorities) and several other parties who found the release of the video material problematic, it was agreed that the tapes would be kept out of circulation for five years.

During that time, I was unable to show even "Underground Painting" as I had hoped to, and worse, I was led to believe it dangerous to the artists if I tried to contact them in any way, even to tell them of the disposition of their work. In 1989 we re-connected, and began to plan completion of the piece.

7. The exhibition was nearly closed by the Union, and after some hesitation, it was opened. It contained several controversial works, including the work by Sergei Mironenko in which he announced his candidacy as "The first free candidate for President of the USSR" in a large panel composed of mock-heroic photos of the artist and a text exclaiming "Swine, Look what they've turned the country into!" Also in the exhibition was an installation work by Dmitri Prigov, which consisted of text and fantastic images dealing with the idea of glasnost, and appeared to have been partially censored by authorities. Perhaps the most controversial work was a painted chair with an allusion to sexual activity. Issues of sex and sexuality are rarely raised in even the most radical Soviet avant-garde art.

8. For a good review of this event, see the reporting of Jamey Gambrell in *Art in America,* October 1989, vol. 77 no. 10, Gambrell teamed up with the documentary filmmaker Barbara Herbick to produce a feature-length documentary study of the auction and the weeks surrounding it.

9. For a discussion of this, see Jamey Gambrell, op cit.

10. Mandel, op cit p. 163.

11. Khamdamov was the author and original director of the film *Slave of Love,* the work that brought Konchalovsky to the attention of many American and European audiences. According to Khamdamov, the film was taken away from him during production because of assertions that he had allowed the work to become too sensual and erotic. In mid-production, the film was turned over to the well-connected and well-respected brothers Konchalovsky and Mikhalkov.

12. That evening, while my colleagues visited several other young artists, I dined at the home of an admirable progressive woman named Elena Alekheiko who worked with Khoroshilov at the Ministry. Her husband, the playwright and film director Pavel Lungin had invited me to join them with Khoroshilov and a visiting mutual friend, the Director of the Düsseldorf Kunsthalle, Jurgen Harten. I recount the event for several reasons. First, Lungin's amazing story of what it took to obtain a pork loin to roast (his "Hunt for Red Meat in October," featured a clandestine meeting in a secret passageway located in the rear of an otherwise standard — that is essentially empty — food market. Bribes, promises, intrigues and of course over four hours of waiting led to a trip to an underground private meat locker); second, the vision of the Lungin's ten-year old child glued to the VCR, watching a bootleg video copy of *Star Wars,* with a single voice-over dubbing the entire dialogue into Russian; and third, the hours of continuous low rumble that turned out to be division after division of very large tanks, missile launchers and other mobile weapon systems rolling by the apartment at full clip in rehearsal for the next day's parade to commemorate the October Revolution.

For some reason, hypnotized by the parade, I recalled an incident during my 1979 visit. To my delight, I was invited to the re-creation of Sergei Eisenstein's study by the Eisenstein Curator, Naum Kleman. Hanging on his wall amongst the clutter of shelves reflecting the filmmaker's catholic interests was a birthday greeting to the great Russian artist from Walt Disney, who was both a fan and friend from Eisenstein's ill-fated Zapata film. Disney's cartoon: a jubilant Mickey Mouse hailing HAPPY BIRTHDAY SERGEI! in large Mickeyscript. Snapped out of my reverie by my dinner companions, and

spurred on by the vodka, I shared a not-so-bold prediction that the next logical step in the *novostroika* would be the establishment of a Sovo-Disneyland incorporating Lenin's tomb, thrill rides, massive parades of military hardware and fast-food outlets into a Red Square theme park. My hosts agreed wholeheartedly, insisting that they were already used to waiting in long lines, and that all they lacked was some reasonable payoff.

13. Smithson, Robert, "Art and Dialectics," *The Writings of Robert Smithson,* edited by Nancy Holt, New York University Press, New York, 1979, p. 219.

14. We were later to learn from Margarita Tupitsyn of a famous Collective Actions performance that took place in the park in 1975. Tupitsyn refers to this in *Margins of Soviet Art,* P. 117)

15. As this trip continued, we became increasingly anxious to find evidence of any kind of feminist discourse at work, or any women's work that seemed similarly directed. Ironically, we had to wait until our next visit to discover that the woman who was helping Zvezdochetov move work in and out of the tiny room [later introduced to us as his wife Larisa Rezun Zvezdochetova] was herself an artist and the maker of extremely powerful, strangely beautiful and ingenious kitsch-based constructions.

16. From an interview with Victor Tupitsyn in Margarita Tupitsyn's *Margins of Soviet Art,* op cit, p. 166.

17. For a description of the concept of "green" in Soviet conceptualism, see Tupitsyn's catalog to her *Green Show,* Exit Art, New York, 1989–90.

18. On our last night in Moscow we were invited to dinner with the art historian Svetlana Dzhafarova, and her husband the widely exhibited Socialist Realist sculptor Leonid Baranov. Changes in the Ministry of Culture had moved Khoroshilov and his associates out of power, while elevating Svetlana to power. To my distress, she was highly critical of the exhibition we had organized, calling it a misrepresentation of Soviet art, and claiming that contemporary manifestations of avant-gardism lacked the connection to the *realpolitik,* and denied the essence of the historic revolutionary avant-garde. In the presence of her husband's

private, highly sexual sculpture — working models of his public works celebrating the great nineteenth–century Russian literary giants—and his bread and butter work — classic Soviet sculptural renditions of Lenin — we continued our pleasantly heated discussion. Hearing that he had been invited to join the exhibition of "Treasures from the Kremlin," (a parallel exhibition at the Goodwill Games) we invited her to come and speak out critically against this show in Boston, assuring her that she would feel perfectly at home in the increasingly neo-conservative American critical community.

19. During this first visit, I learned of a well-known Leningrad dealer of unofficial art who was arrested and later tried and convicted to a lengthy jail term for the crime of "black marketeering." The "black" market he had been engaged in was the sale of the work of artists who were not part of the Artists Union, and which was not sanctioned for sale to Westerners. Added to this form of economic criminality, was the assumption that avant-garde artists working in an anti-Soviet manner were often punished or treated as psychopaths, and confined with the mentally ill.

20. An exhibition held at the ICA London in 1977 included work by many of these artists as well as by two of the then still obscure conceptualists. Organized from the collection of Alexander Glezer by the collector himself, it was a decidedly mixed bag, reflecting, in the words of a review by Michael Shepard in the February 1977 issue of the British magazine *Arts Review* the "courage of those artists who risk their life to be true to themselves . . . as well as . . . the mediocrity which may be then the triumphant result of ignorant repression in any country or society."

21. Lunacharsky, Anatoli, "Revolution and Art," *Russian Art of the Avant Garde,* John Bowlt, ed., Thames and Hudson, NY, 1957, p. 190.

22. Berger, Peter, *Theory of the Avant-Garde,* translated by Michael Shaw, University of Minnesota Press, Minneapolis, 1984, p 61.

23. from *Ten Characters,* Ronald Feldman Fine Arts, New York, 1988.

No. 6/1 Sretensky Boulevard

Richard Lourie

6/1 Sretensky
Boulevard,
Moscow

From the outside you can see why Le Corbusier called this the "most beautiful build-
ing in Moscow." It still soars, a castle transported, stone by stone, from a country
that never existed. Fanciful in conception, neo-classical in decoration, the building is
Russian in its heroic stoutness which stretches arches into cupolas. The facade's light
brown bricks iced with white columns give it a gingerbread look.

The structure was built as an apartment complex for the exceedingly well-to-do at the turn of the century by the "Russia" insurance company, a misnomer if there ever was one. For, though the building's solid flamboyance bespoke confidence in the future, that future was going to last less than twenty years. The tenants would have been well advised not to take long leases.

After the Revolution of 1917, people who had been able to afford grand apartments were either dead or abroad, in jail or desperately trying to adapt. The building at 6/1 Sretensky Boulevard underwent transformation and was itself a source of change. During those heady, violent years it housed both Red Army Artillery Headquarters and the first Ministry of Education, a very Soviet combination. Lenin's wife, Nadezhda Krupskaya, worked in education and so Lenin had any number of good reasons for visiting 6/1 Sretensky, often in the company of Maxim Gorky, one of Russia's foremost writers at the time. (In Russia writers are not only killed by the leaders but take walks with them.)

Lenin's is the only image that has lasted. Politically, and visually. His face is everywhere, peering through tree branches and grids of I beams. Lenin visited 6/1 Srentensky often enough to merit a plaque — an old-fashioned futuristic rhomboid, Lenin in profile, goateed, alert as a hawk. But this building has been touched by history, not because renowned leaders worked or visited here, but because Russian people lived here. People were arrested here, this was home for men who went off to war and never came home, though some people did return after years in the camps, like ghosts who still remember their address.

The building is as empty of the life it was designed for as the Duomo of Milan. As soon as you're in the door, you have entered what the Russians call "Soviet reality." The hall is dim and vast. The walls, yellow in the final stage before grey, are tattooed with rock–and–roll graffiti in misspelled English. But the writing over the buttons in the elevator is in grammatically correct Russian: "Death to Kikes and Tartars."

The left rear corner of the elevator floor is dependably damp with urine and always begins its risky ascent with a reluctant thud. The elevator only goes to five. Ilya Kabakov's studio is on the sixth floor, reached by a flight of wide, dish-water gray stairs. But Kabakov is away, in Vienna, in demand. The gardener has taken his flowers to market but the humus of his art is still there, a collective apartment on the fifth floor where thirteen people live in five rooms, sharing one kitchen, one bathroom.

In one room an old peasant woman is waiting to die. Almost blind, she is impatient for death, even irritated at this final delay, queuing even for oblivion. Other than that, she's usually full of good country cheer and barnyard humor. Just as she was when she came from the starving countryside fifty years ago, she is still a virgin and illiterate. Another room is occupied by a man thought to work for the KGB, his wife, and his son. Aside from his attitude — a mixture of arrogance, aloofness, and anxiety

6/1 Sretensky
Boulevard,
Moscow

Plaque of Lenin
and grocery side
in 6/1 Sreten-
sky Boulevard,
Moscow,
photographs by
Richard Lourie

— there is also the circumstantial evidence that the KGB's headquarters, covering a huge area in downtown Moscow, is just a short and pleasant walk away. Unlike him, his wife and his son have the endearing innocence of the very simple. In another room there is a young scientist with talent and ambition, his red-headed hot-tempered Siberian wife, and their two children.

A family of five has the other two rooms but, as bad luck would have it, those two rooms aren't even adjacent. The mother and father want nothing more than an apartment of their own so they can at last be home alone together. Both literary people in their mid thirties, they have chosen value over ambition, the perfection of the life, not the art. She has devoted herself to the three children, to give them the strength to withstand "Soviet reality." Both parents have converted to Russian Orthodoxy. They rarely speak of it and the icons they keep are inconspicuous.

All the rooms in this communal apartment are very large and, except the kitchen, are all engulfed in a Rembrandtian brown-gold gloaming that is everywhere in Russia. Laundry is always strung dripping from the high-ceiled kitchen which contains four refrigerators, three tables, and two stoves.

Pots are bubbling, children are crying, two wives are exchanging insults that may lead to blows, the KGB man replaces his yogurt in the fridge and is gone in a wink.

Psychic space is sculpted differently when your bedroom door opens onto a sidewalk. The only unbounded space is within. Inwardness is mandatory for survival. It must be continually enlarged and reinforced so that it can bear the pressures of a public space that intrudes into kitchens and minds. Prayers, science, poetry, even the quiet madness of eccentricity, the manner doesn't matter in the least.

Moscow is massively still in the late hours. But these are the hours in which it truly lives, freed from the weight of the day. The grime of detail is washed away in tea and stories, faces radiant with fatigue and elation. The woman who converted to Orthodoxy gets out a little work that Kabakov had made for her, the best art — from the artist, given in love. For an artist whose specialty is the communal apartment turned soul-side out, his work could not have found a better museum than that room where a bookcase separates a bare table from a small bed.

Photograph of Lenin on side of Kiosk in front of 6/1 Sretensky Boulevard, Moscow

U-turn of the U-topian

Margarita Tupitsyn

> There is an inner horizon, which stretches vertically so to speak in self-darkness, and an outer horizon of large breadth in the light of the world. Both horizons, in their background, are filled with the same utopia.
>
> Ernst Bloch

At a time when Soviet alternative art is at the height of exhibition opportunities both at home (an inner horizon) and abroad (an outer horizon), it is important to remember that until recently its social history revolved around the struggle for public exposure and that its formal qualities and physical appearance were contingent upon the assumption that it would most likely never be shown publicly. Moreover, the whole issue of a separation between official and unofficial art was in many cases not based on stylistic/iconographic parameters (which are not always presented clearly) but on a distinction between those who showed their art publicly (official) and those who did not (unofficial).[1] The Aptart generation of the early 1980s, to which many of the artists included in this exhibition belong, effectively redefined the idea of the public exhibition in 1982 when they established an informal gallery in the apartment of the conceptual artist Nikita Alekseev. By organizing shows and performances there, they turned the twenty-year-old tradition of showing art in apartments and/or artists' studios as an alternative to public exhibition into a conceptual spectacle. They also gave a new edge to the chronic deficiencies of alternative art, such as small canvases and poor materials, when they stopped trying to solve the technical problems of painting (previously the main concern of Soviet modernists) and began to assimilate those deficiencies within media in which they chose to present their ideas, including shabby

installations and objects found in Moscow rubbish. In general, all Aptartists shared a casual approach toward artistic materials, widely incorporated mass imagery in their work, saturated visual elements with verbal ones, and subjected many issues to parodic treatment.

Ilya Kabakov, Collective Actions and Sots artists are three forces in domestic conceptual art of the 1970s which account for the new conceptual qualities which one witnesses in Aptart activities. Kabakov challenged the status of painting as "an exceptional realm of manual mastery" when he pierced a big nail through the surface of a painting called *Who Hammered This Nail?* (1970). Furthermore, he began to feed conceptual content into his works by appropriating the "speech" of communal kitchens and shabby textures of communal interiors. For the first time in alternative Soviet art these anti-aesthetical works by Kabakov challenged the notion that art has to reflect the sublime and that there is no place in it for the profane. Monastyrsky, a close colleague of Kabakov and a theoretician of the Collective Actions group, further questioned the act of making commodifiable (aesthetic) objects in a country where the market for their consumption did not exist. Instead of promoting the idea of action as a sufficient creative gesture, he would ask Moscow artists, poets, and friends to come to a vast, empty country field to blow up balloons, appear and disappear in a forest, or lie down in a ditch. These "voyages into nothingness" or "empty actions" served as remedies from urban pressures and identified emptiness as the main characteristic of Soviet existence.[2]

Although Kabakov on his own, and Monastyrsky with Collective Actions, substantially expanded the contextual horizons of domestic alternative art, they, like Soviet modernists of the 1960s, avoided an encounter with explicitly ideological material. This was broached in the early 1970s by Sots artists Vitaly Komar, Alexander Melamid, Eric Bulatov, Alexander Kosolapov, Boris Orlov, and Leonid Sokov who proposed to view Socialist realism and propaganda imagery not as mere kitsch or simply a vehicle for bureaucratic manipulation, but as a rich field of stereotypes and myths which they could transform into a new language, one able to deconstruct official myths on their own terms. Sots artists also applied parody as a primary tool in their deconstructive campaign which deposed a view of art as a substitute for religion.[3] Thus, to different degrees, Kabakov, Monastyrsky and the Sots artists provided a theoretical source for young artists which was powerful enough to begin to reduce their dependence on Western artistic discourse. These new conditions signified that at the time of the Aptartists' appearance, the Moscow vanguard had accumulated enough layers of local issues to sustain a multiplication of meaning and to begin to operate widely on the level of what Julia Kristeva calls "intertextuality."

With a leadership backing Mikhail Gorbachev in 1985, the rigidity of exhibition policies finally began to crumble, and by late 1986 former Aptartists were faced not

Mukhomory
installation in
first Aptart
Exhibition in
Moscow, 1982

with the question of where to exhibit, but rather with the dilemma of where to produce their large-scale works. Most ex-members of the Aptart community found working spaces in abandoned art nouveau apartment buildings located on *Furmanny pereulok* (lane). These studios which closed down in late 1989, due to the buildings' reconstruction, functioned from early 1986 on, as the key places for foreign dealers who saw Soviet art as a profitable product for the Western art market, for collectors bewildered by Sotheby's triumphant auction, and for curators asked to put together hasty exhibitions.[4] In the words of the artist Konstantin Zvezdochetov, if . . . "Aptart was one type of socio-cultural psychopathology," the *glasnost* period created "a different type."[5] Zvezdochetov's close friend and colleague Vadim Zakharov stresses the difference between the two epochs of Soviet alternative art:

The fact is that three years ago there were only thirty of us in the whole Soviet Union. Now the situation has radically changed. A period of seduction has set in. A mass of new names has appeared, people of a completely different formation. [Sergei] Volkov, for example, and before him, the Kindergarten Group and so on. That is, a normal artistic situation has arisen, which for us is not easy to adjust to. In other words, we've entered an age of competition.[6] As Zakharov suggested at the time the *Furmanny pereulok* studios were closing down, the "new names" were in excess, including artists from the provinces who wanted to be closer to various exhibiting and sales opportunities. Curiously, when *Furmanny* artists found another abandoned building to move into, only *svoi* (their own) were invited to join.

A large part of the work produced in the late 1980s at *Furmanny pereulok* or in other Moscow studios responded, either directly or indirectly, to a new socio-cultural context brought about by Gorbachev's policy of liberalization. Significantly these responses varied substantially; an in-depth analysis of them could provide a rich area for socio-cultural study. In the closed atmosphere of the Aptart era, for example, Zakharov occupied himself with extroverted activities including public performances and bold deconstructive campaigns targeted at the masters of the Moscow art community. But in the period of openness, he produces hermetic painting and conceptual objects based on fragmentation, mostly excerpting from the iconographic arsenal of his earlier multi-media production. The concrete images such as Zakharov's trademark self-portrait with an eye-patch or the small porcelain elephants used in the 1982 performance *I Know That Any Resistance to Elephants is Useless; Elephants Hinder Our Life* are now transformed into the imaginary characters of an elephant-man and a patch-man as in *Baroque* (1986) or are reduced to abstract forms reminiscent of human and animal limbs as in *Illustration* (1987). The iconographic precision of his earlier work was in compliance with the clear social function which it performed: the artist was working out a paradigm of a generational conflict addressed to a very closed community of intellectuals. That is why he felt it essential to include his image

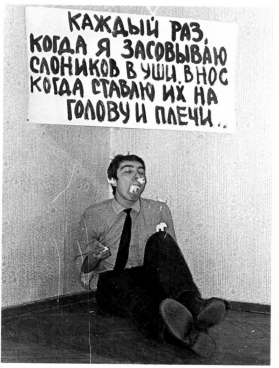

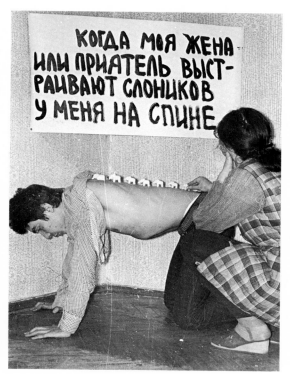

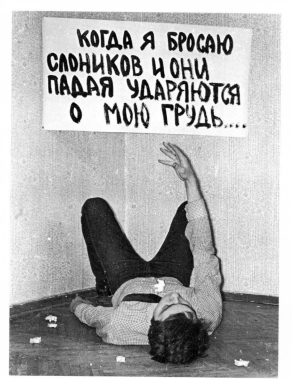

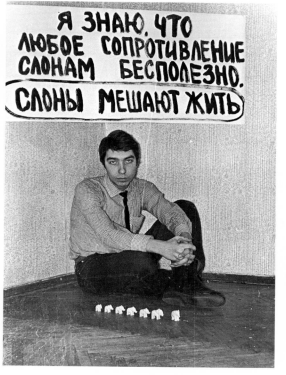

Vadim Zak-
harov, *I Know
that Any Re-
sistance to
Elephants Is Use-
less. Elephants
Hinder Our Life.*
Performance,
1982

in most of his Aptart projects. The portrait itself carried a provocative meaning. Similarly, the fragmented nature of his present work allegorizes the loss of that community which automatically shifts his work from being the cultural text, as it was in the Aptart era, to an auto-referential discourse. Zakharov betrays his awareness of this change when he says: "Don't talk to me about communality. I've already been burned by that."[7]

Unlike Zakharov, Sergei Mironenko, a former member of the *Mukhomory* group, takes advantage of the new freedoms for alternative artists and feels comfortable confronting large audiences. In 1988 he staged a campaign offering himself as the first free candidate for President of the USSR with photographs accompanied by slogans like "Bastards! What Have They Turned This Country Into," and other campaign paraphernalia. In this work Mironenko makes a strong political statement which suggests that Soviet bureaucracy has brought the country to total disintegration. Conceived in the early period of *perestroika,* this work reflects the optimistic mood of many members of the intelligentsia and a belief that political and social conditions can be changed if effective government is at hand. In this way it presents a rare example in Soviet alternative art of a "positive" utopia and as such fits the position of a postmodern successor to numerous utopian models expressed in posters, photographs and photomontages by the avant-garde artists of the 1920s and early 1930s. Mironenko's more recent installation *Room for a Hero* (1989) is an austere space with a metal bed, night table and a worn-out slogan which declares, "Imperialism is the Source of Military Danger." Executed only one year after Mironenko's presidential campaign, this work already shows signs of cynicism and a switch to non-utopian being, a farewell to both the "positive" utopia associated with the heroic avant-garde and the "negative" one offered by the Sots artists.

Although Sots artists deconstructed Soviet myths, they continued to operate with utopian spaces, turning what Fredric Jameson calls the "non-conflictual utopia" of Soviet ideologies into a fabricated utopian text. The artists participating in *Between Spring and Summer* are already working in the space of "crushed myths" which include ideological as well as private ones such as, for example, the myth of the West. This does not mean that these artists are disappointed in the West but rather that they now see it much more realistically. At home where propaganda material disappears from the streets, taking with it the aura of a "non-conflictual" atmosphere, the images of squalor and decay come to the forefront and catch the attention of artists' subversive gazes.

Both Andrei Roiter and Sergei Volkov are fueled by the desire to reveal the disintegrating fabric of the Soviet version of *Civitas Solis* (City of the Sun). They show it on their canvases through imitation of the crumbling textures and dull colors of storefront signs, warehouses, industrial machinery, architectural monuments and

decaying building[5] and by combining these textures with common advertisements and "pictures" taken from Soviet textbooks and postcards. This work avoids the auto-referentiality referred to in an earlier discussion of Zakharov's artifacts, and instead draws on an archive of common experiences, such as language, or rather, the "corpo-reality of communal speech," which Volkov and Roiter incorporate in their works via the use of Soviet verbal cliches. To emphasize the repressive role of the speech-oriented practices in Soviet society, Roiter goes beyond a direct appropriation of words and phrases to a more implicit signifying of repression. A number of his canvases have cuts in the shape of old-fashioned radio speakers, which for most Soviet citizens are the mouthpiece of a boundless stream of ideological "enunciation." Similarly, in *Punctuation Marks* (1989), a green, textured canvas with punctured holes, the artist implies the significance of the omission dots in ideological double-talk.

The paintings by Volkov included in this exhibition demonstrate yet another transition made in his work since the *glasnost* era began. During his first trip to West Berlin in the fall of 1988 he executed a series of paintings in which he preserved his thickly painted surfaces but replaced collective signs with highly individual ones. In *Hand, Brain, and Thumb,* Volkov attempts to cross two tropes: the anonymous textures, colors and language of the commonplace as a metaphor for post-industrial non–originality, and human organs and blood (*Blood Analysis,* 1988) as a metaphor for an ultimate authenticity.

A collaborative team of the Peppers (the artists Mila Skripkina and Oleg Petrenko) became known in Moscow through their participation in the Aptart exhibition of Odessa art organized in 1984 in Alekseev's apartment. Now they work in a variety of media and their recent production includes the series entitled *N. P.* (1988–89), a Russian abbreviation for scientific-popular art. It includes objects ranging from plywood panels painted in green and white with drawings or plaster reliefs of a breast and a crescent to ready-mades such as a fan, jars with pickled fruits and vegetables, boot trees, a sink, a basket, a bread loaf. What unites them are pseudo-scientific formulas written over all these objects. The artists have said: "In scientific-popular art what is initially important is the use of dense scientific data which is systematized in tables . . . from which everything extraneous is eliminated. After that, there is only a bare background which opens up the way for an impossibility to escape the author's interpretation . . ."[8] The artist Yurii Leiderman compares this series with Kabakov's appropriation of bureaucratic tables in many of his works including "Time-Table for the Disposal of a Garbage Can" or "Plan of My Life." Leiderman writes that "In general, in tables the plastic de-ideologization reaches its limit because any idea — scientific, housing or any other — turns them into a homogeneous surface of purely graphic marking."[9] I would disagree with the above statement because it seems that the "scientific" functions precisely as an ideological disguise wearing the mask of positivism.

The Peppers, *Types of Discharge According to Mandelshtam/ Chromodiagnosis According to Schiller*, 1989, Diptych, enamel on plywood, found objects

In other words, the Peppers use scientific formulas in order to divert our attention from the "bad taste" objects which they produce or select as ready-mades, assuming that their entering into the field of aesthetics can be justified by the presence of enigmatic (for most people) scientific "texts." As a result the viewer concentrates on the process of decoding those formulas while the artists perform the act of pushing through the boundaries of artistic practice the bizarre objecthood of the Communal. Thus just as Volkov and Roiter bring the mundane into aesthetics by re-representing the shabby textures of Soviet reality in painting, the Peppers achieve the same goal by "decorating" mass-produced articles with "prodigal" signs of what Lacan called "discourse of the university."

Several artists included in this exhibition touch upon issues hitherto never raised in Soviet alternative art. A number of these issues relate to the problems which women experience in Soviet society and which for the first time now have their reflection in aesthetics. It is especially significant that these new themes are shared by male artists when they collaborate with their female partners. Recently the Peppers produced a series of plywood panels addressing the issue of abortion and its devastating impact on Soviet women who are not only deprived of contraceptives and constantly face the fear of getting pregnant, but then subjected to inhuman medical treatment [without sanitation] or the privilege of anesthesia. In these panels the Peppers coolly approach the dangerous and current indigence of Soviet medicine. They use charts and instructions from outdated medical books (which are powerful simply

due to their inveteracy often mistaken for authenticity), and attach basins similar to those used during abortion procedures to the plywood surfaces.

Elena Elagina and Igor Makarevich's concern with the same subject is demonstrated in their collaborative installation *Pure* (1989) and in Elagina's own piece entitled *Children's* (1989). Both works were included in the Avantgardists' Club exhibition *Perspectives of Conceptualism* organized by Joseph Bakshtein in the summer of 1989.[10] This was the Club's third exhibition and as such, according to Monastyrsky (who refused to participate in it because he saw "no perspective" in local conceptualism), was a demonstration of "pure psychopathology," especially evident in the room where *Pure* and *Children's* were installed, creating a sort of "clinical" aura.[11] *Children's* is a horizontal plywood panel with an outlined portrait of a baby with a loosely painted green and white background. The word "children's" is written across the panel, and next to it is a stool with bandaged legs and a bandaged hot-water bottle lying on it. *Pure,* an object which conveys a grotesque impurity and decay, is a white box into which five urns from a crematorium are placed, with plastic worms either nearby or crawling out of them. A big glass vessel full of a disgusting yellow fluid with the same worms on the bottom is set on a nearby standing stool. Both installations subject the Soviet medical establishment to aggressive critique, specifically its treatment of women in abortion cases and/or labor and childbirth. Both the Peppers and the Elagina/Makarevich team have been influenced by Kabakov's radical introduction of Soviet "rubbish" into art as a "schizo–aesthetic" aesthetic category. And also like Kabakov, whose last installation in New York at Ronald Feldman Fine Arts, entitled "He Lost His Mind, Undressed, Ran Away Naked," effectively shifted myth from the collective to the personal, these two teams (especially the females) make powerful statements about the vulnerability of their bodies in Soviet society.

As I have already mentioned, Elagina, Skripkina and the two other female artists included in this exhibition — Maria Serebriakova and Larisa Zvezdochetova — open up an important chapter of women's art in Soviet alternative culture and provide significant material for a thorough exploration of feminist issues in that society. Although equality of the sexes was among the chief promises of the Revolution, its realization failed like so many other utopian projects, bringing to light the realities of women's physical exploitation and intellectual suppression. Unlike Western women, Soviet women as a rule make no attempt to openly pronounce their revolt against male domination in society and home. The most independent female personalities still aim at the erasure of any ideologemes polarizing the two sexes. This position brings us to what Julia Kristeva distinguishes as two generations of feminists, that is: "the first wave of egalitarian feminists demanding equal rights with men . . . and the second generation, emerging after 1968, which emphasized women's radical difference from men and demanded women's rights to remain outside the linear time of history and politics."[12] Works like the Peppers' gynecological series or Makarevich/Elagina's *Pure*

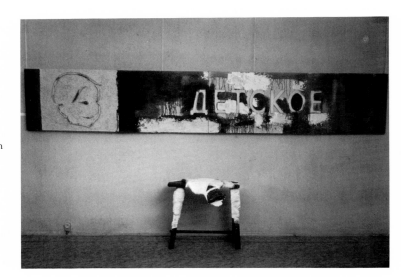

Igor Makarevich
& Elena Ela-
gina, *Children's,*
1989, Mixed
media

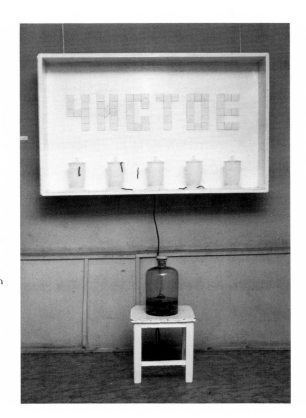

Igor Makarevich
& Elena Ela-
gina, *Pure,*
1989, Mixed
media

and her *Children's* expose the specificity of female experiences in the Soviet Union and show signs of women's involvement in what is noted by Craig Owens as "the discourse of the other."[13]

Zvezdochetova is an important contributor to this change in intellectual thinking. Born in Odessa, she had her debut in Moscow in 1983 at the open-air show "Aptart Beyond the Fence" where she installed cut-outs of white angels on tree branches and entitled it *The End of Avant-Garde* (1983). In the same year she produced her first commentary on the phallocentric nature of Soviet society in a work entitled *Committee of Worried Citizens* (1983) — a square with four rows of identically black-clothed men with blank faces painted yellow. Zvezdochetova's distancing from what Sherrie Levine calls the "representation of male desire" is visible in her choice of ready-mades which include decorative objects (embroideries and cheap carpets) specifically associated with women's craftsmanship. In the 1920s the decorative arts acquired a radical status because male and female artists invested in them their most advanced ideas about social reconstruction. When Rosemarie Trockel appropriates some of the Russian avant-garde textiles, she evokes in our memory a specific moment in history and associates herself with those utopian aspirations. Although Zvezdochetova is preoccupied with a different set of objects and themes, they are just as pregnant with historical significance. She relies on popular culture born in the Stalin era including cheap carpets and corny embroideries, which in the past served as the main decor for dismal communal apartments, as well as tedious Soviet television whose programming until recently primarily involved sport games and popular ethnic films. The latter particularly inspired the iconography of *Egyptian Cake* (1988) and of *Chukot Legend* (1988). In general the above–mentioned apartments and especially their kitchens, often accommodating as many as ten cooks, have led to the creation of "The New Woman" victimized by the pressures of communal living. Kabakov attempted to re-create such a character in his album *Olga Georgievna, Something is Boiling!.*

Serebriakova's series of collages and drawings selected for this exhibition also depend on found materials, such as photographs discovered by the artist when she moved to her new studio or various cut-outs from popular magazines. This work comes close to Sherrie Levine's experiments with media-derived material which Douglas Crimp called "pictures" when he wrote:

> These pictures have no autonomous power of signification (pictures do not signify what they picture); they are provided with signification by the manner in which they are presented (on the faces of coins, in the pages of fashion magazines). Levine steals them away from their usual place in the culture and subverts their mythologies.[14]

Larisa Zvez-
dochetova, *The
End of the
Avant-garde*,
1983, Instal-
lation

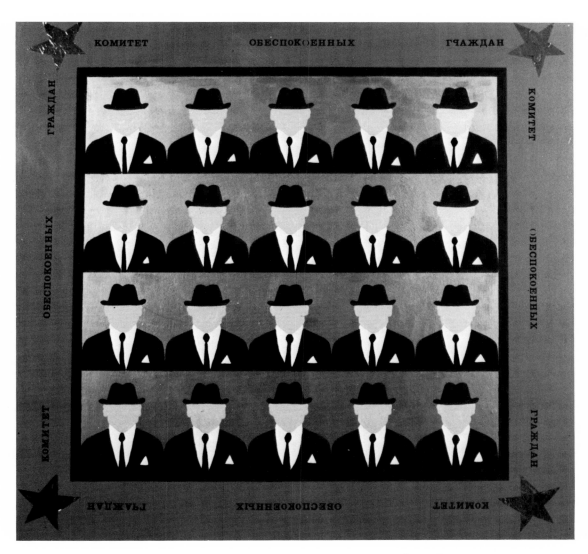

Larisa Zvez-
dochetova,
*Committee of
Worried Citizens*,
1983, Mixed
media

Larisa Zvez-
dochetova,
Embroidery,
1988, Mixed
media

Larisa Zvez-
dochetova,
Chukot Legend,
1988, Mixed
media, plywood
relief and
enamel

Ilya Kabakov,
*Olga Georgievna,
Something Is
Boiling!* 1984,
Folding album,
64 pages

Serebriakova's "pictures" are quiet photographs of landscapes, antique furniture, anonymous families as well as fragmented drawings of rooms, factories, men eating ice cream, women making cakes or opening milk cartons. These images are often juxtaposed with abstract shapes of textured paper, pieces of canvas, gauze and other fabrics. When Sots artists stole propagandistic "pictures" away from their usual place in Soviet culture and subverted their mythologies, they could do it because those "pictures" had already possessed specific ideological significations. Similarly Kabakov's appropriation of everyday refuse subverted the myth of the communal. Indicative of her loss of intrigue in the Oedipal traps of familiar ideological contexts, Serebriakova's "sights of dystopia" possess no a *priori* mythologies and are about the absence of what she calls "a saturated stable culture."[15] The success of Serebriakova's collages and drawings lies in the fact that because they lack local significations they are flexible in absorbing other discourses, specifically provoking thoughts about gender, authorship, the body, sexuality and everyday life.

The group Medical Hermeneutics (M/H) (Sergei Anufriev, Pavel Peppershtein and Yurii Leiderman) is preoccupied with a similar attempt to shift from what we may call the imperial imagery of Soviet mythos to more archival material whose signification is yet to be defined. In general the group rejects the heritage of Sots art, for they identify it with "the critical enthusiasm of the youthful days of ideology." Among other directions M/H take, they turn to the archive of children's literature, creating a large series of collages composed of cut-outs from the books of Anufriev's childhood. Leiderman stresses the fact that "in the Soviet Union one illustrates not reality but pure ideas, and thus, in a way the October Revolution was nothing but an attempt to illustrate [the idea of] Marxism . . ."[16] When various Soviet artists illustrated children's books they were not so much reflecting children's realities and fantasies as promoting such familiar ideological postulates as "Children are the only privileged class in the Soviet Union" or "Children are our future." Having in mind this underlying ideological sub-text of children's books, Anufriev's collages, in which authorial intervention is manifested only in the choice of juxtapositions of cut-out pictures, act precisely as the deconstructors of Soviet educational politics.

Similarly, in the group's installation *New Year* (1990), the artists turn to children's themes by recreating the atmosphere of New Year's Eve, which is the only non-ideological holiday in the Soviet Union. Three trees are installed on a dark red carpet and covered with decorations which carry no ideological or regional signs. Also, dolls, teddy bears, cats, foxes and dogs are changed from their original clothing into pure white ones and are seated around the three trees. This supports the group's self-denomination as agents of schizo-politics who attempt to escape to the imaginary (children's literature), thereby flowing out of the oedipized context of the ideological.

Elagina's *Children's* discussed earlier comes to mind as a diametrically different resolution of the same subject matter. She politicizes the problematic aspects of children's lives in the Soviet Union by showing the very core of its decay. Medical Hermeneutics members aim at "illustrating the unknown" oozing from the spaces between the hysterogenic spots on the same agenda. In *New Year* they accomplish this by sterilizing an iconographic arsenal of decorations (non-political) and clothing (non-regional). This position is reflected in their recent statement about their work:

> . . . postmodern thought has created a "carpet," i.e. a stormy mental
> surface, that does not presuppose what is "hidden" as an object of interest.
> Our attempt at working in the "empty spaces of the carpet" is a situation
> of a foreseen non-coincidence of *signifiance* and signification. [17]

In the beginning of this essay, I said that one of the main achievements of Soviet conceptualism of the 1970s was its triumph over the modernist aesthetic categories which at the time monopolized alternative art. What remained unsurpassable for them, as well as for the modernists, was the presence of the "universal doctrine" of Socialist Realism to which implicitly (Kabakov, Monastyrsky) I or explicitly (Sots artists) every work produced before the Gorbachev era referred. This simplistic cultural function provided a limited amount of fruitful mechanisms for the creation of significations, keeping Soviet alternative art within the singularity of *signifiance*. After the dismantling of "universal doctrine," the artists came to realize that underneath each ideology there is always another one. They began to reflect upon those other ideologies, and thus founded a mechanism of creating locally oriented chains of significations as well as signifying practices and/or signifying discourses which helped exorcise the spectre of emptiness that has haunted Soviet alternative art for the last few decades.

During the epoch of "stagnation" the alternative artists would constantly dramatize their fate, creating half-sincere, half-parodic mental images of themselves. One such "dramatization" was narrated by the artist Gia Abramishvilli: "Let's imagine that we are Japanese flyers in the end of World War II; we've mastered the art of flying but only to such an extent that we could take off . . . To sum it up, one should say that this type of wandering kamikaze, as a kind of non-landing sensibility, possesses quite a few attractive features." [18] Perhaps, the time has come for a "wandering kamikaze" to wake up from his/her non-landing reverie. In fact, the change in course is already noticeable as the u-turn of the u-topian.

Notes

1. For example, such major artists of alternative community as Ilya Kabakov and Eric Bulatov are official artists because they are members of the Union of Soviet Artists' section of book illustrating. However, the fact that they never officially exhibited their independent work in reality makes them unofficial artists.

2. After his visit to Czechoslovakia, the first trip outside of the Soviet Union in 1982, Kabakov wrote an essay entitled "On Emptiness." It reflected his reaction to the Soviet Union vis à vis the West as a vast empty, uncultivated space.

3. For a detailed discussion of conceptual art, performance art and Sots art see Margarita Tupitsyn, *Margins of Soviet Art: Socialist Realism to the Present,* Giancarlo Politi Editore, Milan 1989.

4. The most typical example of such exhibitions is "10 + 10" in which the "dialogue" between contemporary American and Soviet art–cultures was held within the limits of pure visuality at the expense of the contextual referents and/or justifications.

5. Margarita and Victor Tupitsyn, "The Studios on *Furmanny Lane* in Moscow," *Flash Art,* no. 142, October 1988, p. 103.

6. Ibid.

7. Ibid. p. 123

8. "Oleg Petrenko and Mila Skripkina," *Flash Art,* Russian Edition, no. 1, ed. Victor and Margarita Tupitsyn, p. 142.

9. Yurii Leiderman, *"Polaganie Traktov, Polozhenie Shluzov* (Scientific-Popular Art of M. Skripkina and O. Petrenko)," *Iskusstvo,* no. 10, 1989, p. 27.

10. Bakshtein has to be credited for organizing a number of important exhibitions in Moscow beginning with the *glasnost* period. In the context of the Soviet's inadequate exhibition practices his curatorial activities are especially important.

11. Andrei Monastyrsky, "Exponemes of Conceptualism (psychopathological aspects of expositional metamorphoses)," forthcoming in *Flash Art,* Russian Edition, no. 2, 1990.

12. *The Kristeva Reader,* ed. Toril Moi, Columbia University Press, New York, 1980, p. 187.

13. See Craig Owens, "The Discourse of Others: Feminists and Postmodernism," in Hal Foster ed. *The Anti-Aesthetic: Essays on Postmodern Culture,* Bay Press, Port Townsend, Washington, 1983.

14. Douglas Crimp, "Pictures," in Brian Wallis ed. *Art After Modernism: Rethinking Representation,* The New Museum of Contemporary Art, New York, p. 185.

15. Victor Misiano, "Interview with Anatoly Zhuraviev and Maria Serebriakova," forthcoming in *Flash Art,* Russian Edition, no. 2, 1990.

16. Yurii Leiderman, "Ballaret and Konashevich," unpublished manuscript, 1989.

17. Victor Tupitsyn, "The Inspection of Inspectors," Flash Art, no. 147, Summer 1989, pp. 133–135. *Signifiance* refers to creative transgressive meaning, whereas signification is socially instituted and socially contolled meaning.

18. Gia Abramishvilli, "Champions of the World" in Margarita Tupitsyn, *Margins of Soviet Art,* op. cit. pp. 172–173.

On Emptiness

Ilya Kabakov

I was in Czechoslovakia in the spring of 1981, and among my most interesting impressions and conceptions was one which was linked to the possibility of looking upon "our place" from the point of view of a "different place," of one who has left. How does it look "from the outside?" The situation is roughly akin to riding in a train, riding for an interminable length of time, sitting all the time in the compartment without exiting and then all of a sudden getting out at a stop, walking out onto the platform of the station, and from the platform, from the outside, looking inside through the window to the very same compartment in which one has just sat.

This instantly encapsulates an important experience which unites everything, determines itself and grants everything its place — this clear, final vision of emptiness, the void-like state of that place in which we constantly live.

First and foremost in this conception, of course, is the resolutely spatial representation. For the artist this experience of space seems native and characteristic; it is almost a professional feeling for him. But the conception of emptiness with which I am concerned is not simply spatial or optical. Its substance is of an entirely different sort.

A gigantic reservoir, the volume of the emptiness in question which represents "our place" is not emptiness per se — a "vacant place" in the European meaning of the word. This approach would characterize emptiness as a space not yet filled, not yet mastered, undeveloped or developed poorly, a little, etc. In short, it would see emptiness as an empty table upon which nothing has been placed, land which has not yet been planted, but upon which something could be placed, and in which one could plant. This European, rationalist notion of emptiness as a field where it is potentially necessary to apply human forces, so that the place "awaiting human labor" can be

mastered, is entirely unsuitable for our phenomenon of emptiness. The emptiness of "our place," of which I would like to speak, is of an entirely different sort. It cannot be described in terms of mastery, settlement, the application of labor, etc., i.e., the terms of European rationalist consciousness.

Instead, this emptiness presents itself as an extraordinarily active volume — as a reservoir of emptiness, as a particular void-like state of being, staggeringly catalyzed, but opposed to genuine existence, genuine life, serving as the absolute antipode of any living existence. As is known, nature does not tolerate emptiness. But I would like to add: " Emptiness does not tolerate nature." The emptiness of which I speak is not nought, is not simply "nothing." The emptiness in question is not a neutrally charged, passive border. "Emptiness" is staggeringly active, its activeness equal to that of affirmative existence, be it the activeness of nature or that of human activities or even greater forces. But its activeness is directed to another side, moreover with that very same energy and strength that characterize the striving of living existence, striving to be, become, grow, build, exist. By such ineradicable activeness, force and constancy, emptiness "lives," transforming being into its antithesis, destroying construction, mystifying reality, turning all into dust and emptiness. This emptiness, I repeat, is the transferring of active being into active non-being and, most importantly, this emptiness lives and exists not by its own power, but by that life which surrounds it, which it transforms, pulverizes, collapses into itself. Emptiness adheres to, merges with, sucks being. Its mighty, adhesive, nauseating anti-energy is taken from the transfer into itself, which like vampirism, it gleans and extracts from the existence surrounding it. Searching for a metaphor for what I wish to say, I see a table covered with a tablecloth at which people sit conversing, a table set with dishes and food at which these people are taking lunch, and upon which a hostess constantly sets new dishes. And I see someone who is constantly unnoticed who inexorably pulls off that tablecloth, with everything on it flying to the floor in the even thunder and sound of falling plates, glasses and cups. Why? What was the purpose? This question can be put only to the living, the intelligent, the natural, but not to emptiness. Emptiness is the other, antithetical side of any question. It is the inside, the opposite, the eternal "no" beneath everything small and large, whole and individual, intelligent and mindless — all which we cannot name and which has a meaning and a name.

This very emptiness really inhabits the place in which we live, from "sea to shining sea." It is a special (however bombastic the word) hole in space, in the world, in the fabric of being, with its own location, which is contrasted to the world as a reservoir of emptiness, carrying out its terrible voice-like duty in relation to the entire remaining world. And this, I repeat, is not someone's evil will, but as I already said, the very condition of the existence of emptiness, its vampirism of energy in relation to being and the world.

But in that territory where emptiness dwells, its physical surface is firm and dense, covered with trees, earth, mountains, live people and beasts; it is occupied in a physical sense. Upon its surface live millions of people with their cities, houses and other things. What kind of life is this, when the residents of this place interact with emptiness? This is precisely what I should like to examine.

First and foremost I would like to speak about a peculiar psychic mold, a psychological condition of those people born and residing in emptiness. As if fully penetrating emptiness itself, each of these people's experiences and sensations is included in every reaction and deed, is combined with each task, word, and desire. Every person living here lives, consciously or not, in two dimensions — whether in relation to another person, in business, in nature, or in relation to emptiness. Moreover these two dimensions are opposed, as I stated earlier, to one another. The first is "construction," organization; the second, the destruction and annihilation of the first. On the everyday, worldly level this separation, bifurcation and fatal disconnectedness of the first and the second dimensions is experienced as a feeling of the universal destruction of everything that man would do, the uselessness, groundlessness, and senselessness of what he would have built and undertaken. In all of this there is a feeling of ephemerality, absurdity, and fragility. This life in two dimensions creates the peculiar neuroticism and psychopathy of all those residents of emptiness, with no exceptions. Emptiness creates a peculiar atmosphere of stress, excitedness, strengthlessness, apathy, and causeless terror. These are the properties of the psyche of those residing in emptiness.

Their psychic status resembles the psychic stress of primitive man of the little tribes in central Africa waiting for anything from the terrifying, vital, endless world of jungles. But there is a large difference between the consciousness of a neurotic surrounded by jungles and that of a person living in emptiness. Sooner or later the resident of the jungle learns how to relate himself to the spirits of the forest, to name them, to produce a number of incantations, prohibitions, since the forces of the jungles are real for him, parts of existence. However enormous and terrible they are he can live with them, come into contact with, cajole, battle, eliminate, and escape them. Such is not the case for the resident of emptiness. The emptiness which he experiences is of an entirely different nature: first and foremost one is incapable by definition of recognizing, naming, or by any other means signifying it. After all, emptiness is neither natural nor supernatural, it is ANTI-NATURAL, and to live with it is as if to constantly not live. It is impossible and unbearable. The dwellers' sensation of emptiness is the nauseating terror of the blood donor, whose blood is continually and constantly pumped out and taken away. But the denizens of emptiness have their own technique, a psychotechnique of life in emptiness. They have produced their own set of denominations regarding emptiness, they have, so to speak, personified and named

it. For them, nature has an absolutely firm appearance, a fantastic, yet defined aspect, but we shall discuss that later.

Here I would like to discuss a possible topographical form of residence in emptiness. Topographically this form is expressed and exists in the principally insular character of the settlement of emptiness. We can speak directly of a distinctive Ocean, of an archipelago of small and large settlements, lost and scattered about the expanse of emptiness resembling some sort of Philippines, but these are not islands in a warm ocean, but in an ocean of uncertainty, an ocean of emptiness. Here, in our case, the shape, the essence of emptiness shallows itself. The very dimensions of the territory — its invisibility, endlessness, uncloseability, immeasurability — are not simply a large space, which one could calculate, comprehend and assimilate, but rather a groundless, interminable blending-together with emptiness, a moving over into emptiness. These islands of habitation contract and huddle together unto themselves, protecting and preserving themselves from the surrounding emptiness. This applies to both the configuration of villages and hamlets, where houses are pressed up against one another, as well as the gigantic cities, the very dimension of which speaks of the multitude of people gathered and crowded within them, running and saving themselves from emptiness.

As is the custom in insular culture, these islands of habitation are unified with one another by systems of communication, bridges across emptiness. But these communications, all of these roads, paths, highways, rivers, and railroads, belong to a somewhat different form of emptiness, and are in a certain sense the opposite of the life of the islands, but we shall discuss that a little later. Just now I would like to emphasize the peculiar state of mind of the residents of these islands which inheres in the special knowledge that emptiness and nonexistence begin immediately beyond the border of the island, past its final home. Let us move to an examination of an island itself, of that place in which the "colonists of emptiness" are crowded — its permanent residents, islanders for many generations. What does this community, this fellowship of people "swimming in emptiness," this "society in a canoe," constitute? Does this community present a certain unity and continuity, in short, a single, interacting human social body in the face of emptiness?

Nothing of the sort.

Scrutinizing an island on which there are from a hundred to a thousand people as in villages, or from one to seven million as in enormous cities, that which is most important in them comes to light: a man on this island, in this village, city, or large city conducts himself JUST AS HE WOULD IN EMPTINESS, not noticing the tens, hundreds, and millions crowded alongside him, resembling him. The feeling, the terror of the experience of emptiness within him is so great that he and those around him see and endure it as emptiness. The sea of people around him does not lead to

the formation of links between him and others, to benevolent harmony with the other. Everything around him is equally indistinguishable and inimical. Everything is equally the other's — the streets, houses, today's tasks and yesterday's, the things surrounding him — all is void-like. Everything incarnates emptiness. Inside the island salvation from emptiness is the very same emptiness, and thus for each denizen of this island all that is outside and inside the island, without exception, is nothing, emptiness.

Let us move to the next level of the topography, topography inside the island.

All the inhabitants of the islands feeling themselves to be surrounded by emptiness take refuge in BURROWS.

These burrows constitute the most important cell, the basic atom perhaps in the atomistic construction of the island. The burrow is the sole place of residence of the inhabitant of emptiness, a relatively hopeful refuge from emptiness and its bearer — Man. And as the island itself is an asylum from the emptiness of space, so the ever so similar burrow is the asylum of the individual man from the other inhabitants of the island. This structure is principally non-social and antisocial, as it should be, since emptiness is the arena where all of this takes place. It is ubiquitous, acts in every cage, penetrates everything which is arranged on it. The other inhabitants surrounding the "burrow man" present a potential danger for him, they are inimical or, in the best case, neutral, harmless, and homogenous. The movements of the "burrow man" reproduce the communicational structure of the insular culture as a whole. In the same general way, he moves about the island as through emptiness, shifting to a different burrow, that of one of the few residents close to him, for whom he feels trust, trying as he can to pass and traverse the dangerous zone between the two burrows, the zone located immediately behind the line of his entrance into the burrow, the line where his security ends and emptiness begins. All of the streets, roads, and sidewalks of these islands, these villages, cities, and settlements are filled with thousands of these "burrow residents" rushing from one burrow to another, who neither see nor notice anyone and fear all while outside their burrows, although they shove and collide with many similar to themselves.

There is almost no interaction or interrelation of the inhabitants of one burrow with those of other burrows except among acquaintances. And there is less garrulity here than among animals living in the forest, where there are spatial zones of influence of every form, an autonomy of particular paths, and a regulated spatial stratification of being.

Earlier we talked of the personification and denomination of this feeling by the denizens of these islands. This denomination is connected with the conception of "stateness" for the residents of the burrows. This conception is located in one sequence with such conceptions of our place as emptiness, island, communication, and burrow.

The stateness in the topography of this place is that which belongs to an unseen impersonality, the element of space, in short all that serves as an embodiment of emptiness, combines with it and expresses it. A metaphor comes closest of all to a definition of that stateness: the image of wind blowing interminably alongside and between houses, blowing through everything by itself, an icy wind sowing cold and destruction, howling and crushing with one unchangeable composition.

In precisely the same way as the wind's aim and meaning and the constant pressure of the stateness are incomprehensible for the burrow dwellers, its terrible fits, changes of direction, its movement, are all equally incomprehensible. The constant, ferocious pressure, the menacing, terrifying fits directly behind the door of the burrow inspire horror in the soul of the person sequestered within, filling him constantly. And for nought. In these fits, in these claps and blows of thunder, in this implacable, irrepressible movement inaccessible to either comprehension or entreaties, the timid resident of these places recognizes the voice of emptiness. The stateness is emptiness itself, not materially or substantially given to the denizen of these regions, but all the while instilling terror, fear, and appearing as his punishment. Above all, the stateness, an operation incomprehensible to this man, is opposed and inaccessible to him by meaning. It demands from him the execution of its own "governmental aims," known only to it, which are fixed, promising only mercy in return. What sort of goals does this wind, this stateness, set for itself, if they exist at all? These goals always bear in mind the mastery of the scope of all territory occupied by emptiness as a SINGLE WHOLE. The inhabitants of this place are cast into this sweeping stream, themselves becoming powerless elements of the whirlwind.

For just this reason authentically governmental acts often have to do with superhuman, megalithic projects and constructions: Peter the Great's canals, flowing across the entire country from North to South; the regular, militarization of the cantons along the entire border of Nicholas the First's empire; Stalin's forest-protecting zones, his razing of mountains and changing the flow of rivers; the passage of skiers from Khabarovsk to Moscow and back; Krushchev's development of virgin soil and space flights: *and other acts possessing governmental significance.* But all these constructions and projects, replacing one another like terrifying fits of wind, changed nothing either in the territory itself of this place, nor in the situation and state of mind of the inhabitants of these burrows, although all of them were realized by the power of those residents. The residents always feel themselves cast into these dislocations, fits, and great deeds, sensing them as gloom, violence, or as senseless intoxication.

It follows from the above, and goes without saying, that all communications and links between both burrows and islands belong also to this wind, this stateness.

Do these places, this insular archipelago arranged on emptiness, have a history? IT does not exist. ITS islands move off into the past, as into emptiness, they dissolve into it like clouds losing their form and configuration. Memory of bygone

islands disappears, stops short with the disappearance of one set and the appearance of new islands beyond the edge of today, as the very same emptiness gapes beyond the edge of an island. There exists no history, no sedimented deposits, no continuity. Only easy poetic recollections remain: there were monasteries as sets of culture, there were cities, there was a certain life sometime, but everything melted like smoke in emptiness. Nothing results from anything, nothing is connected to anything, nothing means anything, everything hangs and vanishes in emptiness, is born off by the icy wind of emptiness.

And one of the most important signs of life of all local inhabitants is flight, dislocation, and drivenness. The wind of emptiness carries off and blows residents from their burrows, it drives them like leaves along the uniform face of the enormous surface of this country, admitting no delay, letting no one become rooted. Each person is provisionally present here, as if they have arrived from nowhere very recently, the other on someone else's land.

How do the inhabitants of these places relate to this feeling of emptiness, to this restlessness?

Something like four forms of relations can be distinguished. The first is to attempt, in general, not to notice emptiness with one's consciousness, to live "naturally" in it and to consider all events, causes, and connections of life in emptiness simply "as they are," natural and necessary.

The second is to consider this void-like state unworthy and unacceptable for a person, for human life. In this case, all possible projects and reforms, from economic to legal, are necessary in order to change this place and the living conditions of the local people by a path of construction, displacements, labor, and new reforms.

The third relationship is mystico-religious, according to which this place of emptiness and insecurity is extremely useful for the human soul. Precisely here, in this existence-less place — the place of "evil, lies, and non-existence" — it is easier to be saved, to experience "heavenly heights," to search for and find higher truth.

The fourth is simply to see this place as it is in fact and describe it as a doctor might describe the history of an illness with which he is terminally afflicted.

If we return to the image of emptiness as an ocean, it may be said that what we have here and what always was, is, and truly will always be, is the situation reminiscent of the life of scholars in tents in the uninhabited and icy Antarctic. Of course, one can go visiting, drink tea, or dancing, moving from one tent to another, from the Soviet to the American and vice versa, and be selflessly carried away by this activity, but true, authentic relations will consist in the sensation of the place where these tents stand. These will be the relation to a five-kilometer thickness of ice, from which one may await anything one pleases, and first and foremost, death and destruction.

Translated by Clark Troy

The Third Zone: Soviet "Postmodern"

Elisabeth Sussman

For Americans the Soviet Union represents the Other, the immense unknown, divided from the West by the polarization of opposing political ideology, the imperial rivalry of the Cold War. Bad communism vs. good capitalism was the determining narrative of East/West political relations. This polarization — bad East, a good West — was reversed, however, in the opening chapters of twentieth-century artistic modernism, written in the West by, among others, Alfred Barr, first director of the Museum of Modern Art in New York. Barr's 1928 visit to Moscow, recorded in his diary, introduced him to a citadel of avant-gardism: "We feel," he wrote," as if this were the most important place in the world for us to be. Such abundance, so much to see: people, theaters, films, churches, pictures, music . . . It is impossible to describe the feeling of exhilaration: perhaps it is the air . . . perhaps the cordiality of our new friends, perhaps the extraordinary spirit of forward-looking, the gay hopefulness of the Russians, their awareness that Russia has at least a century of greatness before her, that she will wax, while Florence and England wane."[1] In that narrative, unimpeachable authority was awarded to the radical artistic innovations fostered in the climate of Lenin's U.S.S.R. Tatlin's visionary architecture, Myerhold's radical theater, Vertov's constructivist film, were ranked high in the symbolic pantheon of heroic twentieth-century modernism. The post-revolutionary Russian avant-garde that Barr observed, wrote about, and collected for the West, exemplified the historic avant-garde which, to quote Peter Burger, had as its goal nothing less than "the revolutionizing of the praxis of life."[2]

However, with the arrival of Stalinism in the 1930s, the historic narrative of art changed, and "officially sanctioned" modernist experimentation, and artistic free-

dom in general, came to an end. The Soviet Union was decisively expelled from the utopian dreams of modernity and the West was awarded the banner of artistic progressivism. Heroic modernism became unquestionably located in and promoted by the "free world" of the West as the best "propaganda" for a democratic hegemony.[3] Stalinism, in the East, imposed the policy of Socialist Realism, "the subordination of artistic creativity to the tastes and purposes of the ruling statocratic class,"[4] onto all levels of historic production. In the historic narrative of a utopian artistic modernism, the divisions continue, but significant doubts about its basic assumptions plague us. The political separation between East and West persists, but modernism's authority has been questioned in both places. By the early eighties in the West, in the eyes of many critics, the revolutionary hopes of modernism had failed, "the demand that art be reintegrated in the praxis of life within the existing society can no longer seriously be made."[5] Condemned as "authoritarian, chauvinistic or even imperialistic," modernism now stands accused of ignoring new social currents — feminism, gay liberation among them.[6] In a sustained critique, Western modernism is seen to be intolerant of a plurality of artistic voices and the "free" market is seen to eliminate the marginalized from centers of power. The good/bad polarization — of freedom of expression vs. controlled expression — a polarization fundamental to modernism's authority, has similarly been challenged by the growing tolerance of the "unofficial" in Moscow. Recent events in the Soviet Union and the Eastern bloc generally - the election of Vaclav Havel as President of Czechoslovakia for example, or the movement for Lithuanian independence, cause us to question whether the Cold War oppositions still exist. Such growing tolerance makes moot the position that the Soviet Union is still separate, still the U.S.'s Other, withdrawn and intolerant of modernism and its transformations, supportive of only a state-run aesthetic ideology and bureaucratic art apparatus.

Without diminishing the enormity of historic, cultural, political and economic differences that separate the by now collapsed Cold War opposition, it can be asserted that, in reality, there can be no complete and emphatic separation — indeed that one has not existed in an essentialist form for many years. We can recognize that there exists what might be called a post Cold War "third zone" or a state of hybridity, between East and West. In the third zone, political oppositions are questioned and aesthetic positions overlap. It is important to recognize that this is not a one-way street of influence with a "third zone" located only in a new Soviet Union hybridized by changes in its own culture as well as by Western influences. With the collapse of the utopian modernist agenda, the bipolar opposition has broken down and a scenario of aesthetic cross-fertilization, from West to East, East to West, dominates forms of expression. It is this state of hybridity, for example, which is the message in the Bayonne work of the famous Russian emigres Komar and Melamid, conceptual artists who view American culture ironically, reformulating it through a Soviet lens.

Russian conceptualism, the focus of this exhibition, has been conceived in this state of hybridity. The designation, Russian conceptualism, is a highly contingent one and ultimately should be considered under the rubric of the postmodern, a term that in the West marks the end or at least conditional end of modernism. Without attempting an umbrella definition that sweeps aside the differences or oppositions between positions (and defines an aesthetic space with greater continuities than can be found), certain similarities connect the projects of American and Soviet writers and artists. Parallel descriptions of the shift, from expressive to conceptual attitudes may be found, for example, in the work of the Soviet writer/artist Sergei Anufriev and the American critic Hal Foster. Writing in 1989, Anufriev reflected on the beginnings of conceptual art in Moscow. "The specifics of the Moscow school," he noted, "consisted of the fact that artistic pathos was replaced by investigative pathos very early on, in the 1960s, when the Moscow school had formed its group called Sretensky Boulevard which . . . was more investigative than artistic. A curiosity of thought made for a shift from the results of expression to the means of expression and from that to the very question of expression as such."[7] In 1983 Foster described the tenets of what he termed the "anti-aesthetic" of Western art in which "a poem or picture is not necessarily privileged, and the artifact is likely to be treated less as a *work* in modernist terms — unique, symbolic, visionary — than as a *text* in a postmodernist sense — 'already written,' allegorical, contingent."[8] Both writers describe the paradigmatic shift in the art of the last twenty years. They delineate the tendencies toward an art with layers of meanings or codes that are buried in strategies (such as irony, parody), systems and references. This art is linguistic and textual (without necessarily being narrative). It does not rely on affect as much as on analysis ("investigation") as a form of interpretation. Privileging the differences among spectators or viewers that determine differences in reception, and accepting the resistance of the language or code to yielding a single meaning, both Soviet and American writers anticipate that there will be a multiplicity of interpretations surrounding the art work. It is not suprising that when Sergei Anufriev formed his own artistic collective in 1987, he named it Medhermeneutics, relating his art making to the science or art of interpretation, particularly of the scriptures, known as hermeneutics.

Soviet conceptualism, in that it confronts the ending of the utopian dream in the U.S.S.R., and interrogates the absurdities of its aftermath, can be thought of as a form of postmodernism. As Ilya Kabakov says, describing the end of the modernist experiment: "Our generation arrived on the scene after the utopia had been accomplished and after the cooling off of the nuclear explosion. Radioactive fallout has descended and we have rediscovered ourselves in a post-utopian world."[9] A similar disillusionment, disgust, contempt for the modern is voiced by Alexander Melamid: "Where do we go to escape the modern? Modern is no good, we know. Big mistake.

Huge mistake — ugliness and cruelty and horror and squalor and publicity. Modernism wanted to change the world and it achieved *nothing*."[10]

Although postmodernism as a term has not been absorbed into the critical discussions surrounding Soviet art, postmodern assumptions had clearly inflected upon sixties' Soviet art. Russian conceptualism emerged from, and extends to, several sources: American Pop art and conceptualism, and Soviet Sots art. Sots art, which was definitively born with the work of Komar and Melamid and other Soviet underground artists involved in unofficial "Aptart" or apartment exhibitions of the early seventies, was linked, generally, to American Pop art. Sots art was an avant-garde which inscribed itself in a reflection of the banal, the quotidian, as signifiers of the social. It defined itself as an underground practice situated between mass culture and the avant-garde. The similarities between Sots art and Pop art have been described recently by Soviet critic Elena Izumova: "Pop art," she writes, "was an aesthetic reaction to the symbols, signs and cliches of mass consumption which had become the characteristic mark of 'Western life style' in which the domination of commmercialism led to the overproduction of advertising. Soc-art [sic] was a reaction of artists to the social 'advertising' of the 'building of socialism' and to the redundancy and overabundance of ideological propagandistic graphic production. The countless slogans, quotes and monotonous posters surrounding a Soviet person during his entire life had lost their original meaning and turned into a part of the scenery, like, for example, an advertisement for Coca-Cola in American towns."[11]

In 1986, when Gorbachev instituted his policy of glasnost — revealing his interest in Western culture, cautiously encouraging open exhibitions and allowing artists to travel — his overtures were greeted with astonishment. And yet, in fact, the American art underground had long infiltrated Soviet culture. Sots and Pop met on a subcultural level, sharing an artistic language historically predating the advances of glasnost. As the Soviet critic Boris Groys has written: ". . . since the beginning of the fifties, since the time of the thaw that occurred after Stalin's death, Western art magazines, books and catalogues have arrived at somewhat regular intervals, if not to the general public, at least to circles directly involved in the production and evaluation of art."[12] American mass culture, in the form of rock music, had similarly invaded the Soviet bloc, affecting the formation of a Soviet radical youth culture. Timothy Rylback tells us that "Millions of rock-and-roll recordings . . . were in circulation throughout the Soviet Union and Eastern Europe during the late 1950s."[13] Severe repression kept direct influences from the West in check, but knowledge of Western currents was there, like a constant static hum.

And yet where American Pop used the abundant and ever-present commercial world as a readymade, the Sots artists used ideology, which they also had in abundance, as it was expressed in signs, slogans, and perhaps most pointedly, in the officially-sanctioned Socialist Realist art. Ilya Kabakov is the central artistic figure who

has addressed himself to the realities of Soviet life, and his early work certainly is part of the Sots art tradition. However, the allegorical and philosophical dimensions that rule the Social realist surface of his work bring the Sots art attitudes into a more conceptual arena, which as we will see, becomes the more elastic field of discourse for recent Soviet art. Russian conceptualism, personified by Kabakov, grounds itself in a state of hybridity. It shares with the West not only the attitudes of social discontent and disillusionment with the modernist agenda, but also the forms with which these attitudes have been expressed.

As an exile in his own country, Kabakov had as early as 1963 (the same year as Pop art appeared in the West) moved art off its aesthetic pedestal and into the realm of everyday life. Along with the painters Bulatov and Vasiliev, he became interested in the portrayal of Soviet life and was attracted by the representation of things non-artistic (in the case of Kabakov, restaurant menus and bureaucratic documents). Kabakov's art, however, cannot be precisely pinned down to the ironic strategies of quotation used by Sots artists. For Kabakov's work evolved to include a very Soviet form — writing, narrative, storytelling — as a central element. Indeed writing, or the use of texts, specifically links Kabakov to the movement, now formally termed conceptual art, that emerged at the end of the sixties in America among a group of artists (including Joseph Kosuth, Douglas Huebler, and Lawrence Weiner, among others) as a shared construction that foregrounded concept, information, language and system. Kosuth's argument that "in the nature of art, beginning with the twentieth century, there was a shift in the visual experience from morphological to conceptual" and Weiner's pronouncement that ". . . the art I make . . . differs from previous art in that it relies upon information, whereas previously the art was just presented,"[14] effectively opened the doors to an art where text, photograph, systems and objects that conveyed information superceded the more traditional studio practices and expressive media. In Kabakov's work, which has definite connections with this movement, writing and installation, however, take the more Russian form of storytelling.

Nevertheless, what appears straightforward, even linked to a Russian literary realist tradition, is most decisively, in Kabakov's work, always multivalent, and in the terms of Foster "allegorical," or Anufriev, open for "investigation." Beginning in what he termed "a pure zero, a pure grey anonymity," Kabakov constructed a "metaphysics of the commonplace,"[15] creating albums of words and images based on the lives of ten characters, all imaginary, who were residents of the prototypical Soviet communal apartment. From the lives of these characters, he has spun narratives, most recently actualizing episodes from these narratives in installation pieces, thus placing his characters in a dynamic public structure. Kabakov's expression of social reality around notional subjects reformulated Sots art, extending it from the specific context of Soviet ideology, allowing for an analytic space where ideology inflects the self, mind, ego of the nominal subject to emerge. His direction is particularly, significant, then, in

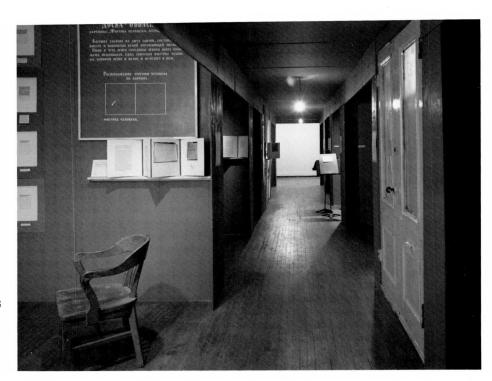

Ilya Kabakov,
Installation
View from *Ten
Characters*, 1988

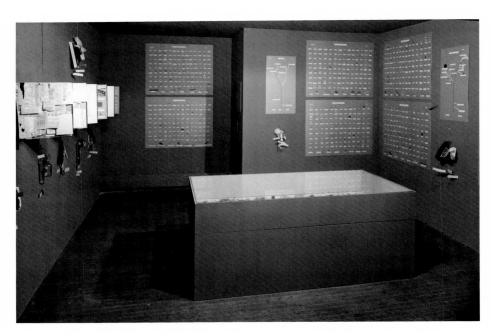

Ilya Kabakov,
*The Man Who
Never Threw
Anything Away*,
1981–88, Detail
from the *Ten
Characters*,
Mixed media

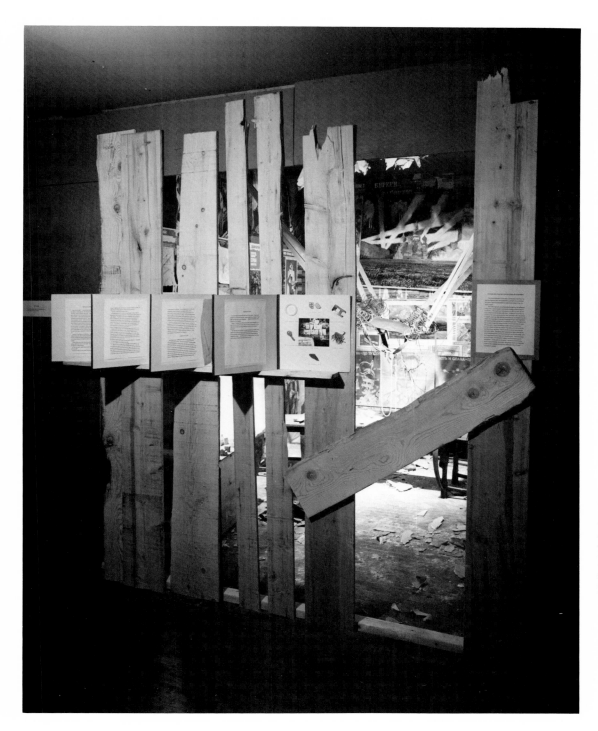

Ilya Kabakov,
*The Man Who
Flew Into Space
From His Apart-
ment,* 1980–88,
Detail from *Ten
Characters,*
Mixed media

the culture of the "third zone," as Soviet ideology becomes transformed, and in the particular historical condition as Soviet artists migrate, crossing back and forth over ever-changing boundaries between the U.S.S.R. and the West. The mirroring of this political condition is found in the substitution of the exact deconstructive tendency of Sots art by a more porous semiotics where signs and illustration detach themselves from precise political interpretation and are endowed with greater psychological or subjective characteristics. This tendency toward an open-ended, more abstract art is found in the work of Moscow artists Sergei Volkov and Andrei Roiter, Volkov, influenced by Kabakov, tries to ground his painting in an everyday reality — the paintings, worked with a palette knife into overlapping swatches, are meant to resemble the surfaces of Moscow kiosks where multiple, overlapping signs and personal advertisements are posted. In a recent body of work, Volkov took images from magazines and added banal proverbs or jokes to them, causing verbal and visual codes to collide and deconstruct one another. In effect, such image-text works constitute an empty sign that can, in a liberating paradoxic, be full of meaning. Andrei Roiter, similarly, creates paintings that are dialogues with everyday life. He too avoids the ironies of ideology in search of a more abstract, sensual, open semiotics of surface and sign. His New Wave sensibility relates to the studio atmosphere in which he and other artists worked in the 1970s. In their abandoned kindergarten, rock music, performance, painting and sculpture overlapped as alternative practices. The textures of some of his paintings — oil, mud, sand — reveal a live biological structure. For Roiter, signs mean everything: they are visual, not intellectual; they are laconic and precise, yet always refer to more than one thing. Recent paintings have been reduced to less obvious linguistic signs, such as quotation marks, or punctuation marks. In his painting, *Pushkin,* a fragmentary image set into a monochrome surface alludes to the latent romanticism of the work itself in an attempt to introduce the psychological dimension of memory.

It is Roiter and Volkov's allusion to signifiers as empty that connects them to other aspects of Russian conceptualism. Conceptualism located in a state of hybridity, addresses the defeat of idealism, the failure of modernism. The key metaphors are emptiness or waste, nothingness or degeneration, and Kabakov's art is again, prophetic and paradigmatic. The fullness of Kabakov's narratives (the result of his extraordinary descriptive powers) are undercut by the reverse, the artist's sense of emptiness. In Kabakov's albums, the final page of each narrative has for many years been white, a "color" gesture that signifies for Kabakov the finality and infinity that underlie and/or cancel every narrative. In a banal or concrete discourse, Kabakov introduces garbage as something not unlike a signifier for the entropic process that leads to this abyss. This is seen, for instance, in the installation, *Sixteen Strings,* created for this exhibition where strings, festooned by garbage that is labeled, create a maze in a simulated communal kitchen dominated by the voices of quarreling Rus-

sians. Emptiness, as a theme, figures prominently in the work of other Soviet conceptualists. Andrei Monastyrsky, one of the "fathers" of Russian conceptualism and a member of the group Collective Actions, links emptiness to Russian connotations (the U.S.S.R.'s actual geographical borders with Asia) as well as to the ideas of John Cage, who introduced Eastern philosophy into Western artistic practice, using the Oriental idea of chance as the basis for creation. In the action *Ten Appearances,* which is documented in this exhibition, ten performers from Collective Actions dragged white strings across a field of white snow, making parallel indiscernable paths. They disappeared into the forest at its edge, and subsequently reappeared, in a performative text on erasure and nothingness. The artist Andre Filippov, in a series of objects such as the wax encrusted *Old Testament,* and the hammer-and-sickle-ornamented table of *The Last Supper,* reworks the idea of the spiritual/transcendental linked to Kasmir Malevich's suprematism. Filippov identifies the transcendental with the idea of a great spiritual center — a fourth Rome — surpassing the Stalinist myth of Moscow as the third Rome. Similarly, the group Medical Hermeneutics (a collective of the artists Yurii Leiderman, Pavel Peppershtein, and Sergei Anufriev) are influenced by Monastyrsky's interpretation of Kabakov's idea of cultural emptiness. As Anufriev has written, "Kabakov made the object of representation 'emptiness' of the picture itself, then in my works the object of representation was 'emptiness beyond the picture.'"[16]. The MedHermeneuts share with Sots art the idea that ideology is expressed pictorially: they undercut ideology by appending unrelated texts to pictures, or reversing usual text/picture relationships by having the text illustrate the picture. In their vocabulary, it is childhood, its customs, its paraphernalia (like books), which is shown to be the site, the beginning of the lie of ideology. These strategies of dissociation and multiplicity of interpretation ultimately point again to emptiness.

Soviet artists were, before glasnost, unofficial, unrecognized, underground. Since 1986, they have been tolerated and liberated, and this shift has caused a breakdown in oppositions and a possible transition of meanings and intentions in the work, or new possibilities for the "third zone" of Soviet art — a "third zone" located both within and without the geographical borders of the U.S.S.R. Dmitri Prigov, a leading Soviet conceptualist poet, has recently described this changing cultural situation:

> The cultural situation, previously worked on a clear official-unofficial duality, which was reproduced like a magnetic polar opposite at each individual point of the structure . . . A situation like this also necessarily typifies the forms of communication available to art: magazines, galleries and stages, on the one hand, and apartments, coffee houses and typewritten texts, on the other hand, while both generated their respective, self-adjusting orientation and reception mechanisms . . . Today the cultural situation is marked by the elimination of the opposition structure (whereby I mean the socio-cultural situation and not

Andrei Filippov,
The Last Supper,
1989, Mixed
media

just the cultural, as will always be the case). This means that the most difficult thing now is to define an opposition position exclusively on the cultural level. So understandably a third cultural zone is just now emerging, which is still hidden, and not clearly articulated but which emerged at virtually the same time."[17]

Three artists emerge as talismans of this particular moment in Russian conceptualism, the hybrid "third zone." They are: Vadim Zakharov in whose work, a biological condition — infection — signifies an existential death; and Vitaly Komar and Alexander Melamid, whose Bayonne series conceptually reforms a mythic "non-place" between the ideals of East and West.

Zakharov has arbitrarily created a system of information over time which he now seeks to willfully deconstruct. This action is analogous — on many biological levels — to the arbitrariness in the growth of the social formation: Marxist/Leninism or glasnost. First, in performances, Zakharov adapted personalities: an elephant man and a patch man (signified by photographs of the artist with a patch over his eye). Mutation — described as hiding, melting, infecting — then took over the body of work. Narrative text became a single word, pieces of paper containing information about past art that he had previously spelled out, were crumbled and hidden. Residual bits of visual information were all that remained from past representations, such as an elephant's trunk or a finger. Tiles, introduced as a structural grid built on an embryonic module, were reduced or expanded. In an eventual reduction to monochrome, colors systematically signified a process of decay: gray and black (the color of the landscape), or green (signs of infection, a fatal disease). Significantly, these works were executed and shown as Zakharov traveled to Vienna and Cologne, during the glasnost "mutation." *Two Years Between Hiding and Infection,* the six-part piece in this exhibition, contains a line that gravitates to the left, toward the crumpled waste of information.

Crumpled waste or garbage — the waste of ideology, of words, of the environment — the failure of an "experiment," is the consistently recurring signifier in Russian conceptualism. Zakharov's rumpled paper is echoed. Similarly, Komar and Melamid fashion Smithson-like installations — entropic garbage from Bayonne, the site of their new "home" in America. Although they have recently become American citizens after emigrating here in the seventies, Komar and Melamid are truly residents of a "transtate." Their Bayonne is a site that exists only in the imaginary space, in that third zone in America, a space in which one searches for nostalgic remnants of the Marxist dream — the happy worker — as he might have existed in a pre-Leninist Russia. The accusation in the art press that their "paintings and objects contained no real examination of the economic realities of the workers' lives or their status as relics in rapidly deindustrializing America"[18] was inaccurate. In fact, Komar and

Melamid's Bayonne is an ironic, conceptual site work, though their rhetoric may make claims for a true celebration of the American lives of the workers at the Bergen Point Brass Foundry. This Bayonne, where the "smell was very characteristic of our childhood in Russia," exists in the "third zone." "Of course, our project doesn't belong to the United States or the U.S.S.R., it is universal," say Komar and Melamid. "It is about industrial life anywhere, we do not mean for it to have specific social applications."[19] With the oppositions of East/West collapsing, the new eyes of Russian conceptualism provide a new vision where the nation/states are concepts that allow "the West" to exist in the "USSR" and the "USSR" to exist in "the West."

Notes

1. Alfred H. Barr, Jr. "Russian Diary 1927–28" *October* 3, p. 12. Entry for December 26, 1927.

2. Peter Burger, *Theory of the Avant-Garde,* Minneapolis, University of Minnesota Press, 1984, p.91.

3. Serge Guilbaut, *How New York Stole the Idea of Modern Art,* University of Chicago Press, 1983.

4. Boris Kagarlitsky, *The Thinking Reed,* London, Verso, 1988, p. 114.

5. Burger, p. 91.

6. Serge Guilbaut, "Preface-The Relevance of Modernism," in Buchloh, Guilbaut, Sorkin, eds. *Modernism and Modernity,* Halifax, Press of the Nova Scotia College of Art and Design, 1989, p. x.

7. Sergei Anufriev, "An Inspector's Statement," in *The Green Show* Catalogue, N.Y., Exit Art, 1990, p. 15.

8. Hal Foster, "Postmodernism: A Preface," in Foster, ed. *The Anti-Aesthetic,* Washington, Bay Press, 1983, p. x-xi.

9. Ilya Kabakov in an interview with Claudia Jolles, published in ICA Documents 8, *Novostroika/New Structures: Culture in the Soviet Union Today,* ICA London, *1989.*

10. Alex Melamid in "Talk of the Town," *The New Yorker,* April 24, 1989, p. 32.

11. Elena Izumova, *Ogonek* (USSR) "Breaking All Barriers," (trans. by Nicole Svobodny) July, 1989.

12. Boris Groys, *Durch,* Vienna.

13. Timothy Rylback, *Rock Around the Block,* Oxford University Press, 1989, N.Y.

14. November 2, 1969, WBAI-FM, New York "Art Without Space: A Symposium," in Lucy Lippard, *The Dematerialization of the Object,* N.Y., Praeger Publishers, 1973, p. 12–133.

15. Op. Cit. Ilya Kabakov in an interview with Byron Lindsey in ICA Documents 8.

16. Op cit., Sergei Anufriev in *The Green Show* catalogue, p. 15.

17. Dmitri Prigov, *Durch,* Vienna.

18. Eleanor Heartney, "Komar and Melamid," in *Art News* 88, October, 1989, p. 196.

19. "Vitaly Komar and Alex Melamid: Russian Artists in Bayonne," interviewed by Louise Kennelly in *Washington Review* 15, August/September, 1989, vol. xv, no. 2, p. 10–11.

On Conceptual Art in Russia

Joseph Bakshtein

In attempting from the very start to speak of conceptualism in Russian art it is expedient to explain that it has something in common with conceptualism in the West. This elucidation becomes all the more necessary because any breach in intellectual and aesthetic communication can result in a perversion or obscuring of the original meaning of a given concept. Such deviation cannot be escaped even by those groups in closed societies which maintain the positions of common sense vis–à–vis the dominant obscurantism. On the other hand, the unavoidable vagueness that arises in interpretation of terms and phemomena borrowed from other cultural traditions can be conscious. It appears that the simple acknowledgment of this is an adequate place from which to start to compare the two traditions.

These problems have a direct relation to conceptualism's first appearance in Russia in the 1970s when that country still presented itself as the model of a closed society. The term conceptualism, as used by Joseph Kosuth, quickly became popular at this time not simply due to the originality and depth of Kosuth's ideas, but also due to the fact that conceptualism expressed some very essential aspects of the entire artistic process in Russia. Later Ilya Kabakov was to note that "the word 'conceptualism' descended to us and we revealed in ourselves what we had long possessed and utilized supremely: it turns out we had been speaking prose for a long time."[1] Kabakov's remark refers to the fact that such important components of conceptual art as commentary, interpretation, or self-interpretation have long been inherent in Russian art.

The lack of a developed "hermeneutic homogeneity" and a tradition of working out a consensus in the making of political, as well as artistic decisions had contributed

to those conditions. This led up to the state in which exhibition organizers felt compelled to accompany given exhibitions with detailed explications, supposing that without these the public would not understand what they were seeing. The text-explications became equal in their meanings to the works of art, and in the Soviet period sometimes even surpassed them. Under such conditions, there was resistance to the notion of the autonomy of art and the power of the institution set the tone for the relationship, which was one of authority and subordination. The other side of this atmosphere of total violation of individual consciousness and thinking was that "the dictators, in accord with political necessity, found it necessary to delude the masses by lowering all culture to their own level."[2] The totality of explication was projected in the idea of the total citation, popular in Soviet conceptualism, and this idea in turn reflected a populist "imagination of power." Thus, the true goal of centralized explanation served to deprive the bearer of artistic language, through the system of double-thinking, of the right to be the subject of interpretation of his/her own impressions. Soviet conceptualism insists on the fact that in order to re-obtain this right it has to free itself from magic treatment of art language.

Yet another cause of the primordial conceptualism of Russian art lies in its ideological nature. What is meant by this is that the artist-ideologue performs a dual gesture: on the one hand he/she depicts reality, and on the other points out, via a delineated set of "markings," those various collective values which he manifests in the process. In such a schizoid position, the artist is hampered both in the preservation of his artistic identity, and the full formation of his artistic style. It is for this reason that in Russian art styles have often borrowed from or "creatively transformed" each other. In official art, ideological features were highly emphasized, and thus Andrei Monastyrsky's idea that "Socialist Realism is also conceptualism" is just. We have to remember, however, that what is demonstrated and implanted is not private or collective values, but governmental and official ones.

Curiously, in the seventies, ideologues had a ricochet-like effect on unofficial culture. Freedom from ideological choice did not exist; the social world was one of black and white contrasts because unofficial culture within which conceptualism emerged worked out a powerful counter-ideology.

The Sots artists, such as Komar and Melamid and others, initiated a movement of de-ideologization directed not so much at official art criticism (since there were not too many points of contact) as at religious and nationalist fundamentalism.

In these years even the existentialist problematics of Kabakov's work included a dimension related to social evaluations. This resulted in a condition in which in Russia the objecthood of art came into being neither in the form of a cultural tradition, nor in a mimetic relation to the world of things, but as reified social relations. In addition to the previously noted ideological nature of things, this perhaps happened due to the fact that the world of things in Russian culture is not elaborate enough, instead it is

discrete and does not dwell, as Spinoza would say, in a comprehensible world of ideas.

The aforementioned duplicity of the artist-ideologue's gesture forced conceptual artists to employ this duplicity as an artistic device. Particularly owing to the efforts of Ilya Kabakov and Monastyrsky, Russian conceptualists developed the concept of a dual aesthetic vision, combining in a single optic the gaze of the artist with that of his character. The latter also functions as a creator of these art works, becoming the author-character. In accordance with this, a range of artistic characters emerged within the framework of a conceptualist mis-en-scene. Komar and Melamid created some of the first of these author-characters: "Zyablov" and "Buchumov." Zyablov was offered as Russia's first abstractionist, who lived in the eighteenth century, whereas Buchumov was a *Peredvizhniki*[3] who for many years painted a single landscape against the background of his own nose. Kabakov, too, utilized the idea of the artist-character in his *Ten Characters,* and Monastyrsky, in conjunction with the author of this article, attempted in a sequence of dialogues, to imitate the mode of thought peculiar to the critic-conceptualist. The latter's central task was to camouflage, rather than elucidate his position, to make it non-identifiable with the position of the critic-ideologue, to escape into unidentified zones.

In order to successfully resolve this task, the critic-conceptualist had to deconstruct the pure form of Soviet art. How was this possible? Through a realization of the possibilities of the dual optic. Thus, Kabakov, appearing as a conceptualist who also functions as a critic, said, commenting on the work of Eric Bulatov, that he (Bulatov) had been able to reproduce the generalized, recognizable features of "Soviet painting." Bulatov performed it in the same way as one might reproduce the stylistic features of the Impressionists' painting. But the complexity of Bulatov's conceptual approach resides in the fact that he does not simply generalize the features of Soviet painting (which would be a simple analytical procedure) but actually paints them. This depiction must simultaneously include the following characteristics: concrete image, concrete visual sign, as well as the stylistic characteristics of official art. This is a typical example of how an artist-conceptualist creates the artist-ideologue as a character, and then within the horizon of his consciousness "by his hands" creates an art work. In precisely this manner reflective conceptualism deconstructs the naive conceptualism of Socialist realism. The task for artists like Kabakov and Bulatov was to construct representations which would be adequately understood by the Soviet viewer. At the same time the viewer was to distinguish the ambivalence of the gaze and discern the object of aesthetic investigation. The phenomenon of the dual optic thus comes down to the fact that complementing the plain gaze is the reflective gaze, which discerns in the plain gaze its existential and ideological horizons. In addition the latter gaze solidifies the structural peculiarities of ideological representation, or as Barthes would say, its type of "openly expressed linguistic regularity." Finally, this

Eric Bulatov,
*Two Landscapes
on the Red
Background,*
1972–74, Oil on
canvas

Eric Bulatov,
*People in the
Country,* 1976,
Oil on canvas

very same gaze creates a special version of ideological representation, in which, because of semantic displacements vis-à-vis the official canon, the erasure of linguistic regularity occurs. This results in the representation (or "text") which lacks an authorial, individualized flavor.

The suppression of the subject of representation, which leads to a surface absence of the Soviet brand of conceptualism, can be perceived as cliche. Its utilization of "prefab" elements aligns it closely with Pop art. As in Pop art, conceptualism refers to linguistic paradoxes and the gestalts of mass culture, where originality is replaced by an edition or a quotation. But citation, a frequently used postmodern device, is transformed in Russian conceptualism — into the idea of total quotation. The true hero of the work becomes visual language itself, its system of its signifiers and the figures of ideological sublimation ossified therein. And here an interesting circumstance arises. The conceptualist, "optical" deconstruction of official culture shows that, at base, "Soviet representation" possesses a designative rather than procreative function: it creates its own semantics, its own world which differs from the world as it in fact is. Here there is no presumption of an independent existence of the aforementioned world, nor is there the procedure of differentiation of the levels of its authenticity. In other words this representation presupposes the world as it should be in the eyes of the artist-ideologue. It comes as no surprise, then, that Stalin was seen in his time as the chief and sole artist-ideologue.

At the same time, Russian conceptualism has perpetuated such traditions of Western conceptualism as a "post-philosophical activity," which, as a practice, constitutes an investigation into the production of meaning in culture."[4] But insofar as this culture was ideological, the investigation of meanings produced within it required the invention of a completely new set of devices.

Such a set of devices was proposed by Sots art which is one of the versions of Russian conceptualism. As Margarita Tupitsyn has said, "Komar and Melamid borrowed from official myths, subverted them, and came up with a new set of cultural paradigms."[5]

In Sots art, the active presence of social themes and an aesthetic critique of Soviet-type consciousness signaled a new stage in the development of unofficial Russian art — one of increased freedom of the artistic gesture. Sots art was the first great style of Russian art capable of being understood within the context of Western art. Once again, Russian art was attempting to integrate itself into a broader, global context. But the acquisition of artistic freedom required more than just an aesthetic surmounting of the social. The appearance of Sots art, a form of aesthetic dissent, transpired within a context of political dissent (it was precisely this context which forced several of Sots art's founders to emigrate). However, both political and ideological critiques are not the sole aims of artistic practice. Art seeks out realms of existential, rather than just political, bondage. The fact is that political circumstances

can have an influence on man's existence and that is precisely what happened in Russia. Sots art was a relevant reaction to the hostile relation of politics to existence. And such a reaction became possible only in the seventies, not before, and not afterwards. Until 1953, aesthetic dissent was equated with political dissent, and its adherents were liquidated. In the sixties, independent groups emerged in unofficial art circles. Ideology and politics surfaced in this art, but only as objects for unmasking or exposure.

In the seventies official culture stagnated and then stabilized, systematizing itself as a language rendering an account of the broadest range of phenomena. Official culture could describe all but one thing — it could not describe itself. The only thing capable of portraying official culture was the reflective element operating within unofficial culture. But the question was how to carry this out, without falling into "invectiveness"; that is, how could an aesthetic position still be maintained? Sots art solved this puzzle. First, Sots art was a response not simply to ideology and politics, but to the texts of official culture. An ideological and political semantic arose only by virtue of its presence in these texts. The universal meaning of this gesture, its fitness within a Western art context lies in the fact that in any country there is the problem of the dependence of personalities on strong social groups. Second, Sots art developed aesthetic distancing devices. Here one can recall Komar and Melamid's *Stalin* series, where Stalin is not the object of angry philippics, but the hero of a reconstructed ideological myth.

Thus what is left for us is to clarify the specific character of Moscow conceptualism. For the seventies, this issue is more or less comprehensible. Carried away at this time by aesthetic dissent, its adherents criticized official culture by means of artistic devices. In this respect, it is logical here to specify the changes which transpired in the interrelations of official and unofficial art, the core of which consisted of conceptualists. A point of view exists now, which states that this distinction no longer exists, as the former antagonism in the realm of ideas has passed. But even if this is not the case, a stylistic antagonism remains, insofar as up to the present, official art has mimicked the real tradition of *peredvizhniki*, or else falls into unprincipled eclecticism. Aside from this, distinctions remain in the area and mechanisms of finance. Yesterday and today, official art was and is an art supported by the government, in the form, for example of sponsorship carried out by the Ministry of Culture, whereas unofficial art endeavors to support itself. Also, it is important to not forget that until only recently unofficial art was virtually illegal.

But what's taking place in the eighties? First, it should be noted that although political motives have changed form, they remain, and could not but remain, although they have no doubt weakened. This is happening not because conceptualism has become apolitical, but because its militant individualism does not allow it to enter into depersonalized political relations.

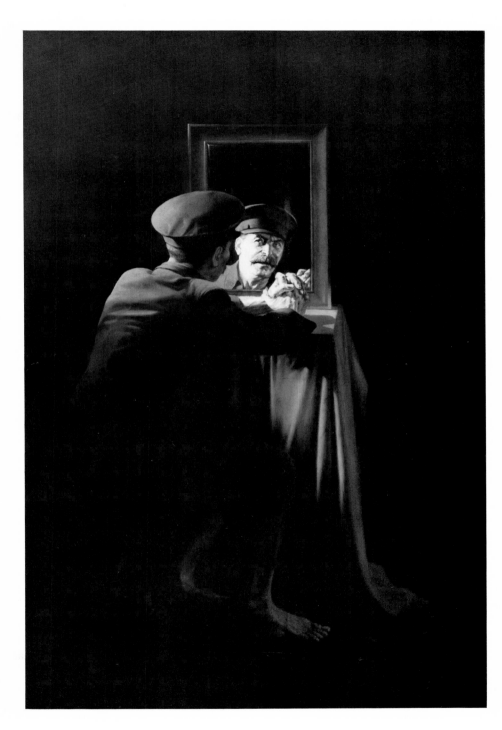

Komar &
Melamid, *Stalin
in Front of a
Mirror*, 1982–
83, Oil on
canvas

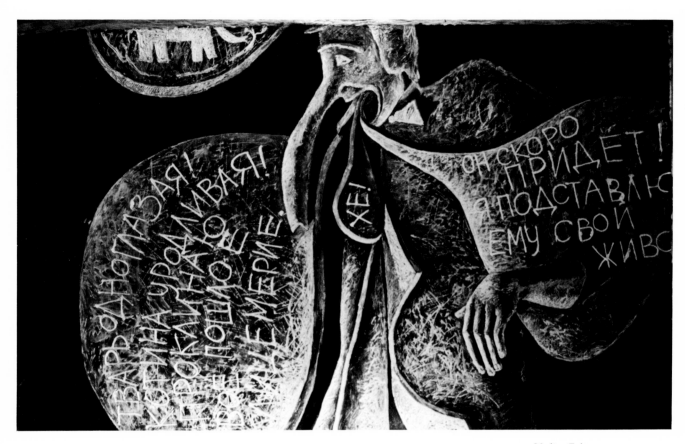

Vadim Zak-
harov, *B-Ua*,
1986, Oil on
canvas

In distinction from the seventies, conceptualism's object of aesthetic study in the eighties has become not the elevated language of a totalitarian "imagination at power," but language of the fantasy of "*homo sovieticus,*" be it Konstantin Zvezdochetov's soldier's folklore or the elephantesque personage of Vadim Zakharov. The space of the Soviet communal mythos, which the seventies' conceptualists reconstructed, became, in the eighties, closed, as if painted over with the paints which decorate city walls. Against this background, new worlds, themes, and subjects began to appear, losing their rigid, social evaluation. This phenomenon had already been utilized by Kabakov in his "Communal Series," where he polemicizes with the theme of "painting" as canonized in official artistic consciousness. Kabakov began to evenly decorate the background of his works with paints like those which adorned the walls of public places in the fifties. But in his case this color scheme fulfilled a direct, signifying function, referring to the class of existential situations towards which his "announcement boards" were deployed. Kabakov's students and followers decorate the backgrounds with similar images, but to different ends. Their works use axiologically neutral elements of the Soviet mass media system, and the contemplation of these elements evokes no deep existential associations. Sergei Volkov implemented this device of decoration of a communal perspective most expressively in his emblematic series in which representation truly becomes utterly flat and absolutely impenetrable by the eye. Some time back, Kasimir Malevich utilized a similar image, when he blocked, by means of his black square, the direct perspective of traditional European representation.

Margarita Tupitsyn at one time advanced the justified opinion that: "(the) priestly stance and the idea of endowing art with semireligious connotations (shared by Monastyrsky with Kabakov and Bulatov) in the early 1980s met with dissatisfaction from younger artists who instead wanted total involvement in 'real life.'"[6] Possibly this involvement, which resulted in a number of moral-psychological complexities caused by an "intercourse" with the Western art business under the sign of what Victor Tupitsyn called the "phallus of consumerism," has led to the current state of tremendous dependence by young artists on the ideas of the seventies' conceptualists. Be that as it may, it was in the seventies that fundamental aesthetic "thought-forms," which allowed Russian art to return to the orbit of the global artistic process, were developed. And this was accomplished by the conceptualists. Partly because of this, conceptualism remains the legislator of aesthetic modes in Russia, the most influential intellectual strain in Russian visual culture. The results attained by the conceptualists developed an ability to preserve (or obtain) degrees of freedom indispensable to any art. All this enabled Russian conceptualism to become a full-fledged movement, with its own history and continuity of ideas.

Translated by Clark Troy

Notes

1. From Kabakov's unpublished essay "Conceptualism in Russia," 1982.

2. Viktor Burgin, *The End of Art Theory: Criticism and Post-Modernity,* 1986. Burgin's idea is akin to Clement Greenberg's position expressed in his essay "Avant-Garde and Kitsch."

3. The *Peredvizhniki,* or Wanderers, were a school of nineteenth-century realist painters in Russia, the most famous of whom is Ilya Pepin (1844–1930).

4. Joseph Kosuth, "History For," in *Flash Art,* Russian Edition no. 1, 1989.

5. Margarita Tupitsyn, "Ilya Kabakov," *Flash Art* no. 126, February/March 1986, p. 67. and also her catalogue, *Sots art,* New Museum of Contemporary Art, New York, 1986.

6. Margarita Tupitsyn, "From Sotsart to Sovart," *Flash Art,* no. 137, November/December, 1987, p. 78. p. 172.

East-West Exchange:
Ecstasy of (Mis)Communication

Victor Tupitsyn

"Russian fatalism is exemplified by . . . the fakir who sleeps for weeks in a grave."
Nietzsche

"Nietzsche did not know that man's culture was advancing towards its adulthood."
Nikolai Fedorov

"Within advanced culture, every subject is pregnant with madness."
Peter Sloterdijk

The chronicle of the interrelations between the East and the West quite obviously establishes the fact of a contextual disjuncture, the presence of which — in some sense — compromises a utopia of "syntagmatic communication." The situation's piquancy inheres in the fact that each of the poles of the binary opposition in question (East-West) identifies itself with reality, attributing to its "negative twin" the features and manners of a phantasmic character. As a result, the topography of the dialogue between the Factual and the Imagined on the map of Soviet-American relations discloses the presence of a definitive gap leased — simultaneously — both by fiction and reality. Such an ambivalence — in the majority of instances — is hysterogenic, for it leads to collective psychoses. As far as the so-called "Soviet geo-political sacrality" is concerned, its "conspiratorial" context, in part, is construed in the West as the preserve of its own displaced desires and/or phobias, or as a receptacle of the Western

transindividual unconscious. This, an apparently anecdotal ideologeme, turns out to be not so innocent when subjected to more serious analysis. Firstly, the metaphorics of the "iron curtain" dovetails to no small degree with the combinatorics of "bars" demarcating the conscious and the unconscious. Secondly, the imperative to save the "reality principle" (as well as that of "sanity") influences the scenario of self-identification in such a way that preference, as a rule, is given to the "real" and the "conscious" (sane). Jonathan Culler terms this "the urgency of choice" between real or imagined events.[1]

However, one could scarcely find anyone who would seek to assert that the artistic mentalities of the East and West over the course of the last three decades were Siamese twins. Anyone familiar with the counterculture of the sixties and seventies could naturally have understood that at that time, while Soviet alternative art shared with its Western counterpart moments of formal similarity, the phenomena had little in common at the level of content.

When the lavishly reproduced icons of Western modernism (via the so-called "coffee-table books") began to surface in Russia, they were apprehended as things of extraterrestrial lineage. And this was not simply because modernism seemed at that time synonymous with progress in art, but also because, in distinction from the ideologically abused situation of official Soviet culture, which seemed to its opponents to be a form of divine punishment for previously committed sins, Western art was fantasized as a cathedral of eternal harmony, unsullied by politics and not subjected to decay. Thus, the aforementioned coffee-table books were felt by Soviet marginal artists to be on the level of Gospel; it seemed to them that one had only to follow all of these behests and commandments, these guiding lights and luminaries — and immortality would be guaranteed. In other words, Soviet nonconformists preferred the most modest place in the iconostasis of "genuine" and "pure" Western cultural tradition to the very highest pedestal in the pantheon of "false" and "unsterile" domestic art-situation. In the sixties and seventies a significant number of Russian artists began to orient themselves towards foreign buyers, exhibitions outside of the USSR, and publication in the Western press. To be a member of the state-controlled Union of Soviet Artists or embark on a career as a cultural bureaucrat ceased to be the sole means of attaining a "creative" reputation and an adequate standard of living, as had been the case previously.

As is known, Western modernism found its chief apologists in the critics Clement Greenberg and Michael Fried. Recalling Lessing's warning on the subject of incest between the verbal and the visual, Greenberg published his famous essay "Towards a Newer Laocoon," in which — alongside an advocation of the "myth of originality" of abstract painting — the spectre of literalness in fine arts was subjected to an exorcism (the expulsion of demons). As far as the Greenbergian model is concerned, culture polarizes via the principle of the binary opposition: avant-garde/kitsch. The second category is what (according to Greenbergianism) Socialist realism aligns itself

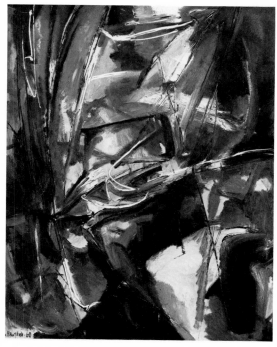

Lidya
Masterkova,
Composition,
1962, Oil on
canvas

Vladimir Nemu-
khin, *Untitled*,
1960, Oil on
canvas

Mikhail
Shwartsman,
Composition,
1969, Oil on
canvas

Vladimir
Nemukhin,
Composition,
1965, Oil on
canvas

Eduard
Shteinberg,
Composition,
1976, Oil on
canvas

with. In Socialist realism one notes even more of the chimerae of representation which Fried marked as taboo, theatricality. However, the situation is (or rather, had been) considerably more complex. And the point isn't even that both avant-garde and kitsch are subject to the law of interreversibility: both of these poles dovetail in their shared zone of psychodrama. Both Greenbergian modernism and Zhdanovian realism, acting — each within its own borders of corporeality of communal speech — as the dominant-repressive formulas of cultural life, become coterritorialized regions of the so-called "discourse of the hysteric." In this respect one may even suggest that modernism and Socialist realism are Romulus and Remus, reared by the one and same she-wolf.

Returning to the problem of the external similarities between the experiments of Soviet unofficial artists and the museo-commercial shrines of Western modernism it is logical to note that borrowing appeared, first and foremost, on the level which Roland Barthes connects with "primary signs" [for Jean Baudrillard this is the Eldorado of the simulational virus ("first-order simulacrum")]. A difference is realized, as a rule, on the register of secondary signs, or in the space of signification, in relation to which "primary signs" play the role of the signifier. Barthes defines the articulation of secondary signs as "mythical speech." Here one and the same visual stereotype, in the case of a contextual disjuncture (rupture) can turn out to be a platform for dissimilar literary, philosophical, and religious-mystical connotations. As a result of several exhibitions of Western art, and also the stream of coffee-table books at the end of the fifties and the beginning of the sixties, Soviet artists suddenly began to study the Abstract Expressionism of the New York school or meditate on the origin of color and form in the traditions of Cézanne or Bonnard. The result turned out to be somehow utterly estranged from its wellspring, both on the plane of authorial intentions (a "new" signified), and on that of significations. The point is that local "avant-gardists," having armed themselves with the signifiers of Western modernism, did not realize why and in what circumstances such signifying practices arose and in which myths they were utilized as raw material. Evidently, the longstanding cultural isolation of Russia explains why the polemic in art and about art (vis-à-vis its "other") consequently materialized in the form of this or that " politics of representation" which served as the vital context and living history of Western visual culture from the twenties to the eighties remained for Russian artists something incomprehensible, vague and/or inessential. The very idea that artistic principles were ephemeral and that yesterday's inarguable truth might tomorrow turn into a mistake, extravagance into banality, radicality into reaction, and that seriousness had a chance of becoming an object of ridicule, appeared at these times blasphemous.

For Russian artists all modernist styles and schools seemed to exist simultaneously, their founders seen as not unlike personages of some idyllic group portrait resembling Raphael's *School of Athens* (as if no contradictions, possible revisions and/

or alterations existed). Estranging itself from the culture of Socialist realism with its claims to finality and a stable heirarchy of dead and living leaders and heroes, the non-conformists nevertheless projected exactly the same utopianism onto a stratum of Western socio-cultural practices. Insofar as alternative Soviet culture of the sixties and early seventies is a land of embryonic significations, researchers of this period have either endeavored to "read into" unofficial art a heteroglossic (or belonging to another temporal context) "mythical speech," or have attributed to it the versions communicated (to them) by the authors themselves. In this regard, one may try to investigate the alchemy of the choice of an authorial hermeneutical gesture. In the majority of cases the artists chose to interpret their own work as a manifestation of the sacred, a variety of the icon, an index pointing to a path to the spiritual world. In a word, it is that which belongs to the sphere of an "authorial ideology" of the type characterized by Theodor Adorno as the "ontologization of the factual." Besides, the nonconformists believed that the contents of their reverie of true art corresponded to the "signifieds" that their Western colleagues had in mind. It follows from all of this that an interpretation of the works of Soviet oppositional modernism should be appre-hended as nothing other than interpretations of interpretations, exegeses of exegeses and so on. This in no way lessens the significance of the artifacts of the post-Stalin underground. On the contrary, it imparts to them a more interesting — from the point of view of contemporary theories — perspective. The problem lay in the inade-quate comprehension of that period, in the attempt to pass it off as something other than what it, in reality, was; in the hullabaloo concerning the "myth of originality" to the detriment of other horizons or other coordinate systems.

It seems that the insistence on imagined significations at the expense of negat-ing factual ones, is characteristic not only of marginal Soviet art, but of modernism in general. However, alongside the spectre of institutionally and socially controlled signi-fications there is another aspect of note, namely, that of a transgressive, creative meaning, which Julia Kristeva links to the notion of "*signifience.*" Taking into account the inadequacy of the interpretations of Western art-production on the part of Soviet artists of the sixties at the level of signification, it would be uninteresting to see how precisely their intuition operated within the diapason of "*signifience.*"

But if the latter were able to obtain a one-hundred-percent translucency in the rays of the nonconformist exegesis, than such magical act of a de–signification of Western mythical speech should logically be understood as a variant of the "unbodily transformation" of which Deleuze and Guattari have written. But if one believes their antagonist Jürgen Habermas, the culmination of this utopian detour would be the so-called "ideal speech situation."

There is no doubt that the aberration spoken of above was present as well in the time of cubo-futurism: the conflict with Marinetti during his visit to Russia in 1913 bears witness to an inadequate *a priori* interpretation by the Russians of the "mythical

aura" of the Italians. (However, the same reproach might be directed just as well at Marinetti.) As applied to the alternative Soviet culture of the sixties, the phenomenon of aberration, when traced through the framework of Derridean notions such as "spacing" or "*différance*" on the plane of the study of paths of correlation (and of the inverse connection) of art to itself — still awaits its students.

In Fellini's film *Amarcord* there is a scene in which the inhabitants of a provincial seaside town find out that on the following night, an American superliner is scheduled to pass within a few miles of the shore. In order to see this, the residents set off in boats into the open sea, where in the outer darkness there appeared before them a sumptuous, twinkling giant, which at that moment — like a ghost — disappeared, having dissolved into the night, in the eyes of the spell-bound spectators (too beautiful for its reality to be believed). This allegory, similar to a hallucination, recalls the spirit of the late fifties and early sixties, when before the eyes of the nonconformists the magic ship of modernism arose. Other anomalies of those years also yield to discussion in terms of aberration, in particular that of contact with foreigners.

One remembers the enthusiasm with which foreign diplomats and journalists accredited in the USSR related to "dissident modernism," buying works and providing the coverage that appears in the Western press. This simulation of the Western art-infrastructure in a Socialist environment gave birth to a host of unforeseen problems. One of such problems had to do with an addiction (on the part of the artists) to "a sort of 'Cinderella Syndrome,' an expectation that the West would turn into a fairy-tale prince appreciative of their devotion to true art. Thus some of them became bitterly disillusioned when after emigration they realized that most art dealers, curators, and critics had no such interest in, or knowledge of, their production."[2]

Besides the phenomenon of splitting between the basis of locally produced non-Socialist realist art and its superstructural referents (residing beyond the "iron curtain") the list of the side-effects also includes the trauma caused by the alienation of the author from his/her homegrown creation doomed to an exclusively foreign consumption. All this becomes even more dramatic as one remembers that the West — in the eyes of the Soviets — has always been a fairy-tale land. Thus, "our" acquisitions of "their" art could be seen as a reciprocal gesture: fantasmic referents buying back their out-wed reifications. It seems appropriate to refer the above-mentioned psychodrama to the Lacanian discursive system:

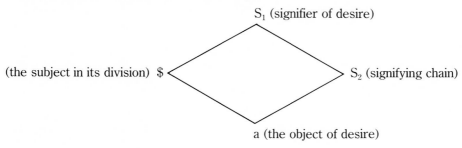

S_1 (signifier of desire)

(the subject in its division) $\$$ S_2 (signifying chain)

a (the object of desire)

According to Lacan, the discourse of the hysteric can be described as follows:

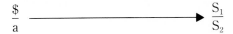

$$\frac{\$}{a} \longrightarrow \frac{S_1}{S_2}$$

What matters in such a formula is the primacy (position above the bar) or subordination (position below) given to the subject in its relation to desire. In the case study of Soviet dissident modernism, primacy should be given to subjectivity ($\$$). The object of desire (a) overcoded by hieroglyphics of hysteria was, in fact, a mirage whose "retreated origins" were kept beyond the "reality principle." Despite its ephemeral societal standing the alternative signifying structure (S_2) of that period ardently supported the primacy of the signifier of desire ("desire to desire").

As far as the "enlightening" mission of foreigners in Moscow, the fact is that, alas, with rare exceptions, these people had only vague notions of the actual artistic and socio-cultural issues and problematics of vanguard art in their native penates (in their own countries). The entirety of what makes up the critical consensus of the time did not fall within their purview. All they could offer their Russian friends in the guise of "Kulturtrager" were the same coffee-table books or catalogues of "block-buster" museum shows. In other words, they offered that which had already become synonymous with money and was equivalent to a capital investment. The radical tendencies of American and European artists and their contextual referents proved to be beyond the reach of these types of catalogues and publications. Thus, the nonconformists accidentally identified themselves not with marginal activity and not with the creative gestures of their Western contemporaries, but with "ascendant" culture, assimilated (tamed) and, in the final analysis, endorsed by the Establishment. As a result, Soviet alternative artists, while remaining in opposition to domestic officialdom, without suspecting anything, served as apologists of the Western (corporate)[3] cultural Establishment. This latter circumstance to a certain extent explains the unfavorable reactions of leftist critics to exhibitions of the nonconformists' work abroad.[4]

Professional criticism (i.e., articles and reviews in art magazines) on the occasion of Russian openings in America and Europe has been a rare enough phenomenon. On the other hand, a significant number of Sovietologists and Slavicists, lacking in any theoretical, artistic and critical experience have contrived with invariable aplomb to write on unofficial artists (moreover, for the most part, in publications having an illusory link to art). Their unqualified "aid" to Russian culture, together with their mystical interest in it (something which might be qualified as a manifestation of Orientalism), is one of the paradoxes of the epoch of détente.

Some think that this has deep roots insofar as various comments on Soviet art after 1930 have been lodged in Orientalist discourse. For whatever comes from Russia along the lines of cultural exchange is usually treated as a test tissue of some sort of metastasized narrative, which in accordance with Western (occidental) academic wisdom continues to be "diagnosed" in annoyingly descriptive fashion. In this respect,

one may quote Said's remark that Orientalists' arguments are usually "presented as emanating exclusively from the scholar's impartiality underwritten by a zealotry."[5]

In fact, even as far as today's situation is concerned, the excitement — "emanated" from abroad — about perestroika could be accounted for as a relapse of Orientalism. Gorbachev's Russia has become, from the point of view of the foreign seeker of acute sensation, an object of sublimated "desires," fantasies, self-deceits, and so on. The demystified historical East, saturated by tourism, ceased being associated with the idea of "adventure" and intrigue a long time ago. In short, the USSR under glasnost appears to be a post-industrial paradigm of the Orient.[6]

Speaking of Orientalist ventures, one should also discuss the "success" of the Sotheby's auction in Moscow, which — to a naked eye — seems completely dreamlike, because if Sotheby's were not a reality, then it would have to be seen in a dream.

Normally, such institutions are not meant to create prices. The latter are supposed to be legitimized and stabilized through the auction sales. What happened at the Sotheby's auction is in no way connected to the real state of affairs in the art world. Almost everything that was "sold" at this auction in point of fact (due to the absence of a Western market for the local art) did not possess an "exchange value." Rather, it had to do with what Marcel Mauss called "symbolic exchange" (potlatch).

In its ostensible definition potlatch is identified with the ritual of presenting and accepting gifts (totems), inseparable from a "referent," or from the pair "giver-receiver." On this plane, everything towards which potlatch gravitates follows "the logic of sacrifice." As they become inveigled in potlatch, the Soviet artist and the foreign acquisitor of his art perform a joint act of immolation: the first brings an artifact to sacrifice, the latter brings money, which ceases (in that moment) to be a sign, thereby losing its semiotic function, but — in exchange — acquiring a symbolic dimension. On account of the absence (in the West) of a real market for Soviet artistic production, it is almost impossible to resell the purchased works, "desymbolize," or create for them a semiological equivalent in the form of "exchange value."

In other words, neither the money, nor the artifacts are (in principle) returnable, supplantable, or replaceable. One may say of such a situation that it is "asemiological."

But on the other hand, such a sudden eruption of the Symbolic into the realm of the art-infrastructure may be perceived as an accelerating factor, a metaphor, rife with new opportunities for Soviet art sales abroad. Of course, if one chooses to rely on a strictly diachronic model for the development of an artist's career regarding the prices on his/her works, etc., then the chances for the Russians to win the U.S. or the European art-markets are, indeed, very slim.

However, let us return to a discussion of the earlier period. Changes appeared in the seventies with the entry into the arena of a new generation, who (as had also been the case before) stimulated the centuries-old conflict (problem) of fathers and

children. The paradigmatic perspective of this collision, its "incomparable comic and grotesque features" (in the words of Friedrich Schlegel) indicated (alluded to) the uncertainty of "eternal life" in art. After all, if the religion of the fathers becomes outdated, then sooner or later that of the children will fall victim to the opportunism of the grandchildren. Thus, the dialectic of Western modernism's cultural experience turned out to be (at long last) assimilated by the Russian artistic mentality. Russian Pop art, Russian minimalism, and Russian conceptualism (performances, texts, visual poetry, photoconcepts, conceptual albums, etc.) all arose practically overnight. Which is to say that the styles which developed in the West in one or another chronological or culturological order (diachrony) acquired, in Russian soil, a status of simultaneity (synchrony). Bakhtin refers to this type of phenomenon as the "Dantesque Chronotope" (the chronotope of vertical time).

One characteristic feature of this period is that, in comparison with the "fathers," whose signifiers were museum antiques, the innovations of the "children" had quite a bit in common stylistically with the experiments of their Western contemporaries. The similarity, naturally (owing to the embryonic character of the social in the Socialist environment) did not affect the register of significations. On the level of the signified, as before, a gravitation towards the sacred (or, more precisely, towards provocation of the sacred) remained something like a moral imperative. However, the paths by which such a gravitation manifested itself entered a zone of the more highly refined modus of the "ontologization of the factual." But there were also exceptions — for example, Sots art. At the moment of its entry into the arena in 1972–3, Sots art was characterized by its striving towards a break with the familiar tradition of the borrowing of signifiers from the arsenal of visual clichés of the Western cultural heritage. In the search for new "intertexts," the choice fell to Socialist realism. As far as significations are concerned, Sots art's appropriation of the ideological and stylistic stereotypes of official Soviet culture transformed wholly into those very same Schlegelian "incomparable comic and grotesque features" with all of the carnivalesque manifestations of a Dionysian sensibility peculiar to this first postmodernist "project" in the history of Russian art. The revolutionary aspect of similar anti-Westernism had its precedents in the history of Russian pre-World War I avant-garde. One has only to remember Natalia Goncharova and Mikhail Larionov who turned to domestic popular culture and religious imagery in order to desimulate Russian art and to break up with the post-Petrovian tradition of the habitual counterfeiting of the "other" (i.e., the West).

If, following Greenbergian doctrine, we consider Western modernism and Socialist realism to be "contraries"(S and − S), then Soviet dissident modernism and Sots art fulfill the functions of "subcontraries" (− \overline{S} and \overline{S}). The diagram presented here illustrates the interrelations between the "historical-cultural agents" in question:

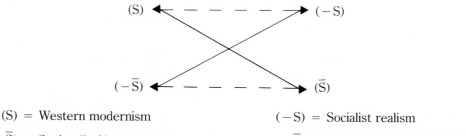

(S) = Western modernism (−S) = Socialist realism

(−S̄) = Soviet dissident modernism (S̄) = Sots art (Moscow period)

In this case one may identify the so-called "neutral term" with Soviet postmodernism (which includes, besides Sots art, Kabakov and Collective Actions of the late seventies, Apt art, the "Nome," etc.). That which is called "the complex term" oscillates between Fascism, corporate control of culture, and national chauvinism (a good example of which is the PAMYAT Society in the USSR).

Sots art was studied and theorized as a movement by Margarita Tupitsyn. Therefore, in the current survey I would like to focus not on the mastery of "new" hermeneutic horizons, but on a critique of Sots art. Moreover, it would be interesting to discuss Sots art in terms of the strand of it associated with Erik Bulatov.

Bulatov's oeuvre includes, among other paintings, his Sots art work called *The Sun Goes up or the Sun Goes Down* (1989), in which a giant representation of the Soviet state emblem is either rising from, or falling into, a naturalistically painted blue ocean. Such ambiguity should be seen as a double allegory: the rise and fall of the Soviet Empire. As far as psycho-ideological contents embedded in this imposing composition are concerned, it becomes all the more transparent when one analyzes Sots art's narratives plotted around the libidinal set-ups of a communal world-picture. This appears to be related to a number of reasons.

In speech-oriented cultures (like that of the USSR) the visual is repressed by verbal practices. This logocratia, traditionally durable in Russia, results in the phenomenon that an art-work turns out to be — in a literary (rather than Lacanian) sense — structured like language, serving as a mouthpiece of the corporeality of a spoken kitsch. The latter's pillary is so immense that it becomes hysterogenic, causing its supplement (i.e., the visual) to function as a psychedelic agent of the communal ethos.

Most Sots canvases are haunted by this psychedelic imagery. They present striking testimony which eloquently reflects the USSR's socio-cultural psychodrama. Looking at Komar and Melamid's representations of Soviet leaders or at Bulatov's hallucinatory depictions of ideological reality, one cannot escape the sensation that all these icons — despite their subversive appearance — incarnate one and the same referent: the pathos of communal speech.

Although *The Sun Goes Up or the Sun Goes Down* happens to be a manifestation of Bulatov's deconstructive powers, it places under erasure the ends rather than

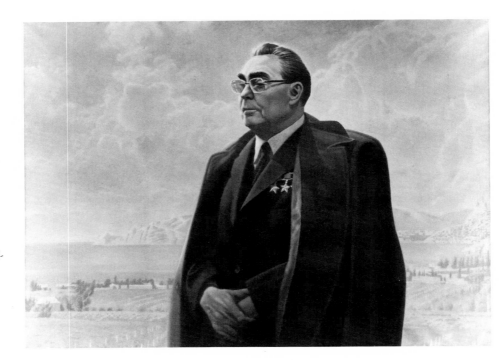

Eric Bulatov,
*Brezhnev in Cri-
mea,* 1981–85,
Oil on canvas

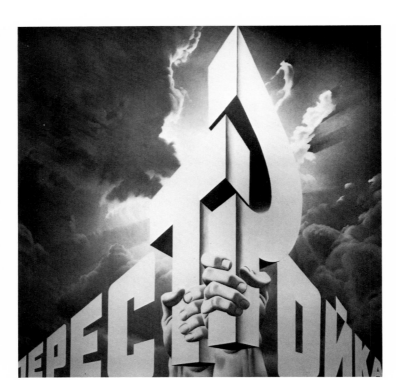

Eric Bulatov,
Perestroika,
1988, Oil on
canvas

the means, whereas *Perestroika* (1989) is aimed at exposing the very core of the Soviet will to myth-making. In both paintings an erotogenic gestalt of a utopian space of desire is re-coded into hysterogenic dystopia. This kind of unbodily transformation is, however, lacking in Bulatov's New York themes (skyscrapers, etc.). The artist's cogito "I live = I see" is apparently more applicable to "the what" than to "the how" of seeing which continues to be phonocentric and logophilic. Adapting Peter Sloter-dijk's interpretation of Nietzsche's *The Birth of Tragedy* one may suggest that the ultimate separation between Socialist realism and Sots art occurs when Dionysus encounters Diogenes, that is when the latter's individualism confronts the former's will to break the chains of individuation. This results not only in the "kynical" wisdom of Sots art, but also in its "drama of madness."

Aptart (a series of apartment exhibitions in Moscow in 1982–4) happened to be the next (following Sots art) postmodernist strain of which it made sense to speak in terms of a "movement." Despite the fact that there had been apartment and studio shows earlier, to exhibit under the aegis of Aptart became a style, and not simply a "grudging necessity," as had been the case in the sixties and seventies.

Graffiti and "Santa Claus aesthetics" together with a subversive appropriation of the accessories of the Soviet communal quotidium (transformed into schizoid part-objects), plus an immeasurable carnival energy was the baggage of this Soviet variety of the New Wave. As an elemental protest against the intellectualism of the early conceptualist activities of Kabakov and Monastyrsky, the new movement took upon themselves the same role that humor, according to Kierkegaarde, played in relation to Romantic irony.

From the Greenbergian point of view Aptart can be qualified as the apotheosis of kitsch. The Aptartists themselves are typical examples of what the Moscow philosopher Mikhail Ryklin diagnosed under the rubric of the notion of "peasants in the cities." But, after all, without this (in the absence of any centripetal adventurism) marginalia would have remained marginalia and the center would have remained the center, which would have led to the total oedipalization of culture, to the impossibility of its de-centering, democratization, and renovation. In other words, the Bakhtinian "two-world condition," staged on the boards of the confrontation between avant-garde and kitsch, is the guarantor of the normal ecology of culture.

The death of Aptart in 1984 was violent: the authorities accused the artists of participation in pornographic activities. However, the movement was able not to be disintegrated, and has been reborn under glasnost. The association of the residents of the *Furmanny* Lane Studios has become the new paradigm of Aptart. The most recent event connected with this phenomenon was the open-air exhibition in New Jerusalem (outside of Moscow) in August, 1989: the exposition (scarcely as radical in the epoch of perestoika) should be interpreted as a type of sentimental gesture towards that which in Brezhnev's time served as a formula for cooperation and mutual

Mukhomory
Group, View of
installation,
1982, Aptart
show

Andrei Filippov,
*Aroma of the
Steppe,* 1982,
Aptart show

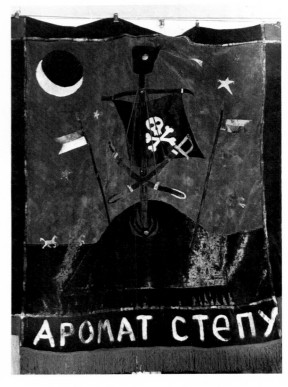

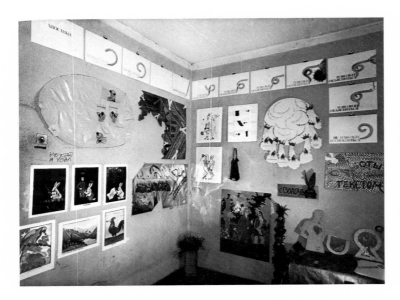

Installation by
Odessa Artists
Exhibition in
Aptart space,
1984, (Show
included Sergei
Anufriev, Jurii
Leiderman, the
Peppers and
Larisa Zvez-
dochetova)

sympathy between alternative artists (who have become newly addicted to the opium of commercialism).

At the same time as Sots art archaeologized the heritage of Socialist realism, Aptart was able to do just the same thing in relation to the alternative culture of the sixties and seventies. Both of these metaphors, in the final analysis, led to the emergence of what Michel Foucault termed an "archive." The latter provided the artists with the stratum of intertexts as well as the means of "multiplication of meanings," in the absence of which culture becomes an M.D.P., a canary cage for involuntary artistic twittering.

The use of the idea of the M.D.P. (manic-depressive psychosis) in the preceding sentence was not accidental. In connection with the new economic conditions accompanying perestroika and, in particular, with the reckoning of the possibility of the sale of works of art for hard currency, a question arises, concerning the collective mentality of alternative culture. Understandably, alongside the therapeutic aspects of perestroika, various psycho-pathological side-effects might come into play as well.

When a deviation occurs in the relation between infrastructure and superstructure, the resulting abyss inevitably influences "production forces." This in turn leads to a psychodrama in which the gap in the collective unconscious begins to fill up with psychotic hallucinations. But unlike in the previous decades, the plot of such hallucinations now takes the form of an "incarnation" of alienated infrastructural referents. The latter, in the case of the Soviet visual culture of the late eighties, are marketing factors of the Western art business which are still problematic in the USSR. Significantly, both in the West and the East the important role in today's art life is awarded to the commercialization of art (the phallus of consumerism). However, seen in context, these differences make for an interesting analysis.

Looking at the canvases of those who do not belong to the neo-conceptualists' circle, one becomes aware of the psychedelically commodifiable appearance of most works, which result from allusions of the local artists to the codes of Western consumerism. This psychosis is exacerbated by the fact that the reliance of contemporary Soviet art on sales abroad led to the unfolding of the aspects associated in the West with the hyper-commercial pastiche of "corporate aesthetics." Needless to say, in a Socialist environment such mimicry cannot be accompanied by the presence of the corresponding infrastructural conditions. In other words, this is the reversed cycle of splitting between the Real and the Fabled, manifested in the form of an alienation of the superstructure which is now there (in the Soviet Union) from the Western art infrastructure (i.e., galleries, dealers, art press, etc.).

An increasing number of Western artists — from Bacon and Rauschenberg — to Gilbert & George are becoming engaged in exploring Soviet exhibition spaces. Perhaps, Walter Benjamin's dictum regarding the annihilation of "the aura of the work of art" has resulted in an Orientalist belief that the East might soon become "rediscovered" as a new aural space for American and European art. Likewise, the Soviets

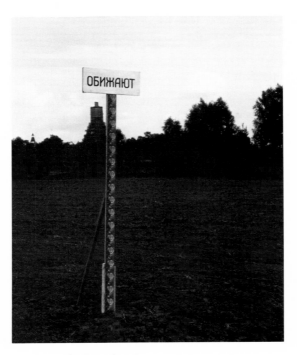

The Open Air Show in New Jerusalem (near Moscow), 1989

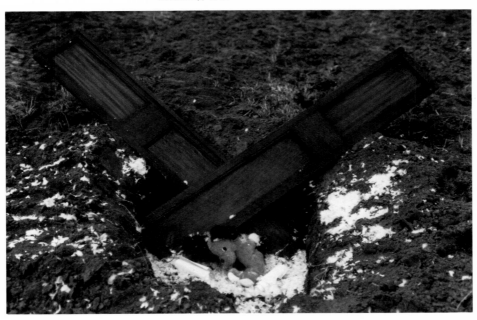

still tend to idealize (auralize) the West as an ultimate preserve of everything that they have been denied at home.

The above mentioned notion of a "neo-conceptualist circle" is indissolubly linked with the artistic career of Ilya Kabakov. In the interview I did with Kabakov in the beginning of 1990 he said: "As a child I felt like a personage of one of the Baron Munchausen stories: a fox who jumped out of its skin and ran away." Due to this narrative the subsequent journey of a "naked man" could be viewed as the artist's never-ending struggle to repossess his "original" skin, "the retreat and return" of which is the main intrigue of his entire oeuvre. Kabakov's installations can be interpreted as acoustic structures through which one may listen to the author's inner voice (which, in Bakhtin's opinion, acts as a surrogate of the unconscious). This "voice" is possessed by a passion for telling stories of an autobiographical nature, impersonating, through these narrations, legions of characters, populating a labyrinth of both personal and collective memory.

An example of this is the story of a man "who lives in a very crowded communal apartment and carries out various graphic tasks for the ZhEK (housing committee), which he does in the 'Red Corner' (the 'altar' spot of the ZhEK). He drew the schedule for the 'Universal Order, Rules and Regulations,' but gradually began to be tormented by the fact that he doesn't meet the deadline. Going crazy, he starts hanging up his clothes on all these schedules and regulations that he has drawn himself. Finally, as attested to by 'witnesses,' he runs from his Red Corner naked."[7]

As far as the above narrative is concerned, one can unmistakably trace it back to the artist's past: the re-run of the fox-tale as yet another cycle of flowing out of context, the satrap. The ideologically abused "skin" is peeled off to be buried in oblivion, for a new "search" is about to take place.

Speaking of Kabakov's circle of neo-conceptual artists (known as the "Nome"), and specifically of the Collective Actions group (Andrei Monastyrsky, Nikita Alexeev, Georgii Kizevalter, Sergei Romashko, Nikolai Panitkov, Igor Makarevich and Elena Elagina), one should not overlook one important characteristic of these artists: if, during the mid-1970s they fit within the framework of what Habermas called "the uncompleted project of Modernism," then, by the end of the 1970s and throughout the 1980s, their discourse fully assumes the character of the schizoanalytical enterprise. This caught on in Moscow through the efforts of Andrei Monastyrsky, author of *Kashirskoye Shosse* (Koshirsky Highway), a schizoanalytical novella for which the primary source (or, to be more exact, the impulse) happened to be the author's own psychedelic experience. The other source is, of course, Deleuze and Guattari's *Anti-Oedipus*, translated into Russian in the beginning of the 1980s by Mikhail Ryklin. Monastyrsky was also the first to unite "schizo-politics" with Oriental *Gedankenforme.*

Regarding schizoanalysis, it's worth mentioning the Medhermeneutics (Sergei Anufriev, Pavel Peppershtein, and Yuri Leiderman), who in their texts and perfor-

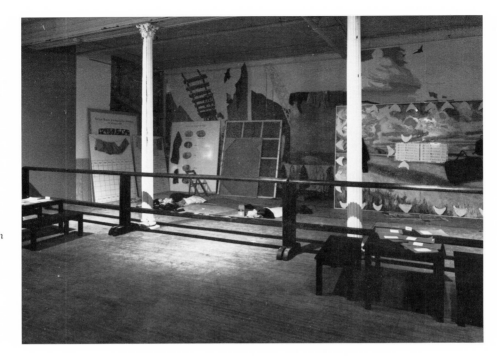

Ilya Kabakov,
*He Lost
His Mind,
Undressed, Ran
Away Naked.*
1990, Mixed
media

Ilya Kabakov,
*He Lost
His Mind,
Undressed, Ran
Away Naked.*
1990, Installa-
tion detail

mances "prostrate themselves" to the idea of schizo-China and theorize most productively in this context, expanding the field of articulations "cultivated" by Monastyrsky, in order to schizophrenically escape to what they call "the Unknown" which — in a sense — bears resemblance to the Imaginary or — for that matter — the pre-Oedipal.

As an epistemological instrumentation indispensable for the detection of the Unknown, the Medhermeneuts have proposed a strategy of "inspection." Sergei Anufriev recalls: "Some time before this denomination (i.e., Medical Hermeneutics) appeared, we led mutual conversations and recorded them on tape. In these conversations we unexpectedly came across an aesthetic category called "inspectivity."[8] According to Anufriev: "To interpret the emptiness as ontological "nothingness" seems pretentious. From a definitional point of view, there is NOTHING we can say about "emptiness."[9]

This sort of deduction is symptomatic, insofar as it seems not only to be a "figure of inspection," but as a form of revision in relation to the positions formulated by Kabakov in his tractatus, "On Emptiness" (1982). Speaking of the latter, one may conjecture that the naked man's trauma related to his abandoned (empty) "skin" contributes a great deal to Kabakov's treatment of the aforementioned concepts of "emptiness" and "nothingness."

To all appearances, the popularity of Kabakov in Moscow's conceptual circles can be explained not only by the seductiveness of his creative method, but also by the fact that he has never run away from cooperation with young artists. Thus, for example, in the course of a few years, Kabakov regularly attended the rural performances of Collective Actions (CA), not limiting himself to being a spectator: his typewritten commentaries serve as a component portion of the five-volume *Country Walks* (as the collection of texts and photodocumentary materials, gathered by the CA group from 1976 through 1990, is called). Together with Monastyrsky (and later also with Joseph Bakshtein, Pavel Peppershtein, and others), Kabakov tape-recorded a great number of conversations dedicated to the discussion of urgent socio-cultural and theoretical problems and exerted an indubitable influence on the evolution of the Nome.

Monastyrsky, however, must be given credit for having been able to direct Kabakov's narrative vulcanism into the channel of theory. Without this aid, such conceptions as a Kabakovian school and Kabakovian discourse would scarcely seem so inarguable today.

Whereas cogitations on contemporary Russian art on the part of the majority of critics (both local and foreign) relate to the object of their exegeses according to a paradigmatic principle, Monastyrsky, Kabakov, Bakshtein, Ryklin, and the Medhermeneutics have been able to create an "internal language" of describing the Nome: a metasystemic approach of a type in which the subject and object of description in fact coincide.

Collective
Actions, *The
Russian World,*
Performance

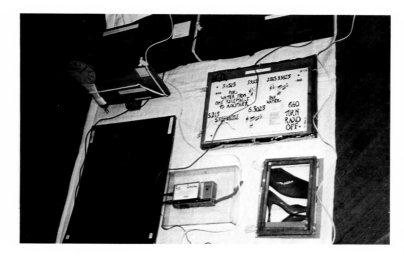

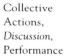

Collective
Actions,
Discussion,
Performance

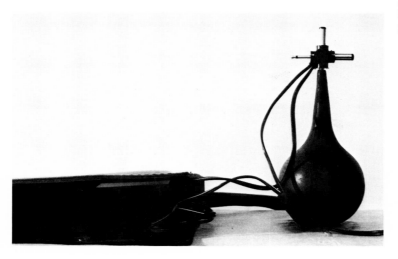

Unlike Moscow artists those who live in Leningrad frequently admit their "loyalty" to the legacy of the historic Russian and Soviet avant-gardes. Leningrad painting differs rather strongly from its Moscow analogue in that transgressivity of artistic gesture remains important in this "city of the three revolutions." According to Sergei Bugaev (Africa) and Timur Novikov, "this revolutionary character (which is not too harmonious with well-tempered representations) continues to preserve itself [on the Banks of Neva]." Another issue worth mentioning is what might be seen as an unfair criticism that exists in the heterosexual Moscovite "Nome," apropos of the art of the homosexual Leningrad "Nome." There is a certain "common" notion that Leningrad art as opposed to the Moscow neo-conceptualists, is meatier, more indissoluble, less reflective. Had it been the case, it would definitely be a paradox, since in the West marginal practices such as feminism and homosexuality are attended by a high level of discourse and theoretical study. Apparently, to be an alternative artist and at the same time a homosexual in the USSR, that is to experience double "otherness," is twice as difficult. It's a kind of a nightmare of multiple alienation (polycastration) constituting a psychedelic ghetto inhabited by obsessive and emotionally charged visions and/or narratives which makes it very problematic to transgress to discursive levels. (Incidentally, Mikhail Ryklin and Sergei Anufriev have written rather interesting theoretical texts on this theme)."[10]

In conclusion I would like to describe one of the most recent performances of the Collective Actions group, which took place in Moscow's Sokolniki Park in August, 1989. As usual, the longest portion of the production turned out to be the one-and-a-half-hour-long stroll in the direction of the "place of the action." It was necessary for all of us, both viewers and participants, to walk at a considerable distance from one another until such time as we (in a manner similar to that of Dante at the very beginning of the *Divine Comedy*) "found ourselves in the murky forest," at which time the organizers (authors) through us to the will of fate. Nevertheless, after some length of time we were able to witness a certain mysterious twinkling — in all probability — about three hundred meters away. A half hour later, having received permission to move forward, we, at long last, approached the epicenter of the events, and discovered (there) a polyethylene tent, inside of which a lantern burned, shedding light on the round space below it. In this arena, blinking with fires, two toy jeeps drove around, incessantly bumping into one another and giving off indistinct sounds. As a whole, the hallucinatory *mise-en-scène* described above can be read as an allegory of the transplantation of the u-topos of Western consumerism into a principally *a-topique* situation, moreover, by precisely the same device according to which codes — erotogenic in one context — become hysterogenic in another. It is interesting that consumerism in the given context related to the specifics of a "space of desire" usually linked not with adult, but with children's codes of consumption — thereby inviting an "allegory of reading" associated with Freud's *History of an Infantile Neurosis*. It

Collective Actions, Performance in Sokolnicheskii Park in August 1989

was hard to believe that around this tent from who-knows-where and this arena in the round there extended the familiar, entirely ordinary darkness and these rather inconspicuous trees. Something which might be defined as the "incompatibility between hereness and thereness" was felt with an incredible sharpness.

It seemed as if the border between the East and the West lay directly before us. The pygmy arena identified itself with the gap between fiction and reality, and the Westernized Muscovite counter-culture — with two blind jeeps, selflessly transmitting (in an unfamiliar language) a message addressed to no one. "The ecstasy of miscommunication," as Baudrillard might have said. "In a zone of nondifferentiation," Monastyrsky would add. It is no accident that the direct sum of these two sentences has a chance of becoming the best definition of Soviet postmodernism.

Translated by Clark Troy and Victor Tupitsyn

Notes

1. Here one can apply Vladimir Propp's "The Morphology of the Folk Tale," with all its "functions," distributed among the so-called "spheres of action" corresponding to their "respective performers."

2. Margarita Tupitsyn, *Margins of Soviet Art: Socialist Realism to Present,* Giancarlo Politi Editore, Milan, 1989, p.37.

3. "Corporate" - the art bought, collected and encouraged by large corporations attempting, in this manner, to control

(corrupt) art, imputing to it the function of the bearer of codes of status, power and authority.

4. According to Dr. Norton Dodge, Paul Sjeklocha who is the co-author of *Unoffical Art in the Soviet Union,* University of California Press, 1967, was a C.I.A. agent. Dr. Dodge learned about this much later from a newspaper on the day when Mr. Sjeklocha was fired from the Agency. Margarita Tupitsyn (in her book *Margins of Soviet Art*) writes that "several embassies in Moscow including the American Embassy collected non-conformist art and thus explicitly demonstrated their support of dissident modernism." For a discussion of Abstract Expressionism as a "weapon of the cold war" see David and Cecile Shapiro, "Abstract Expressionism: The Politics of Apolitical Painting" and Eva Cockcroft "Abstract Expressionism, Weapon of the Cold War" in *Pollock and After: The Critical Debate,* Francis Frascina, New York: Harper and Row Publishers, 1985.

5. Margarita Tupitsyn, "Sots Art: Round Dance Versus Ritual," *Social Text #22,* Spring 1989, p. 148.

6. The recent plethora of articles in leading American and European art magazines on the Soviet cultural problematic and representing a debauch of narrative — so characteristic of Orientalism — serve as confirmation of this. The overtly simplistic style of such narrations (lacking any critical or theoretical issues) is akin to the familiar genre of tales from the heritage of Victorian exotica. A good example of this Orientalist politics of representation (and/or interpretation) is Jamey Gambrell's "National Geographic" approach to contemporary Soviet art (in *Art in America*). Evidently, the habitual ideologeme of "serving the general public" seems to be always at hand when the primacy is conveniently given to shallow journalism at the expense of intellectually oriented analysis.

7. Quoted from Kabakov's explanatory text "He lost his mind, undressed, ran away naked," Ronald Feldman Fine Arts, January 1990.

8. Victor Tupitsyn, "The Inspection of Inspectors," *Flash Art #147,* p. 133–135.

9. Ibid

10. Margarita and Victor Tupitsyn, "Timur and Afrika," *Flash Art #151,* p. 121–125.

Scenes from the Future:
Komar & Melamid

Peter Wollen

"The crisis consists precisely in the fact that the old is dying and the new cannot be born; in this interregnum a great variety of morbid symptoms appear." Gramsci's famous dictum, written in his prison notebook in 1930,[1] seems to describe two apparently disparate situations — the Soviet Union plunged into its long succession crisis, which began after the death of Stalin, and is now entering an unpredictable and chaotic new phase, and (in the West) the succession crisis of a dying modernism, whose "great variety of morbid symptoms" have been given the provisional name of "postmodernism." The two are intimately linked, however, in the trajectory of Komar & Melamid, two Soviet artists, formed in the post-Stalin epoch, who arrived in New York just in time to find themselves potential "postmodernists." In fact, their artistic careers are now more or less evenly divided in extent between the Soviet Union and the United States. They date their first collaborative work from 1965, when they were both students at the Stroganov Institute of Art and Design in Moscow; they left the Soviet Union twelve years later, in 1977, and (after a year in Israel) arrived in New York in 1978.[2]

In the Soviet Union, modernism was brutally expunged by Stalin. However, it would be misleading to see the Soviet avant-garde of the 1920s as simply an extension of the Western avant-gardes of the same period. As I have argued elsewhere,[3] modernism must itself be seen in the context of cultural "Americanism" (or its underlying substrate, "Fordism," the re-organization of factory labor by Henry Ford which made modern mass production possible and thus fueled the upsurge of a more productive U.S. capitalism). The emblematic imagery of the assembly line, the power house, the chronometer and the robot all reflect this fascination. But the fantastic

prospect of "Americanism" was naturally more pronounced the further a nation was, practically and historically, from its real possibility, the more recent its own industrialization. In England, home of the first industrial revolution, the avant-garde hardly existed. In France, alongside Le Corbusier and Léger, we find an anti-Fordist avant-garde led by Breton; in Germany, the expressionists were ousted from their pre-war dominance by the impact of the "Fordist" Bauhaus. In the Soviet Union, the avant-garde was the most militant of all, dominated by the imagery of construction, production, engineering, the machine and the factory, to the extent, in many cases, of abandoning art altogether for industrial design or publicity. This was the avant-garde of Mayakovsky, Tatlin, Vertov, Rodchenko and others, which Stalin so ruthlessly suppressed.

The irony, of course, was that Stalin himself was committed to his own brand of Fordism, as a model for his own industrialization of the Soviet Union and project of "catching up with the West." Indeed, he revered Henry Ford, invited his engineers, his management specialists and his architects to the Soviet Union, and commissioned them to build no less than 521 factories, beginning with a tractor plant in Stalingrad in 1930. This mammoth task of "Fordization," led by Albert Kahn and his brother Moritz, lasted just over two years, concluding triumphantly in 1933 with the completion of the giant works at Cheliabinsk.[4] However, Stalin was not interested in "Americanizing" art. Though he could make use of phrases defining artists as "engineers of the human soul," he wanted a realist form of art, fully integrated with the ideological apparatus of the party. The trinity of "Party, Ideology and People" was proclaimed, simply transposing the tsarist model of "Autocracy, Orthodoxy and Nation," just as the academic institutions, styles and shibboleths of absolutism were also revived.[5]

Thus, by a strange paradox, Stalin's project was to combine a Fordist industrial revolution in the base with a neo-tsarist cultural counter-revolution in the super-structure, freezing Soviet culture in the nineteenth century, while trying to force Soviet industry into the twenty-first. This dual imperative of accelerating towards the future, while reversing towards the past, naturally caused havoc with the Soviet sense of history. Moreover, by a strange by-product of this time-warp, modernism in its Soviet form (constructivism, futurism, etc.) began to recede into the distant past until, by the end of the Stalinist period of super-industrialization, it had become little more than a memory, almost a phantasm. However, because Stalinist industry was simply self-reproducing, building machines to build machines and factories to build factories, and also increasingly inefficient compared to its Western model, it completely failed to improve the quality of life of its labor force (or even of its managing elite).[6] Consequently, the Fordist and futurist vision of the twenties avant-garde also appeared as mythic and even deluded, a kind of messianic utopianism.

After Stalin's death, there was a gallant attempt by some survivors to re-connect with the twenties. Ilya Ehrenburg, for instance, organized a Picasso exhibi-

tion and published his pointed and polemical memoirs. But this attempt to pick up the threads and begin again da capo could not dissolve the effect of the decades of intervening history, the experience of Stalinism and the cultural impoverishment and dislocation it had caused. The years of the "thaw" were marked by cautious and prudent "pluralization" of styles and approaches still under the rubric of "Socialist Realism." The field of permitted subject matter was "bravely" expanded: "One only has to recall what a stir Plastov's painting *Spring at the Bathhouse (The Old Village)* (1954) caused. The new pharisees were shocked by the nude motif."[7] On the other hand, "unofficial" artists began to experiment with expressionist, cubist, and abstract styles, cautiously hopeful about reform as they began to surface publicly in the 1960s, even imagining the possibility of some future convergence with "official" art. These somewhat superficial hopes, of course, were crushed by the Soviet invasion of Czechoslovakia in 1968.

Komar & Melamid, along with Bulatov and Kabakov, belong to the next artistic generation. More pessimistic about reform, the problem which faced them was how to re-locate themselves within a non-convergent Soviet history, how best to extricate themselves from the false dilemma of a choice between official art and dehistoricized neo-modernism. It was plain by then, after the post-'68 crackdown, that the prolonged succession crisis was much deeper than the reformist generation of the "thaw" had imagined. It was necessary to move beyond Yevtushenko and Neizvestny, to confront the stabilized crisis in more radical terms, to re-engage with everyday life, which was equally remote both from the rhetoric of official art and from a neo-modernism irreparably robbed of its original utopian energy.

"We are children of Sots-realism (Socialist Realism) and grandchildren of the avant-garde."[8] Thus Komar & Melamid later encapsulated their heritage. They wanted to confront Socialist Realism, the art in which they had been trained and which still surrounded them, not as a mere style but as an all-embracing ideological presence, not merely "high art" but the pervasive public representation of the Soviet state itself, using, as their inheritance from the avant-garde, not the style of constructivism or suprematism, but the stance of rejection and refusal, of alienation. Necessarily, this double acceptance and rejection of Socialist Realism led them towards an art of contradiction, juxtaposition and irony. The same paradoxical juxtaposition exists in different ways in the art of Bulatov and Kabakov: the project of using a false language against itself, in seeking to expose its gaps and elisions, in probing its limits, making it transparent. To a Western eye, this often seems like parody, but if so, it is parody of a serious kind, making "virtue of necessity," as a Soviet friend of mine observed.

Though Sots art was named after Pop art (and Sots-realism) by Komar & Melamid in Moscow in 1972,[9] its significance is very different. Pop art in the West emerged from an encounter with consumerism, a recognition that the barrier erected

between "high" and "low" art could no longer be maintained. The successful Fordist economies of the West were predicated not simply on mass production, but on mass consumption as well, and artists increasingly lived in a visual environment dominated by the commodity and by commercial art. Soviet Fordism, or pseudo-Fordism (itself a gigantic parody) failed to develop a system of mass consumption. Instead, it delivered ideology, which filled the Soviet visual environment: political slogans, not advertising slogans; ideological emblems, not trademarks or logos; posters and banners, not billboards and ads; a cult of the party, not of the commodity. These two visual (and textual) systems are analogous only in a surface sense. In the Soviet Union there was no fundamental difference between high and low art: each was part of the same totalizing system. But in contrast, Pop art signaled the beginning of just such an integrated system, based on the generalized circulation of commodities and removing the barriers between commercial and fine art, whereas Sots art was an attempt to subvert an already established system from within.

In fact, it was precisely the failure to deliver consumer goods that led to the crisis of the Soviet state. As Platanov put it in his novel, *Kotlovan (The Pit),* as summarized by Komar & Melamid: "The revolution was over and people decided to build a tall building in a field, a socialist palace, where happy people would live. They began to dig a pit for the foundation, for the future, but as the work progressed, more and more people wanted to live in this house and take part in the work. The builders understood each day that the building would have to be bigger and, consequently, the pit should be even bigger and deeper since the bigger the building the larger its foundation should be. Thus, day after day, they did not rise upwards with the floors, but dug down deeper, into the earth."[10] The ideology of Socialist Realism continued to glorify the work and paint a picture of the future palace, but gradually the workers — and, of course, the overseers — came to realize that it was a fiction, that their leaders had no idea how to reach the future for which they were working and suffering.

The theme, or rather the climate, of post-utopianism pervades Soviet art today — the art, that is, of the post-'68 generation. The underlying mood of Komar & Melamid's work has always been elegiac. Their painting is full of ruins, of nostalgia, of memory, of a search for a usable past. It is painting suffused by a sense of entropy. From the start, the Russian intelligentsia was oriented towards the future, construed unproblematically as the elimination of the past. "The past is no longer within our power," wrote Chaadaev, the founding figure of the Russian intelligentsia, "but the future depends on us . . . I have a profound conviction that we have a vocation to solve a great many of the problems of social order, to bring about the fulfillment of a great many of the ideas which have taken their rise in societies of the past, and to give an answer to questions of great importance with which mankind is concerned."[11] Awareness of Russia's "backwardness" found its compensation in an intense commitment to an idealized future.

Chaadaev's vision of Russia's role was given substance by the advent of socialist ideas in Russia. Socialism became the favored version of a Westernized future for the Russian intelligentsia, numbers of whom, of course, eventually made the transition from populist socialism (*narodism*) to Marxism. In fact, Marxism, just like modernism, became an ideology of "catching up with the West," a tendency exacerbated after the failure of revolution in the West itself had left Russia isolated and alone. Lenin and the Bolsheviks had argued that a German revolution would validate their decision to force history in backward Russia. Eventually, in the face of economic difficulties, Stalin would decide to force history even further and faster, desperately trying to close the gap between Russia and the West. As the Russian historian Gerschenkron has argued, the more belated the industrialization, the more virulent the ideology accompanying and facilitating it: Manchester liberalism in England, Saint-Simonian socialism in France, Listian nationalism in Germany, Marxism in Russia — a Marxism which, as Gerschenkron notes, cut adrift from Marx, ending up with the consolidation of Stalinism as "the highly hybrid ideological concoction that went under the misnomer of Marxism."[12]

The Stalin regime showed no concern for the traditional democratic, egalitarian and proletarian values of socialism. It was a coercive top-down system, characterized by enormous pay differentials and ruthless exploitation of the peasantry and the working class. It destroyed the Bolshevik party and tried to obliterate every vestige of an autonomous intelligentsia. As Gerschenkron points out, it was like a nightmarish parody of the regime of Peter the Great, the westernizing tsar who instituted serfdom and consolidated absolutism in Russia. Thus it managed to combine a westernizing zeal with a traditional Russian despotism. For many post-Stalinist Russian intellectuals, one dimension of this concoction has been singled out for attack and the contrasting one praised as its antidote. Thus, a resurgent nationalism and slavophilia has denounced Stalinism (and Leninism) as a poisoned fruit of the West, while a helter-skelter market liberalism calls for immediate, total Westernization and an end to "Asiatic" statolatry and stagnation. The dislocation of any sense of a coherent history (aggravated by Stalinism's own claim itself to be the science of history!) has given tragedy a desperate gloss of comedy.

In 1973, Komar & Melamid painted a large group portrait, *Meeting between Solzhenitsyn and Böll at Rostropovich's Country House*. Komar comments, "You see, we have included in this painting everything that liberals in Moscow love, all you need for a good bourgeois life — a bowl of grapes, nice crystal glasses, a lemon with the peel hanging over the edge of the table. Like Dutch still–life painting of the seventeenth century. Most important, we have done everything in a different style — Cezanne's style, Cubism, Futurism. We painted Böll's left leg in the style of Russian icons."[13] There is also a Socialist realist heavy red curtain with a tassel and, over Sol-

Komar &
Melamid, *Meet-
ing Between
Solzhenitsyn and
Boll at Rostro-
povich's Country
House,* 1972,
Oil and collage
on canvas

zhenitsyn's head, the sly suggestion of a pre-Petrine halo of gold mosaic. In fact, the painting presents an omnibus version of the paradoxically confused ideology of the Russian intelligentsia: the Stalinist remnant overhanging them, the fantasy of the plethora of the West, the echoes of a glorious national and sacred religious past. It combines two strategies which run throughout Komar & Melamid's career: the mixture of discordant styles and the mismatching of style to subject matter.

Two years later, in 1975, they painted a new series called *Scenes from the Future* in which architectural masterpieces of American modernism are depicted in ruins, using styles of the eighteenth and nineteenth century. Thus, Frank Lloyd Wright's Guggenheim Museum, a tree growing up from the courtyard over the broken outer wall, is painted as a lonely ruin in a pastiche of Hubert Robert, an artist collected by Catherine the Great. With nostalgic irony, the West, in all its modernity, is inscribed into the pre-Romantic eighteenth–century vision of antiquity, favored during the heyday of Russian absolutism. In a similar gesture conflating modernity with antiquity, they painted damaged and time-worn versions of a Warhol soup-can painting and a Lichtenstein comic-strip painting, as though they were now sustained and aged enough to be included in a Soviet museum as ancient artifacts. Thus American Pop art itself was "russified" by being seen retrospectively, in the remote past, rather than projected into an imaginary westernized future.[14]

A little later, in 1975, Komar & Melamid painted a multi-panel *History of the USSR,* fifty-eight feet long (one for each year since October, 1917). For this work, they used a modernist abstract style, in which each choice of color, form and brushwork reflected the events and political climate of the appropriate period. Abstraction was thus harnessed to history painting and to allegory. This attempt to reclaim abstract painting by historicizing it was not simply another play with styles. On the contrary, it was part of a re-engagement with history painting, which demanded the development not of a single "correct" style but of an experimental range of styles, each permitting a different mode of historical interpretation. The obsessive re-painting of history to preserve it and to destroy it necessarily led Komar & Melamid to eclecticism, and hence to pastiche, to an "Alexandrian" art of *stromata* and the *cento.*[15] But this protean nature of their work in Russia pre-dates their encounter with the turn of the West towards postmodernism. It reflects a very different background and a very different purpose. As Komar & Melamid shifted between abstract history-painting, Sots art and even the invention of work by imaginary painters of the Russian past, this was not a symptom of the end of modernism, but a sign of their engagement with the massive task of creating a new art from the rubble left behind by Stalinism.

When they arrived in New York, they remained Russian painters, although of course, their new environment forced them to revise their imaginary expectations of the West and consequently their understanding of its art. Emigration has been a frequent fate for Russian artists in this century; consider Kandinsky, Chagall, Larionov,

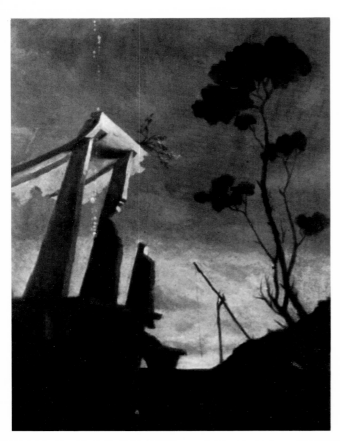

Komar &
Melamid, *Scenes
from the Future*,
1975, Mixed
media

Komar &
Melamid, *Scenes
from the Future*,
1975, Mixed
media

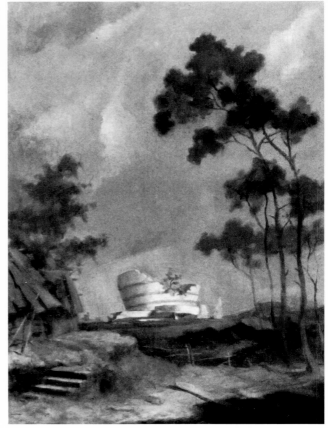

Goncharova, Sonia Delaunay, the *Ballets Russes,* Stravinsky, etc. Indeed, without this emigration, Western art itself would hardly have been the same. It was the Russian artists of La Ruche and the Rotonde who provided the foot-soldiers for the avant-garde, while Diaghilev became its most flamboyant impresario.[16] But, once again, we cannot expect to find a continuity between these two emigrations, pre- and post-Stalinist. In the interim the distinct histories of Russia and the West veered sharply apart and the two could not easily be bridged. The seventies emigration occured in circumstances very different from those of the twenties.

The problem that New York posed for Komar & Melamid was how to escape the omnivorous maw of postmodernism. Their experience of the Manhattan art world sharpened their distrust of modernism, which had become the "official" art of the United States. But, as I interpret it, the divorce of modernism from its role as an avant-garde, which was a pre-condition for its "triumph," also led to its rapid dissolution. From the sixties on, it no longer functioned as a heroic quest, in the way in which Greenberg had programmed and promoted it. Instead, it disintegrated into a competing plethora of neo-styles and mini-movements feeding off the heroic past. After the turbulence of the 1968 period, when there was a limited secession from the dealer-museum system, there was a rapid institutionalization of the new phase of modernism, under the rubric of postmodernism.[17] This development had some positive aspects — the new pluralism permitted a revival of figurative painting, for instance, but its impetus still remained intrinsically formalist and reflexive. Postmodernism was to be defined as "art about art," not in the modernist sense of ontological self-examination and research, the testing and probing of the foundations of painting, but in the new sense of citation, translation, deconstruction and neo-classicism.

The strategies Komar & Melamid brought with them could easily be assimilated into the conceptual field of postmodernism. Their use of pastiche and parody, their doctrine of "anarchic eclecticism," their diaristic polyptychs could all be glossed as signs of a new postmodern variant, albeit with an exotic "Russian" feeling for kitsch. Strangely enough, the most serious of artists, in the Russian tradition of the intelligentsia, began to seem less than serious, seen through the remorselessly frivolous spectacles of the Manhattan art world! For Komar & Melamid, Socialist Realism might be kitsch but it was kitsch that carried the weight of fifty years of Russian history, and its re-working can hardly be dismissed superficially as comedy.[18] New York's absorption in the "flux of temporal values," as Perry Anderson put it, in the insatiable search for the new, "defined simply as what comes later,"[19] ran completely counter to the fundamentally historical nature of their project.

In 1988, they finally made a decisive move away from the "nostalgic Socialist Realism" and transplanted Sots art which had dominated the first decade of their stay in New York. They began to work in Bayonne, New Jersey, on a project based at the Bergen Point Brass Foundry, a small factory dating from the 1890s. Bayonne is an

industrial town, the terminus for the Standard Oil (now Exxon) pipeline. The first refinery was build in 1875 and Bayonne is still dominated by massive tank-farms, oil and chemical installations, and tanker berths. As the 1939 WPA guide put it, "pollution from gasoline products, at first, generally dumped into the bay, spoiled swimming and fishing."[20] Earlier this year, despite clean-up measures, there was a massive oil spill in the channel which separates Bayonne from Staten Island. The WPA thumbnail history of the town principally records spectacular fires and desperate strikes "that left a heavy toll of dead and wounded among the employees." The town is tightly packed on a narrow peninsula with water on three sides. It is filled with saloons, churches, garden shrines and discount stores ("Rock Bottom," "Price Tag"). Culturally conservative and isolated from New York, fifty years later it still retains the feeling of "a workingman's city, and its localized industries are attuned to this basic fact; so also are its recreations and its civic life." In a word, Bayonne epitomizes the rust-belt.

It was precisely these qualities which attracted Komar & Melamid to Bayonne. They compare their exodus to Bayonne to the movement of painters from Paris to Barbizon in the Forest of Fontainebleau. Starting in 1847, in conjunction with the first *Salon Indépendant*, democratic artists began to move out of the city, rent rooms around the village of Barbizon and set up studios in barns. Théodore Rousseau (*Le Grand Refusé*), the instigator of the move, was joined by other artists, the best known of whom was J.F. Millet, who lived there until his death twenty-seven years later. Daumier visited and is remembered holding forth "in Rabelaisian vein."[21] The exodus was, of course, in protest against the Salon, the Institute and the Academy, against the corrupt atmosphere of the capital. It is ironic that Komar & Melamid should have first turned their thoughts to New Jersey from admiration of the garish sunsets diffracted through the corrupt atmosphere of the industrial, rather than rural, hinterland and set out there in search of spiritually clean air.

William Empson began his classic *Some Versions of Pastoral* with a chapter on "Proletarian Literature," seeing there a yearning for a lost dignity, beauty and pathos.[22] Here, perhaps, is the connection between Bayonne and Barbizon, between the foundry workers of New Jersey and the peasants celebrated by Millet. This is a complex "rust-belt pastoralism" which also, of course, contains an element of nostalgia for Russia. In their pen-portrait of Bayonne, Komar & Melamid comment on the sound of vesper bells (doubtless from the church of St. Peter and St. Paul) and the "bittersweet aroma" of wormwood, bringing back memories from their Moscow childhood. These are the same elements that appear in their autobiography of the fictional peasant painter Nikolai Buchomov (1929, Buslaevsk, Penze; Moscow, 1973): "I only remember the sharp odor of wormwood, its smell mixed up with something sweet and good."[23] Compare the "elusive fragrance of wormwood" which now "rises up to mingle with the bouquet of chemical emissions" (Bayonne, 1989).[24] Plainly this

is a version of pastoralism enriched by personal nostalgia but also, perhaps for that very reason, corroded by irony. Yet, at some level, the black foundry-workers of Bayonne echo the muzhik proletarians of Russia, liberated from slavery and serfdom only to enter the heat and glare of the furnace.

There is a curious similarity between Komar & Melamid's description of the Bergen Point Foundry: "While the slanting rays of the sun slice randomly through the lamp-like building, the workers, clad in protective helmets, gloves and aprons reaching down to the floor, move about the foundry fire as if in some ritual dance, pouring out the liquid sun and fashioning it for human needs: drainage faucets, pipes, sewer valves,"[25] and Empson's evocation of the Spanish workers he watched "tread out sherry grapes and squeeze out the skins afterwards, which involves dance steps with a complicated rhythm. I said what was obvious, that this was like the Russian ballet, and . . . [they] showed us the other dance step used in a neighboring district; both ways were pleasant in themselves and the efficient way to get the maximum juice."[26] Empson's pastoral through English eyes, though, is straight, whereas Komar & Melamid undercut theirs with a final note of irony. Yet, not only irony, but also an invocation, once again, of decay, effluence, entropy.

It is interesting to compare Komar & Melamid's Bayonne work with Robert Smithson's New Jersey pieces: *The Monuments of Passaic* (1967) and, of course, the *Nonsite 'Line of Wreckage,' Bayonne, New Jersey* (1968).[27] Smithson was born and raised in New Jersey. He saw Passaic, his birthplace, as existing "without a rational past and without the 'big events' of history. Oh, maybe there are a few statues, a legend, and couple of curios, but no past — just what passes for the future. A Utopia minus a bottom, a place where the machines are idle, and the sun has turned to glass." It was a place full of "the memory-traces of an abandoned set of futures." For *Nonsite 'Line of Wreckage,'* Smithson took pieces of asphalt-coated concrete rubble from a landfill near an old ship graveyard, where the hulks are still rotting today. This same landfill is now covered with wormwood: "Ah wormwood, eternal grass of industrial dumps!"[28] The same year Smithson observed that "the more I think about steel itself, devoid of the technological refinements, the more rust becomes the fundamental property of steel . . . In the technological mind rust evokes a fear of disuse, inactivity, entropy and ruin. Why steel is valued over rust, is a technological value, not an artistic one."[29] Like Smithson, Komar & Melamid transported industrial debris into the gallery to make a "Bayonne Rock Garden." Now they are painting on rusted steel, rather than canvas, leaving sheets of metal out in the rain until it acquires the desired reddish-yellow coating.

Yet, despite these parallels, there are significant differences between Smithson and Komar & Melamid. Not only does their work contain human beings — portraits of foundry workers, studies of heads and hands — but it is oriented more to the sublime than to the picturesque. Komar & Melamid's vision of Bayonne has a melancholy

grandeur: it is bathed in the glow of furnace and sunset. The furnace is the forge of Hephaistos and Vulcan. The art historical echoes are of *An Iron Forge* by Wright of Derby or J.M.W. Turner's *The Limekiln at Coalbrookdale*.[30] Smithson, in contrast, saw himself as a revivalist of the picturesque, mediated to him through Olmsted (who designed the public park in Bayonne), a picturesque which would heal the wounds inflicted on nature, restoring "the democratic dialectic between the sylvan and the industrial,"[31] the terror exorcized.

As you drive through the tank-farms of Bayonne, you can see the dialectic of rust and paint, the rust breaking through the paint, to form patterns "like a Clyfford Styll," then being painted over again by the agents of modernity, ever vigilant in their battle against entropy. Ruins are the monuments of human failure. This endless process of degeneration, this struggle of art against time, is a constant preoccupation. They write: "Restorers commit crimes. Artists mixed transparent colors with varnish, then a restorer will remove the varnish and take the color with it . . . They don't just remove paint. They paint in a new style. Absolutely. They invent an image of the past, a contemporary image."[32] Indefatigable entropy is found also in the movement of human history, in the attempt of utopianism to abolish the past, to live instantly in the future. Both Western modernism and Russian Stalinism were projects that demanded a denial of the past, a constant movement towards an ideal future. But the past cannot be denied. Like the repressed it always returns, and when it is foreclosed (as Lacan noted) it returns in the form of madness.[33]

It is against this sombre background that Komar & Melamid's penchant for parody and irony should be seen. It is a device, a way of combatting the sense of tragedy. They quote Kierkegaard: "In irony, the subject is negatively free, free from the shackles which in reality restrain him so firmly." Irony provides a provisional release from tragedy. At the same time it eats away at rhetoric, hypocrisy and idealization. It corrodes myths, old and new. In his brilliant and path-breaking essay from the late fifties, "On Socialist Realism," Sinyavsky wrote that "irony is the laughter of the superfluous man who derides himself and everything sacred in this world. Irony is the faithful companion of unbelief and doubt: it vanishes as soon as there appears a faith that does not tolerate sacrilege"[34] — whether, it might be added, that faith is in Stalinism, Old Russia or free market Westernization. Irony may provide only a "negative freedom," yet this peculiarly "accursed" Russian irony, this "disorder of the soul," as Blok put it in 1907,[35] is still the only passage out from an epoch of half-measures and half-truths, from a present mortgaged to an imaginary future and a future dragged back by the weight of the past. There are no new miracles or new truths to be spun out of new dreams and new delusions. It is better to start the future over with the wormwood and the rust.

Notes

1. Antonio Gramsci, *Prison Notebooks,* Lawrence & Wishart: London, 1971.

2. For an account of Komar & Melamid's career, see Carter Ratcliff, *Komar & Melamid,* Abbeville Press: New York, 1988. Melvyn B. Nathanson (ed.), *Komar/Melamid, Two Soviet Dissident Artists,* Southern Illinois University: Carbondale, 1979, provides a detailed treatment of their early Soviet work.

3. Peter Wollen, "Cinema/Americanism/The Robot" in *New Formations,* no. 8, Summer 1989: London.

4. W. Hawkins Ferry, *The Legacy of Albert Kahn,* Wayne State University: Detroit, 1970.

5. John Bowlt, "The Stalin Style: The First Phase of Socialist Realism," in *Sots Art,* The New Museum of Contemporary Art: New York, 1986. See also Bowlt, "Socialist Realism Then and Now," Bowlt, *Russian Art 1875-1975,* University of Texas: Austin, 1976.

6. On the Soviet economy, see Alexander Gerschenkron, *Economic Backwardness in Historical Perspective,* Harvard University: Cambridge, 1966, and *Europe in the Russian Mirror,* Harvard University: Cambridge, 1970. For a general survey, see Alec Nove, *An Economic History of the U.S.S.R.,* Penguin: London, 1969, new edition 1989.

7. Quotation from Vladislav Zimenko, *The Humanism of Art,* Progress Publishers: Moscow, 1976.

8. Komar & Melamid, *Death Poems,* Galerie Barbara Farber: Amsterdam, 1988.

9. Op. cit. Margarita Tupitsyn, "Sots Art: The Russian Deconstructive Force" in *Sots Art.*

10. Op. cit. *Death Poems.*

11. Chaadaev cited in Nicolas Berdyaev, *The Russian Idea,* MacMillan: New York, 1948.

12. Op. cit. *Europe in the Russian Mirror.*

13. Op. cit. Komar cited in Carter Radcliff, *Komar & Melamid.*

14. These two works formed part of a "trilogy" whose third component was a series of sketches of Red Army soldiers in historic Western tourist spots: Paris, Florence, etc.

15. Op. cit. *Death Poems:* "The chief work of Clement of Alexandria is 'The Stromata' ('Rag Rugs'). The philosophy of the 'stromata' is the compilation of brightly-colored patches and scraps coming from something that was once a whole, forming a colorful mosaic depicting something new, that is virtually an esthetic type of thinking. In the culture of later antiquity 'centos' were widespread — word mosaics ('rugs') depicting the events of Christian history through verses selected from various works of ancient authors. Christian temples were built using the maximum amount of elements and blocks from ancient temples."

Komar & Melamid's use of patchwork recalls Salman Rushdie's statements in his recent essay, "In Good Faith," published in *Newsweek,* February 12, 1990: "*The Satanic Verses* celebrates hybridity, impurity, intermingling, the transformation that comes of new and unexpected combinations of human beings, cultures, ideas, politics, movies, songs. It rejoices in mongrelisation and fears the absolutism of the Pure. Melange, hotch-potch, a bit of this and a bit of that is *how newness enters the world.*"

16. Kenneth E. Silver and Romy Golan (ed.), *The Circle of Montparnasse,* Universe Books: New York, 1985 and Lynn Garafola, *Diaghilev's Ballets Russes,* Oxford University Press: New York, 1989.

17. Op. cit. *Death Poems,* "If modernism can be compared to an intellectual adventure, the discovery of new lands, then post-modernism reminds one of tourism."

18. Peter Wollen, "Painting History" in *Komar & Melamid.* Fruitmarket Gallery: Edinburgh, 1985.

19. Perry Anderson, "Modernity and Revolution," in *New Left Review,* p. 144, March-April 1984: London.

20. Federal Writers' Project of the Works Progress Administration for the State of New Jersey, *New Jersey,* Hastings House: New York, 1939.

21. John Sillevis, "The Barbizon School," John Sillevis and Hans Kraan (eds.), *The Barbizon School,* Haags Gemeentemuseum: The Hague, 1985, and Jean Bouret, *The Barbizon School and 19th-Century French Landscape Painting,* New York Graphic Society: Greenwich, 1973, which cites Alfred Sensier on Daumier's visit to Barbizon.

22. William Empson, *Some Versions of Pastoral*, New Directions: Norfolk. (No date.)

23. Op. cit. Carter Ratcliff, *Komar & Melamid*.

24. Komar & Melamid, "We ♥ New Jersey" in *Artforum*, April 1989: New York.

25. Op. cit. "We ♥ New Jersey."

26. Op. cit. *Some Versions of Pastoral*.

27. Robert Hobbs, *Robert Smithson: Sculpture*, Cornell University: Ithaca, 1981. Smithson's own writings are collected in Robert Smithson, *The Writings of Robert Smithson*, New York University: New York, 1979. See especially "The Monuments of Passaic," first published in *Artforum*, Dec. 1967, and "Frederick Law Olmsted and the Dialectical Landscape," first published in *Artforum*, Feb. 1973. I am grateful to John Welchman for drawing my attention to these texts.

28. Op. cit. "We ♥ New Jersey."

29. Op. cit. "A Sedimentation of the Mind: Earth Projects." Smithson *Writings*.

30. Francis D. Klingender, *Art and the Industrial Revolution*. Evelyn, Adams and Mackay: Chatham, 1947.

31. Op. cit. Smithson, "Frederick Law Olmsted," in Smithson *Writings*.

32. Op. cit. Carter Ratcliff, *Frederick Law Olmsted*.

33. The French psychoanalyst, Jacques Lacan, used the term "foreclosure" in order to pinpoint the difference between neurosis and psychosis. Whereas neurosis derives from repression, from the transfer of symbolic value and meaning from a repressed memory, displacing it into a symptom, psychosis (such as paranoia or schizophrenia) derives from a fundamental failure to symbolize, which leaves a yawning gap in the fabric of language and memory. While it is dangerous to draw analogies between individual and social pathology, it seems plain that Soviet culture suffers from a general disturbance of the collective memory, from agonizing cultural gaps and voids.

34. "Abram Tertz" (Andrei Sinyavsky), *The Trial Begins* and *On Socialist Realism*, University of California: Berkeley, 1960.

35. Op. cit. Blok's *Irony* (1908) is cited in Sinyavsky.

Concepts and Reality

Alexander Rappaport

Soviet art, having recently found itself under glasnost, has come upon a new set of difficulties. It is in need of a new foundation upon which it can rebuild. The newly found artistic freedom has not solved many of the problems Soviet artists faced, in fact it has created a new set of problems. The abolition of direct and indirect restrictions has taken hero status away from the nonconformist artist, allowing him to have higher expectations regarding his work and to evaluate his work according to his own internal criteria, rather than external restrictions.

The paradox of the situation lies in the fact that everyone, accustomed to the previously existing conditions surrounding Soviet artistic life, has still not grown accustomed to the recent luxury of these restrictions being lifted. The Soviet artistic community will need new tools and new solutions to deal with the problematic relationship of art to life. The imitation of former Western painting styles and the revitalization of the historic forms of the original Russian avant-garde will not possess the same inherent values which governmental interference in the artistic process fostered.

The presumedly central dilemma of Soviet art, that of "lies versus truth," has lost its meaning, since the refusal to deceive oneself does not necessarily bring forth the truth. Eroticism, the bureaucratic striptease, and the noble gestures of dissidents, all former taboos, will not automatically replace the former subject matter of Soviet art, under government repression. Even now it is highly improbable that academic artists would dare to portray formerly taboo subject matter in the style of Stalinist Social Realism for public scrutiny.

Reality, as it is historically portrayed by the plagiarism of artistic styles from one period to another, is in actuality a warped representation of the truth. Truth appears as either kitsch or as ironic reflections, of which there are a multitude of famous examples in Sots art, a term some have coined as the Soviet version of the West's Pop art. It is doubtful that all of the former problems will pass to the wayside, having long concealed themselves behind a naive lightheartedness.

Art reveals a multitude of realities, but even more so it reveals the reality of the artist's consciousness. In the pluralistic world, the juxtaposition of various subjective realities gives birth to a myriad of forms, each of which is in its own right the truth, but not one of which expresses the truth in it entirety. Between the truths of existence and the truths of art lies a system of disparity, which belongs to its own reality. For this reason the requirements of honest reflections of the full spectrum of life in art are unrealizable. All modern utopian concepts, of which Socialist Realism is one, have attempted to bridge this gap. However, the sheer multitude of these utopian plans, which have remained in the realm of possibilities, has become the singular sum of their strengths.

Out of this, an idea of an artistic political leadership has developed which encompasses the realm of possibilities but gives visibility to only one aspect of the world. In light of weakening political pressure in Soviet art, a multitude of artistic systems has arisen, which maintain a pretentious claim to a monopoly on the truth. These systems differ drastically not only from Sots–realism but from the radical conceptualisms of the avant-garde from the first part of the twentieth century, such as Suprematism or the school of "analytic painting."

Situated in the middle of this rehabilitation of artistic values is honesty, which was principally refused by the avant-garde, but imitated by pseudorealism or neoexpressionism. However, honesty, being difficult to grasp, is not enough, since the artistically victorious reflections cause a certain naivete and bring to art an inner problematic. There arises a compatibility of the sensuous and the intellectual, of the preconceptual and the experiential components of the artistic imagination. Exposing lies does not reveal the truth, but something else, which could simply be called "not a lie." This thing which is not a lie, is neither truth nor honesty, but a catalyst for the revelation of reality, manifesting itself in a variety of intangible facets, which art attempts to reproduce.

One of the methods of reproducing this reality is found in Soviet conceptualism of the seventies and eighties. This movement no longer exists, but up until now has been completely ignored by art criticism. Art theory and criticism have remained absolutely aloof to artistic creativity and its process, which have succeeded in creating a life-like reality in a manner which is as far from a literal portrayal or realistic image as pretension is from honesty. It is time for theory and criticism to compensate for their negligence.

Soviet conceptual art has created for itself the opportunity to act uninhibitedly within a strictly inhibiting environment. Soviet conceptualism unifies denial with reflection within a clearly analytical relationship of life to art. In light of this, not only has the Socialist Realism of the Stalin and Brezhnev years been denied but, also the utopian conceptualism of the avant-garde of the beginning of the century. In both cases conceptualism conceived of an artificial system in an attempt to replace reality with designs which were utterly unrealistic. However, the denial of these futuristic utopian designs in order to take steps toward a life-like reality, is not quite the same. The latter remains unattainable. Early conceptualism endorsed reality with an apathetic kind of praise by ignoring the "dishonest" designs of the world's reconstruction. These designs have been subordinated to the art of the first avant-garde. Reality foresees the alienation of the concepts of its retransformation, and at the same time includes within itself the contradiction of concepts and designs. Honesty reveals itself as a space which surrounds the multitude of "dishonest" constructions, whose judgment of these contradictions permits the survival of freedom, independent of a subjective schema. Both truth and freedom are intangible, but the artist, who has managed to liberate himself from all dogma, lies and hypocrisy, is able to communicate to the viewer his surviving feelings of liberation. These feelings explain the truth with the help of irony or cynicism.

This ironic reflection was revealed in the utopian projects for the restructuring of the world and the reordering of the fundamental aspects of space, time and language. The ontological concepts of utopian thought expounded their own purity of thought in an attempt to return to an undeceptive existence. Time was the most powerful of these ontological concepts in capturing the imagination. It opened the present, while concealing the past and the future. Time was also the most alluring concept for the utopian consciousness. It was used to achieve an optimistic ecstasy or to be overcome by the energy of the creative imagination. It is regarding their relationship to historical time that the heroic avant-garde at the beginning and the contemporary avant-garde exhibit their most stark differences.

The early Russian avant-garde was characterized by a historical nonconformism. It rejected the past and pronounced upon itself the right to exist only in the present or future. The contemporary Soviet avant-garde is indulgent and possesses no pretensions to historical revelations. The historic avant-garde aspired to power in hopes that this power would help them to realize their utopian designs for the rebuilding of the world: However, it was this very power which betrayed it, and was substituted by a very widely hated eclecticism. The contemporary avant-garde, having no desire to cooperate with the totalitarian regime, ironically uses the visual codes of the totalitarian culture. The revolutionary avant-garde was well founded upon its own novelty and originality; the contemporary avant–garde is blatantly redundant. The avant-garde at the beginning of the century was self involved with its own stri-

dent imperatives, but the contemporary avant-garde regards itself and its historic possibilities skeptically.

The new avant-garde has reserved the right to relate ironically to the past and the present in the spirit of Pop art. The irony of Pop art, continuing in the tradition of Dada, which has never been officially recognized in Soviet culture, as in all utopian cultures gives in to hypertrophic seriousness, making it insensitive to the comedy and absurdity of its own situation.

Utopian consciousness is a product of a rectilinear categorical historicism, in accordance with which the past inevitably appears, relinquishing its place to the future. Futurism, as a more obvious example of such a utopian historicism, put the word "future" in its name and dreamt of "throwing the past off the ship of modernity." But in reality, the past does not disappear like a nightmare, nor like a golden dream, instead it is included in the present and resigns itself to this. But the future is part of the present. The proximity of the past and the future gives a flavor of the contradictory coexistence of two different systems. This coexistence can result in either the suppression of one system over the other, which is the case in the history of Soviet art culture, or can result in their peaceful coexistence. A peaceful coexistence demands not only tolerance but introspection. Soviet postmodernism may be more introspective than its Western postmodern counterpart, as well as more tolerant. Pop art sufficed in using the innocuous mass culture of consumer society as the subject of its reflections; Sots art takes advantage of the far from innocuous visual culture of Stalin's totalitarianism.

Understanding the vocabulary of Stalin's artistic propaganda requires a highly developed introspection which is absolutely foreign to the earlier Soviet avant-garde, to the Social Realism of the thirties, and to all the later styles which emerged from them. Soviet artistic culture constantly expounded the necessity for truth, honesty and "unmediocrity," excluding mystification. Official culture saw in such open mystification the danger of being exposed and preferred to rely on its blatant hypocrisy, but the liberal opposition recognized within the hoax its own hypocrisy. The oppositions came together, preferring to swap wishes for reality. The inclination for self-deception is certainly fed by more powerful feelings, such as the fear of death and the fear of exposure. One group fears exposure of their crimes, the other fears the disclosure of the depth of their moral depravity. This is the reason the current exposure of hypocrisy in Soviet society takes on the morbid characteristics of black humor. This black humor unites the daily cliches of mass culture with a nightmarish image in a manner which is typical for utopian society, rather than exposing its absurdity and paradoxity.

The paradox of post–utopian fantasies, embodied in the hybrids and the monstrosities of linquistical constructions, lies in the internal incompatibility of these

various parts. Hybrid constructions or designs of the contemporary avant–garde testi-fies to the significance of current events from a historological and ontological point of view. The utopian designs of the Russian futurists were projects for the ontological restructuring of the world. The formation of the ancient cosmos comes to mind as a parallel of this phenomenon in world history. It vanquished the mythological world which preceded it and recognized this metamorphosis as a victory of order over chaos, much like the victory of the gods on Olympus over the mythological monsters. This metamorphosis and mythological symbolism accompany every attempt at deeper ontological reforms in both, and it is no random occurrence, that their traces can be found in both contemporary Soviet art and architecture. Hence, the underlying impe-tus for Komar's and Melamid's portrayal of Reagan as a centaur. In another work by this duo, Stalin is being painted by the muse of antiquity, a stylistic hybrid of political caricature with artistic academism. In their double self–portrait, Komar and Melamid have portrayed themselves as young Pioneers, the Soviet political version of Scouts, and in combining a very specific painting style with such a juvenile subject matter, they have successfully parodied the infantilism of the totalitarian psychology.

The ironic hybrid of the bureaucratic ideals in *Governmental Objects* by Rostis-lav Lebedev creates a metamorphosis, that is, the transformation of the pathway, the symbol of typical Soviet institutions, into the sun, a symbol included on the seal of every Soviet republic. A slogan, which was in previous times very familiar to Soviets, *Slava KPSS* or "Glory to the Communist Party," has been transfixed to a sizeable canvas by Eric Bulatov. One enormous painting by Kabakov depicts the hundredfold enlargement of a tiny piece of paper, upon which is written, "Reservations to see the Mona Lisa can be made in room 16 with Comrade Ponamarev." Having made a virtual mountain out of a mole hill, Kabakov has managed to create a hybrid *matrioshka,* a traditional Russian toy for which there are a number of identical parts which fit one inside the other. In this case the hybrid brilliantly places one parody of Soviet mass culture into another parody of Soviet culture. These parodies include Soviet "official" fine art, Soviet existential realities, and even Pop art itself.

On the other hand, the architectural fantasies of contemporary Soviet concep-tualists, the Paper Architects, are simply full of these kinds of hybrids. For instance in a project by D. and A. Shelestov, *Ark,* a new type of housing is presented, which is able to navigate any medium, a cross between a house and a cross–country vehicle. This ultramodern design does not resemble the technical fantasies of Fuller, but, rather, resembles a typical *dacha,* or country cottage. In the collages of A. Zosimov, a Venetian landscape with a peasant woman is juxtaposed with the ground lobby of the metro station *Arbatskaya.* This hybrid reads like a replica of the utopian slogan, "Erase the borders between the city and the country," which inspired many of the architectural designs of the Constructivists in the thirties. Perhaps the most famous hybrid design in paper architecture is *The Temple City* by Galimov. The design was

Komar &
Melamid, *Por-
trait of Ronald
Reagan as a Cen-
taur*, 1981, Oil
on canvas

Komar &
Melamid,
*Double Self-
Portrait as Young
Pioneers*, 1982–
83, Oil on
canvas

conceived as a partially destroyed ancient Greek temple of gargantuan proportions, constructed from a multitude of buildings of various epochs and styles. In this case the hybridization achieves such an ironic culmination because the sum of its parts belongs to one style. The construction of such a colossal monolith would demand the technology of the future, thus its futuristic element. Yet, in the capacity of innovative architecture for the future, *Temple City* seems doubly insolent, because it is both a ruin and an imitation of a style from the past.

In the gloomy etchings of Brodsky and Utkin, many historical periods and forms of construction intersect. Their images do not achieve anything resembling the past or the future, but something, which is a juxtaposition of all time. Their etchings retain the gloomy characteristics of all previous historical periods, the fruits of senseless efforts to create something which comes out of the framework of simple human needs. The gigantic labyrinth is universal in the design, *Intelligent Market,* which turns out to be simply a jail, or a unique park attraction, which serves the bustling vanity of one's desire to get a glimpse of oneself a thousand times larger than life. A crystal palace, situated in the middle of a trash dump, if examined more closely, turns out to be nothing more than an empty illusion. The fundamental archetype of utopian fantasies which crowns the biblical allusions to these prophesies is the Tower of Babel. Although destroyed millenniums ago, this construction continues to disturb the human spirit and its rivalry with the sky. This historical archetype manifests itself in early revolutionary avant-garde designs of *Tatlin's Tower* and *The Palace of the Soviets.* The contemporary design of Avvakumov, *Cemetery Skyscraper* uses the technology of prefabricated building, the technique by which almost all Soviet housing is constructed today, to evoke the sensation of being buried alive for the inhabitants of his design. In other works by Avvakumov prefab construction symbolizes playing cards, reminding one of the fragility of a house made of playing cards, which is called *L'architettura di carta.* It also brings to mind the possibility of foul play, or even fortunetelling with tarot cards.

The illusionary element of the hybrid forms of paper architecture corresponds to the absurdity in conceptual painting. The absurd is the antithesis of illusion. If in a historical perspective utopian programs of futurism turned out to be illusions, then the realization of these programs brought about the "absurdization" of life itself. Illusions, which are realized in the future, give birth to the absurd; but the absurd itself is none other than an illusion of a despairing consciousness. An illusion, as long as it is not exposed, is an animated foundation for existence and gives one surrogate beliefs, when one's original beliefs have been forsaken. The demystification of historical myths, the loss of belief in God and language, lead to a disillusionment with everything, to a void, or the absurd. The absurd arises from pushing the subtle premises of ideology to the limit. An intangible term which has crept into Soviet bureaucratic architectural ideology is "consumer architecture." This concept has been taken to a

Brodsky and Utkin, *The Intelligent Market*, 1987–'90, Etching

grotesque absurd in the design of Bronzova. She proposes the design of a ginger-bread house to be constructed on a site in the middle of Moscow. The consumer element of this design lies in its designer's wish that the inhabitants of this structure should in time devour it completely. Another example of carrying an idea to an extreme absurdism is the hypertrophy of conceptual designs. In Kaverin's project, *The Third Hemisphere,* he proposes to cut away a part of the earth's sphere, in order to bestow upon it a more fashionable silhouette. The painstakingly drawn project, which is merely a clown's escapade, adds to utopian design the transformation of nature and the cosmos, favorite ideas of the totalitarian government.

Similar concepts examine the absurd, not as an inherent part of the world, but rather as the relationship of man to the world. The re–evaluation of the relationship of the artist or the architect to their own design as a form of the redefinition of his relationship to the world distinguishes the new avant-garde from the avant–garde of the twenties. In particular the design of Kaverin can be considered a direct duplication of Malevich's attempts to bring a cosmically providential foundation to Suprematist forms. One of the variations of absurd hybridization is the inversion of the permutations within the semantic structures of a work. Brushkin's famous work, *Fundamental Lexicon,* portrays all the people as hypnotized plaster figures, but all the now-defunct symbols of totalitarian culture are painted in living color. Brodsky and Utkin propose a design of a columbarium for houses. Of course people would live in these houses, situated on the shelves of this enormous structure. Rather than building a house on an island, Barkin and Belov have designed an island with an artificial reservoir to be built within a home. In the housing designs of Bush and Podyapolski the singular function of the inhabitant becomes the enjoyment of the view from the window. Real functions are sacrificed to illusion, which is the realization of the absurd. Illusions do not require bricks or cement, they only require that the individual viewer consent to see what in reality does not exist. Several of Kabakov's paintings do not contain any sort of figures or images; instead they are a written explanation of how the viewer should perceive the paintings. All of this precipitates a situation similar to that in *The Emperor's New Clothes.* The public's infatuation with illusions places it at the mercy of con artists, who take advantage of the public's willingness to elude itself from reality. An absurd unanimity can only be transformed into the absurd. Kabakov's painting, *The Garden* is accompanied by a list of opinions, supporting all possible critical analysis of the painting. In such a way the painter not only protects his work from the critics, since he has included all possible interpretation within the text of the canvas, but also replaces a conventional image with a conventional commentary. Having declared the opinions within this commentary pluralistic, they become susceptible to mutual neutralization. It would seem that in such a manner, the image would be spared, but the absurdity of the situation lies precisely in the fact that its salvation is fictitious,

because the image is meaningless. Judgments and their subjects are in reality secondary; only the reflection itself should be considered primary. In such a way the theme and judgment are tied together, creating a situation of autonomous existence for the work and thus liberating the artist from any responsibility. This reflection game allows an infantile arrangement of the ideologically oriented consciousness and evades all judgment. It is precisely upon this game that conceptual architectural designs are founded. Judgments are evoked which are irrelevant to the original design, which remain independent from the approval of strict criticism. The level of reflection of both the conceptual artist and designer is manifested in the high level of reflection on the part of the critic or the public. This abstract communication based on reflection is transformed into a variety of illusions: the critic is presented with the opportunity to peer into this reflective mirror, while his intended victim is dying of laughter behind the critic's back and arousing his own naive enthusiasm.

Conceptualism is inherent to the whole of twentieth-century art and is intertwined with a belief in a providential sense of history. The changing proliferation of "isms": Impressionism, Cubism, Expressionism, Futurism, Dadaism and Abstractionism indicates an attempt to catch up to time, or a way in which to push it farther and farther away. The goal of the artist's quest is similar to the horizon, which is ever elusive from its pursuers. After World War II, the direction of this quest changed a hundred and eighty degrees. Mystification was replaced by demystification, and the utopian hope of transforming the art world was replaced by contemplative self involvement. The cult of form within the avant-garde expressed the monism of European artistic thought, and was seen within art as the empirical way, and a very scientific one at that, to achieve truth. Artistic groupings resembled tribes and their leaders resembled chiefs; an understanding of styles in art required a political consciousness.

Conceptualism of the contemporary avant-garde broke with mythological forms and this politic of style, creating its own forms, styles and other components of artistic creativity with a content of free reflection. Here before us, the instructional dialectic of freedom and its relationship to the categorizing of time are revealed.

Either directly or indirectly the enthusiasm of the historic avant-garde validated the necessity of restructuring the world and life in the name of freedom. In this way the artistic avant-garde was caught up in politics. Reality did not satisfy the free creative spirit, and it was acquitted upon the outcome of this decisive transformation. The old world was rejected, and creative energy was directed toward the construction of a new world, which was the future. The cult of the future united the futurists with the Communists. Each group considered itself to be the innovator of the coming restructuring of the world; each aspired to a certain freedom which was blatantly displayed, as if this freedom was an end unto itself. Conceptualism of the Soviet historic

avant-garde was a utopian scheme, within which uncompleted conceptualization compensated for a belief in the creative spirit. Between strategies and tactics a gap formed, and in the end the premise upon which the war for independence was being fought changed, transforming a society of fighters into an enormous concentration camp. The monstrous scissors of dialectical contradictions aided in annihilating every living thing. In the name of absolute freedom the future was not permitted to exist with the present. Also in denying the present's place in the future a death sentence was pronounced on reality by a utopian totalitarian conceptual government. The war for independence declared itself as the singular reality, which was reflected in bureaucratic authority and a dogmatic formula.

The first avant-garde actively, however not always successfully, fought with its own reflectiveness, because the process of restructuring the world could not be realized through contemplation, but rather by action. Contemplation exposes the weightiness of eternity. The heroic avant-garde's comprehension of pure form was the detour of their historical distortion by circumstance. This is why the cult of form and language, which were inherent to the aforementioned avant-garde, contradicted its own historicism and revolutionism. The emergence of the pure tectonics of the black square from the dust of the revolutionary drill might only explain the duality of avant-garde's leadership. Partially belonging to reality, they became the revealers of the hypocrisy of eternal truths. A similar thing happened later to the political leadership, whose idea of immortality took possession of the masses, who were given no other rights than the right to endure unbearable suffering daily.

All of this indirectly confirms that the existence of expedience is not unobstructed; only transcendental time can be free. However, reality demands freedom and, consequently, presumes the existence of time. From this it is obvious that the contemporary avant-garde has nothing to do with the future. The city of the future, a later relic of futuristic fantasies appearing in the sixties, however, sprung directly from the tradition of conceptual design. Illusions of greatness, combined with heroic asceticism of the first avant-garde, has changed into the ironic skepticism of the second, having gone as far as cynicism and self criticism. The metamorphosis remains in the new conceptualism, yet has lost its relation to historical time. The transformation of the family portrait into a military destroyer in Eduard Gorokhovsky's silkscreen series possess no historical subtext. The Russian avant-garde and Socialist Realism gave tribute to the secret dreams of the utopians. The two projects conceived in the spirit of the Tower of Babel remain unconstructed. The etchings of Brodsky and Utkin show traces of this spirit as a symbol of time, which obliterates urban designs, as a denial of utopian conceptualism. The denial of utopia is the confirmation of the human spirit, which does not extend beyond the boundaries of its own nature. Kabakov once called Malevich the "Big Boss," a title which reflects the responsibility of the post which Malevich held, but also expresses a mixture of horror and delight,

which accompanies the transformation of an individual into a dictator. In the denial of utopian concepts it is obviously a validation of the authority of art over life. The notorious "realism" of Soviet socialist art prescribed the artistic mission as the imitation of natural forms, but presented with the responsibility to realize realism and transform it, art submitted to the demand for the necessities of life extracted from one of the last party directives.

The ironic reflections of the new conceptualism permits the existence of only one authority, the authority of thoughts and ideas. The expedient freedom of thought replaces the freedom of the future, but the cost of this expedient independence is the sacrifice of life for the benefit of the intellect. The former demands that it be dismissed from reality, which can seize an individual too powerfully. Conceptual art of the eighties does not know immortality, it is as timely as a caricature, yet with its ironic denial it is possible to grasp the bitterness of its renunciation. The continual prohibitions of art from external sources was overcome by a new asceticism which refused to participate in the mundane. Having chosen its views, its time and its freedom, conceptualism freely condemned itself to alienation. With this its tragic independence was concluded in its own time; and once again art placed within its eternal problematic, its relativity to life. We can end with this: "Intelligence is good, but happiness is better."

Translated by Kim Thomas

Metamorphoses of Speech Vision[1]

Mikhail Ryklin

In the contemporary study of the humanities, a principle which might be termed "Bakhtin's Scissors" is rapidly gaining recognition. I have in mind Bakhtin's distinction between sentences and utterances, between linguistic and speech acts. The former, according to this theory, has no immediate connection with reality, does not determine the responding position of the other, and unlike the latter, lacks signification. From the hegemony of utterance it follows that "we never say words and never hear words, in fact we hear truth and lies, good and evil."[2] To say that we hear "truth in speech" or the "good in speech" is tantamount to confirming that truth does not precede a collective accumulation of utterances, it does not pre-suppose, as philosophy from the time of Platonism would have it, the very conditions of speaking in culture, but serves as an epiphenomenon of the collective accumulation of utterances *as a subject*. I emphasize "as a subject" because the impersonal accumulation of language's open objecthood can also be a condition of the ideas of truth, the good, etc. The "good" in speech belongs exclusively to the collective subject rather than the accumulation of utterances as such, which permits no acquisition of subjectivity whatsoever. Familiarity with the history of philosophy only complicates an understanding of what we will call "panspeech," because basic philosophical and antiphilosophical codes are "scissored" in an equally radical manner by this position: the conception of panspeech is anti-reflective and leaves no room for the unconscious; it opposes Platonism just as it opposes the "microphysics of power" or schizoanalysis.

The role of the word in the realm of panspeech extends immeasureably; it knows nothing external to itself. All cultural signs are included in the verbalized consciousness — "non–literary signs flow in around the vocal element, are embedded in it."[3] Language, the word — that's about all there is in human life.[4] In speech-oriented

culture, the canons of which had been manifest not only in the writings of the "Bakhtin Circle," but also in the entire line of "Russian Cosmism" (Fedorov, Filonov, Khlebnikov, Vernadsky, Platonov), the vertical links between the word and content weaken. Truth within this framework is a meta-linguistic problem. Sight is understood as speech sight, but is reduced to the very basic, simple forms. Sight as a special means of individuation is present here only negatively, as a threat. Speech sight is not visual.

Visuality in speech–oriented culture is connected to the problem of "another world" (heaven and hell). This becomes a way of envisioning the bodies of collective identity as though they were already "in the heavens" not before, but after, the Transfiguration. In the novels of the Stalin era there is a struggle for the right for transfiguration and collective identity, all new paradigms which are selected to form a syntagmae making a bridge to the social heavens.[5] In the art of this period this shift into the sphere of Stalinist literature becomes reified at the level of communal life. Moreover, this is not a vertical (religious), but a horizontal (immanent to culture, atheistic) transfiguration.

During the Stalin era, the decoration of public spaces (the metro, VDNKh, public parks, Red Square) was of great importance. It was there, and not in the specialized repositories of art, that the nomadic mass engaged in societal rituals. Because the pictorial is static it negates the concept of the nomadic mass, and thereby poses a danger to it, compensating for its appearance in the world by the pathos of the utopian — which endowed the icon with the power of the referent. In addition, this reliance was so rigid tht it constantly sensed a shortage of "sublime" signifieds which could have satisfied it. And this is not surprising: this rigid, short-circuited orientation towards the referent means the death of signification. In the sphere of art terror takes the form of an interminable search for an unattainable orthodoxy. The author does not voluntarily place his self under erasure; rather, he is erased by his own fear of the Fall into self-expression. In Stalin's epoch the search for collective identity presupposes a paradise of zombies in its triumph over all bodily functions and empirical manifestations. In other words, a communism of images had already been built at the very source of the striving towards an interminable orthodoxy.

Reliance on violence signifies a perpetual coming-into-being of bodies of culture, the death of contemplation, representation, and the subject, who, in Husserlian terminology, can no longer constitute the world as his horizon. Culture takes the form of aggression against culture. On the other hand, a reduction in the degree of aggressivity — the phenomenon associated with full-fledged *affluence* — signifies the crisis in an ecstatic culture.

In photographs from the thirties and forties, people's faces are often retouched in such a way as to make them appear absolutely smooth, as if transfigured by an infinite feeling which is mummified in them. In sculpture — especially in subway sculpture — the infinity of feeling takes as its visual equivalent the erasure of both the

subject and object of contemplation. Their gaze is dehumanized in the sense that it endorses the inevitability of coming-into-being beyond the borders of life. Collective identity emerges through the gaze and in plastic form it slithers away into representation. This is the irrepresentable itself, that which testifies to the irreducibility of symbolic exchange to the semiotic at all orders of simulacra. The tendency towards collective identity transforms the representation into simulacra: these ecstatic formations do not correspond to anything; they know nothing external to themselves. Thus, on the pictures and in all the iconography of the Great Terror, we find not normal visual images, but zombies, accumulating death in themselves and, for that reason, hyper-vital. In distinction from classical images, ever subordinate to the primacy of the prototype event, zombie-images destroy the very possibility of the prototypical. This is related to their "disinterestedness," their oversaturation with extra-artistic energies, their aggressiveness towards professionalism and virtuosity.

In the West the death of art takes the form of its hypereffectiveness; art, in Baudrillard's terms, possesses the ability to transform the fact of its own disappearance into exchange value. This final circumstance localizes the zone of transgressivity of this "art beyond the bounds of disappearance" (for example, simulationism). In contrast to this, Stalin's imagery oversteps the artistic dimension in the name of purely symbolic effectiveness, resting in this case not upon a demonic suprapersonality, but on collective identity; destruction realizes itself not for the sake of high productivity, but in order to establish a principally different (collectivist) type of coherence, focused on the problem of interminably returning origins. This new aspect of potlatch is threatened by any peeling away of personality from a conglomerate of "bodies" reshuffled in accordance with the laws of "nomadic distribution." In other words, both Mensch and Ubermensch present threats to it.

What made the art of the period from the thirties to the fifties was itself a quasi-artistic act, pathetic to the end. Whereas normal art only imitates the pathos of the demiurge, an extreme form of violence is demiurgic in its own right.

The visual dimension in speech culture does not pass through filters of individuation nor codes of commodification. Collective bodies do not lower themselves to an admission of the irreduceability of the external; they are internally too pathetic to be able to notice it. Banal visibility is tantamount to desacralization. The invisibility of such irreduceable bodies is guaranteed as was already said, by the domination in culture of a totality of speech–vision which can see everything on the condition that it should neither view anything individually nor take note of the irreducibility of corporeal phenomena. The constant chattering transforms itself into a magical enunciation: discourse becomes speech, knowing nothing external to itself.

Bakhtin's book *The Work of Francois Rabelais*[6], written in the early thirties is like a hymn to the victory of the collective. The erosion of the personological principle at that time was so complete that any form of individuation was seen as somewhat diabolical. In this book the bliss of transfigured collective bodies, "acanonical by their

very nature,"[7] contrasts sharply with reflective gesture identified with the act of "isolation." Individuation as a sin par excellence is the master trope in Bakhtin's work, it is the unmediated, painful reaction to the formation (as a result of collectivization) of a gigantic migrating mass, which de-urbanized the cities while urbanizing the rural places to the extent of literally remaking nature — as in Stalin's plan for "the great transformation of nature," the experiments of Michurin and Lysenko in concordance with other "monumental deeds" of this period. It was the collective that became an object of representation for terrorized individuals ("creative intelligentsia") and moreover any attempts to endow the masses with features of a new Subject collapsed. Against the contemplativity of the preceding artistic tradition a tendency towards collective identity arose, making no exception of modernists' heritage, which was literally entombed in 1935 — in a Suprematist coffin — along with its designer, Kasimir Malevich.

The new representational canon subordinates itself to an "epic" speech vision of collective bodies, opposing itself to interchangeability and rational calculation.[8] The enormous Kafkaesque machine begins to inscribe utterances directly onto bodies, covering its extreme orgiasticity with a flood of speech practices eroding content.

One cannot possibly exit from this orgy of communality without having admitted that semiotic exchange can become the basis of a new principle, independent of potlatch, or, in other words, that an energy which transforms symbolic exchange into semiotic exchange may be squeezed out of the disintegration and stagnation of collective bodies. Only in this case do the profane codes of the external — photovision, fashion, the accountability of the image — cease to run against the "inimical headwinds."

In order to move away from the catastrophic ending which is identifiable with atomization, collective forms of corporeality of speech put to use the tremendous reserves of simulative potential inhering internally in them, and incessantly hyperrealize their very selves, never submitting to revision the very imperative to hyperrealize. What I have in mind here is the simulation of semiological dimensions and of codes of the external, indispensable for the reworking of the canon of communal speech and that of the visual peculiar to Stalin's epoch. As a result, in recent years we have come into conflict, on the one hand, with the reproduction of the phantasmified signifiers of the market, and on the other (on the level of mass culture), with a phenomenon which I would like to term pornoangelism[9], the specific "commodification" of the ideologeme of glasnost on the domestic market of ideas and thoughts.

The fall from grace of transfigured collective bodies is simulated at this stage as inevitable, given all of their attributes of finality and decay. This is not simply imitation. Simulation in a way is the opposite of imitation: if the latter relies on a prototype-original which is subject to reproduction, then the former interiorizes all possible trademarks and features of an original within itself. Simulation erases the line which distinguishes a copy from an original, catapulting itself beyond the boundaries of

truth and lie. This is characteristic of not simply technological simulacra, based upon superindividuation, but also of the primordial hyperreal collective identity which annihilates the reality principle by means of its omnipresent totalized consciousness. In the era of glasnost, the rhetorical necessity of the nondiscursive presuppositions of language are beginning to be admitted; speech in this phase of evolution absorbs into itself the external, face-value trademarks of power — discourse. Counter to this, terror has known no contents external to itself, it has been simultaneously its own interior and exterior, subsuming great doses of death unto itself in the form of all new portions of historical optimism. This was the optimism of the zombie, the shining future without variants.

Like technological simulacra, pornoangels imitate not an original, but themselves, escaping (due to their overwhelming intensity) beyond the bounds of imitation where "art ends and soil and fate breathe." They allow the whole world to pass through them, while they remain themselves. But each level of simulation transports collective bodies to the edge of self-exhaustion, beyond which they may await disintegration, or that on which simulation can no longer rely without employing other means and/or the exterior technics. Since the task of the simulacrum is to prevent the real from coming–into–being, then pornoangelism is, strictly, the simulation of that which endangers the survival of collective bodies. These are not only foreign signifiers, but also penetrating signs and codes of technological simulacra, or the general inevitability of their accepting into themselves the gaze of the Other in previously unseen doses. If we consider mutation a catastrophe, then pornoangelism is anticipated and therefore delayed catastrophism. In order to refute the market, one must simulate all external trademarks of the market; in order to not have a gaze, one must incorporate a number of new signifiers into artistic discourse. At this stage nothing is forbidden or feared except for the "political unconscious." Speaking figurally, society is flying on autopilot, the crew has passed into the passengers' cabin and can already scarcely be distinguished from the other participants of the flight; each may in turn rush to the by-now superfluous steering wheel and turn it, imagining himself to be the pilot. These are childish jokes, pathetic and harmless, passed among the Sots artists, rock musicians, and writers rushing to the wheel. Only those who can influence the programming of the autopilot constitute a danger, as does the fact that the fuel in the tanks is running out.

Simulation is the substitution of falling into "unbodily transformation" (the term of Deleuze-Guattari). The mode of exchange becoming more and more semiologic threatens the low symbolic reciprocity, without which the survival of corporeality of communal speech is impossible (which makes inevitable its collision with the infrastructure of pricing and the market). Pornoangelism mobilizes all resources to avoid reduction to semioticity. Only after the catastrophic advance of the empire of "norms," does a striving towards a hypereffectivity of partial objects gradually get a chance to manifest itself.

Simulation of nonviolence signifies not simply a minimalization of violence, but also a real intoxication by pacifism. If simulation is not infectious, normal imitation results. One may speak of the simulation of a disease when all symptoms are apparent, but the disease itself is absent. Simulation is that to which the opposition health/sickness cannot be applied; as a figure of "coming-into-being," it stands outside this opposition. Simulation serves as a synonym for the seizure of depth by surface. For Soviet visual representation in the epoch of perestroika, specimens of which are presented in this exhibition, an escape from the tyrannical omnipresence of "origins," and from the primacy of incarnation over representation, is the most essential characteristic. This art betrays a diminution of the intensity of incarnation, with its mythical association with "origins."

Power at this stage begins to simulate its own nonobligatory manifestations in great quantities. Thereby, like a snake crawling out of its skin, it liberates itself from surplus legitimation of violence not through narration, but by bodily transfiguration (of the communal,) not discussion, but heavenly transparency and exultation. This surplus legitimation of violence through the very mechanism of violence is a goal in the new phase of the hyperrealization of the world, thereby washing away its bygone imitative doubles, as for example, the surplus of supreme motives for control over the societal.

Signs are appearing which indicate that soon the world will "come to its senses," with the semiotic taking the place of the symbolic, and the market's "prose" supplanting carnivalization. The enormous emotional investment in "potlatch," which it is now customary to call politics, has involved experimental theatricalization in the form of cooperatives (i.e., privately owned businesses), auctions of art works and other zones of phantasmic exchangeability. It is as though a rehearsal of the market is taking place: the shaman is testing the reaction to the once forbidden word and simultaneously embedding it in the unconscious by means of repetitive repetition.

The rehearsal of the market is also a rehearsal of a new visuality, a replacement of iconic, speech–vision by photo–vision. The latter is that with which a whole complex of problems is connected (photography as such constitutes only a small portion of it). Photo–vision is first and foremost control of the details of self-presentation: fashion as the responsibility to change in accordance with codes of marketability, which transforms symbolic exchange into semiological, the placing of the internal (the soul) on the exterior. Meanwhile, in our society, until recently, spirituality was immediately connected to a refusal to translate the symbolic into the semiological, with a terror against the external. Through the "soul," "love," and "kindness," collective bodies were constituted as ecstatic formations which excluded self-identity (without which philosophical reflectivity is impossible). Insofar as my self-identity has no external, spacial unfolding, I live not for myself; my life is ecstatic in relation to its very self, I am given to myself solely as an other. In such a case one can only imitate the

signs of the external, not simulate them. In other words, the better I am as an imitator, the worse I am as a simulator.

In relation to Western signifiers the art of perestroika's time is imitative, but in relation to a typically Soviet art production it is simulative. The imitation of Western codes of creativity gives birth to simulacra, which seems designed for the Soviet artistic context. The imitation of the codes of foreign culture is also akin to a means of the shock therapy of local domestic culture. But one should not forget that Soviet culture has in recent years successfully transferred several strata of its former "reality" to the position of the hyperreal. As a result, the original has become the most pathetic parody of itself, and its simulation has been transformed into a banal imitation. The high effectiveness of the works of the Moscow conceptualists as far as the symbolic dimension of the Soviet context is concerned, is linked to the threat of absorption of local culture into an international context, where it becomes "convertible," thereby receiving the status of normal semioticity (this does not prevent Western dealers from purchasing it as an "original," i.e., self-referential, art production). This observation applies not only to the conceptualists, but to all artists oriented towards an international context.[10] In auctions of the "Sotheby's" type, where Soviet artifacts are being sold, the threat of catastrophe is resolved by what Victor Tupitsyn has referred to as "potlatch"-like practice of "gift-giving," and "gift-receiving" rituals.

The West is more and more becoming the repository of artworks whose pathos does not permit identification with the symbolic side of the semiological, and this at a time when postindustrial society is very advanced in transcoding commodifiable value into an exchange value. The threshold of nontranslatability has become more visible than ever before. An indifference to personality emerges as the flip side of egalitarian humanism, the foundation of potlatch "with no end nor edge." Potlatch utilizes technology for its ends, but requires a miminum of counterfeits, fakes and prostheses, preferring to leave marks on bodies as they are. Its element is the abcesses and swellings of bodies, the surface of which is susceptible to the aggression of a mass and therefore changes constantly. The objects of Oleg Petrenko and Mila Skripkina (the Peppers), on the front surface of which one finds either an eye socket forming or a swelling gumboil.

If the resources for the prolongation of symbolic exchange were unlimited, the logic of the highest-priced poverty in the world could be conclusively crystallized as a system, for which semi-disintegration would be a norm. But the fact is that, in distinction from other known forms of potlatch, such as those of Boas, Mauss, and Bataille, industrial potlatch requires such an abundance of resources for its own continuation, its expenditures are so limitless, that soon enough even the largest country's potential is annihilated. Then, with a fatal inevitability begins the attack of signs, with their banal economic efficiency and calculated profitability. The politics of glasnost are the

simulation of a happy meeting between these perpetually competitive friends. Aggres-siveness at this stage becomes simulative; rehearsal for the ultimate transition commences. The theatricalization of the untheatricalizable — the market — forces infection with its symptoms. The communality of transfiguration presents the kind of unexchangeable, for the sake of which "reality" becomes "hyperrealized" including all erstwhile faces of ideology.

But even the hyperreal cannot do one thing: it cannot hypperrealize itself, hav-ing integrated the semiological as the basis (foundation) for a new symbolic order. To achieve this end, the hyperreal must brutally alter the quality of societal bodies engaged in its production and factually deprive them of their very selves. In order to avoid this kind of a catastrophe, it is prepared to simulate whatever is available. The iconographic stratifications of the avant-garde of recent years serve as such "success-ful" simulations. And this is not surprising: that which appears ruinous from inside the system immediately aids in its survival. The inevitability of mutation — if we (arbi-trarily) consider it inevitable — is overplayed by the simulation of such inevitability and therefore finds itself postponed to an indefinite time. Explosion is supplanted by implosion, a burst by a shaking. Moreover, the arena of the battle for escape from pure semioticity and exchangeability proves to be the market, which can never become what it is meant to be, remaining, in the final analysis, the most rational form of magic.

At the stage of pornoangelism potlatch is camouflaged by normal exchange (i.e., sign exchange). The latter hyperrealizes potlatch, not letting it dialectically turn into its opposite. Their interaction takes the form of what Marcel Mauss termed an "agonistic type of supply," the extermination of signs by symbols.

The "becoming-ill" with Western signifiers is a form of battle with them: the ability to verify the strength of their influence by means of a proximate physical infec-tion, to test the resisting ability of a cultural organism hyperrealized by the simulacrum. In this sense the strategy of the Medhermeneutics (M/H) group can be seen as a striving to the limits of convertibility of cultures: summoning the market they interiorize its symbolic demands in their works but without any trace of engage-ment in its infrastructure, as is the case of the Western simulationist paradigm. In comparison with M/H, the more "folkloric" works of the epoch of perestroika fulfill the same function, perhaps less ambitiously, emphasizing their "Russianness," kitchi-ness, colorfulness, ethnographic decorativity, and other already played–out values. It is as if the Medhermeneuts have stolen some great secret from high technology, and have learned to assemble and dismantle extremely complex toys, by using the tech-nology of a "stabilization of psychedelic phantoms" instead of stolen electronics. The work of the M/H group (for example, their art project, published in the first Russian edition of *Flash Art* in 1989) can be seen as a symbolic equivalent of Jeff Koons' bas-ketballs and Haim Steinbach's shelves. This leads to more of a reflection on the

military-industrial complexes of the East and West than can be seen from a purely technological point of view. These "suspicions" are confirmed by aerodynamically complex objects of the Peppers and a series of recent works by Sergei Volkov, connected to the problem of "scrutiny" in its aesthetico-technical aspect. All of these artistic strategies are connected to a form of "attack" or aggressive escape, differing in principle from the evasive escape favored by members of the Collective Actions group (CA). One can also see in the mimetic codes of Andrei Roiter one who does not deal with unpredictably intensive simulations, but instead meticulously rearranges the formal codes of conceptualism with cliched local signifieds.

To pass into depths of symbolic convertibility, or, if one translates this into the language of infrastructure, to dream of the unlimited cultural possibilities linked to a local system of artistic production, is equivalent to demonstrating (at the level of the Imaginary) a limitlessness that in reality does not exist. For all its peacefulness this is an aggressive enough act which gives short shrift to the reality principle.

The activity of the CA group is therapeutic, linked to the healing of symbolic wounds inflicted by the violence of local socio-cultural life. Here, "therapy" relates more closely to minimalist music (and to John Cage's assertion of the primacy of noise over musical sound), than to the strictly visual Western or Soviet values. CA's recent retrospective, the *Investigation of Documentation*[11] was an interesting effacing of the lines between art and non-art: enlarged black-and-white photographs on the walls and on symmetrically arranged desks were read not as things but as swollen images referring to a twofold eventhood, in which exaggerated recollections of events were liberated from constraints, such as the necessity of socializing, movement to and from, chatting, etc. All this resulted in the so-called "fishbowl" effect which was based on the peculiar, rhythmic minimalism of the hanging of the works: the maintenance of even intervals and dimensions along the entire parameter of the installation, the use of soft quartz lamps to illuminate the photographs, the draping of the walls with black velvet and other devices. In one of the halls the lamps illuminated not the photographs themselves, but the emptiness surrounding them, which, within this context became the main masterpiece. In this environment, in which the viewer was not obliged to see things as works of art, a peculiar satisfaction was achieved.

In recent years the feminization of Moscow's artistic context and the emergence of handcraft as an artistic strategy was due not just to the appearance on the scene of new female conceptualists. Manual in principle, art as handcraft made the resistance of the artistic material irreversible (in the Soviet context this is interpreted also as the de-heroization of the status of art, the privatization of the artistic gesture). The framing of such objects is usually intentionally ironic rather than "earnest." What is being framed is a fragment of the world finally mastered by the author, some sort of worked–out piece of artistic Klondike. In the rugs of Larisa Zvezdochetova, the Bed Routines of Nikolai Kozlova, the works of Igor Makarevich, Elena Elagina,

Masha Konstantinova, Georgii Kizevaliter and in the performances of the "Frame" group (Anna Al'chuk, Mikhail Mikhal'chuk, Mikhail Ryklin), framing is parodied, and what is being framed is authorship.

The banalization of the act of framing — of the utmost importance for modernism — is brought to fruition in these works via the use of prosaic materials: bricks, window frames, stretchers, glass containers, children's toys, ribbons, and so on.[12] Arbitrary framing not only subverts the artist's position as "master," and becomes a fiction necessary for the presentation of the object for contemplation, but also deconstructs the modernist tendency of deifying art.

We may soon hope to see artists create a model superior not only to all that is characteristic of collective bodies at the pornoangelist stage, but also to the monstrous ecstatics of the preceding era of "high terrorism." What is taking place now will be comprehensible only when it may enter into the flesh through the skin.[13] To force to think through the skin, according to Antonin Artaud's maxim, is the actual task; without having set this task, it is impossible to overcome the defensiveness nailed into intellectuals by the hammer of terror. Through this, the path to civil society and the creation of a legitimate Subject will evolve, which will replace the metaphysically unenlightened idea of the Collective Subject.

Translated by Clark Troy

Notes

1. I am particularly grateful to Victor Tupitsyn, whose article, "Ideology Mon Amour (Flash Art, no. 137, November-December 1987, pp. 84–85) initiated the application of a simulationist paradigm to Soviet culture. A number of intellectual codes including those which rely on the concept of "potlatch" in relation to the rituals of the East-West cultural exchange, were also suggested by him in our personal conversations in 1988–89.

2. V.N. Voloshinov, tr. Ladislav Matejka and I.R. Titunik, *Marxism and the Philosophy of Language,* Cambridge: Harvard University Press, 1986 (page numbers not accessible because 1929 Russian edition quoted by Ryklin not available).

3. Ibid., p. 21 (Rus).

4. M.M. Bakhtin, *An Aesthetics of Literary Art,* Moscow: 1979, p. 297.

5. Katrina Clark, in her book *The Soviet Novel: History as Ritual,* dedicated to an analysis of an archetypology of the Stalin-era novel, writes: "A hero sets out consciously to achieve his goal, which involves social integration and collective rather than individual identity for himself."

As a result the author ceases to be the master of the text, receiving the status of a copyist of a foreordained fable. All codes within it are determined by the collective structure of utterance; "the force of the author's 'I'is manufactured of external factors," continues Clark.

6. Translated into English as *Rabelais and his World* by Helene Iswolsky, 1968, MIT (or 1984, Indiana University).

7. Mikhail Bakhtin, see above, s. 36 po rus (must find!). The null performativity of language is connected with the negatin of that, which Deleuze and Guattari (in the work *Mille Plateaux,* Minneapolis: University of Minnesota Press, 1987, p. 77) (among which they also include visuality independent of language). In the absence of these nondiscursive predispositions both discourse in the materiality of its phenomena, and also the implicit nondiscursive predispositions of

language (i.e., the external internally inherent in language). In undevelopedness of the initial visual codes in panoral culture serves as an object of interest for the classical Muscovite conceptualism of Ilya Kabakov in his famous installations *Fly with Wings, Room,* etc.

8. It does not therefore follow that we should mistake the visual canon or oral culture with the problem of vision in the Russian tradition as such. OPOYAZ and all of the twenties' Formalism — Tynyanov, Shklovsky, Eikhenbaum — stood more for the visualization of literary context (hence their tremendous interest in the cinema, photography and other means for the "technical production" of images novel at that time), than for the "literarification" of graphic signs. Tynyanov's conception of byt (nb. tr: A term which tends rather successfully to resist translation, roughly signifying a certain quotidian ennui or Weltschmerz, but is discussed most thoroughly in Roman Jacobson's "On a Generation that Squandered its Poets," (tr. Edward Brown) in *Twentieth-Century Russian Literary Criticism,* ed. Viktor Erlich, New Haven: Yale University Press, pp. 143ff.) includes within itself enormous layers of unverbalizable experience not grasped by the panoral conception of the "Bakhtin Circle."

Visualization is impossible without individuation and the latter is so without the functioning of codes of commodification. Only the presence of these infrastructural realiae force the semiotic to "become infected" by the secondary trademarks of the symbolic. The sifting of the symbolic through the semiotic comprises, in part, an index of culture's economic health.

The exceptional domination of collectivist corporeal practices in culture forces the panoral conception to appear self-evident from the point of view of an internal observer. This is an inevitable optical illusion.

9. Pornoangelism does not know the temptation of the transcendental; it is entirely immanent in culture. Its dissemination in Soviet culture is logically related to the fact that its professionalism stands extraordinarily close to the mainstream of mass culture.

10. This leaves us alone with the riddle of the Sphinx: "One wonders whether alternative Soviet Art will finally become integrated into international cultural discourse or be doomed to even further marginalization as an ultimate exotic resort for a libidinal investment of Western orientalist fantasies and desires." With these words, Margarita Tupitsyn concludes her monograph on marginal Soviet art (*Margins of Soviet Art,* Milan: Giancarlo Politi Editore, 1989, p. 137).

11. This exhibition took place in the Krasnogvardeisky Region Exhibition Hall from November 15th through the 30th, 1989. It was organized by J. Bakshstein, E. Elagina, and G. Kizeval'ter.

12. ". . .on detaille les extraits, les fragments détachables comme des signatures (machine à écrire ou plumier rouge, lunettes, parapluie, chapeau, gilet, chaise, cigare, etc., mais aussi les casques ou fusils à lunette), artefacts, appareils à voir, à écrire, à tuer, fetiches monumenteaux ou emblèmes miniscules."
Jacques Derrida, Paris: Flammarion, 1978, p. 209.
". . .there is a detailing of extracts, fragments detachable as signatures (typewriter or red pen case, spectacles, umbrella, hat, waistcoat, chair, cigar, etc., but also helmets or rifles with telescopic sights), artefacts, apparatuses for seeing, writing, killing, monumental fetishes or miniscule emblems."
Jacques Derrida, tr. Geoff Bennington and Ian Mcleod, *The Truth in Painting,* Chicago: University of Chicago Press, 1987, p. 181.
13. This temptation is realized at the level of discourse by Paul Virillio in his conception of "the speeds of bodies" (found in his books, *Speed and Politics, The Aesthetics of Vanishing* and elsewhere). We should not forget in this connection also De Sade, Bataille, Blanchot, Klossowski, Bel'mer, Artaud, Deleuze. . .

Artists in the Exhibition

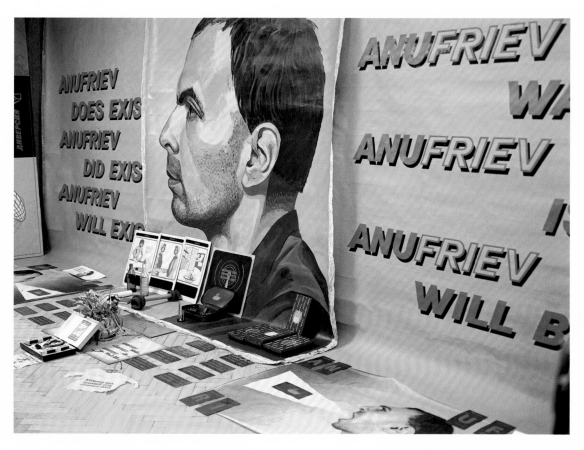

Africa (Sergei
Bugaev), *The
Orthodox Totali-
tarian Altar in
the Name of
Anufriev,* 1990,
mixed media

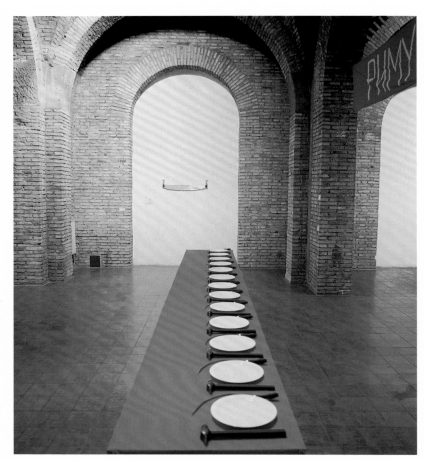

Andrei Filippov,
The Last Supper,
1989, mixed
media

Ilya Kabakov,
*Kitchen #2:
Voices*, From *10
Characters*,
1988, mixed
media

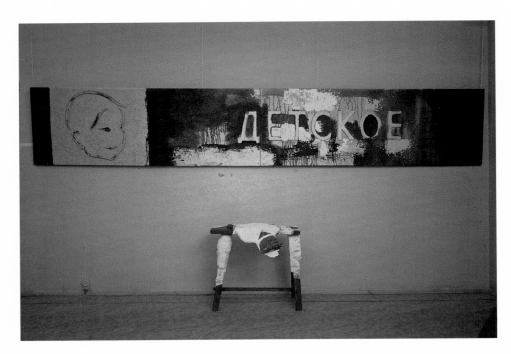

Igor Makarevich
and Elena Ela-
gina, *Children's*,
1989, mixed
media

Timur Novikov,
Aurora, 1988,
mixed media on
textile, Photo
by Chuck
Mayer, Boston

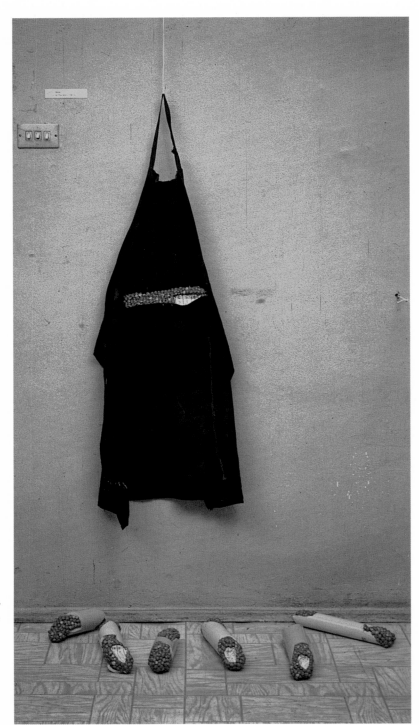

Peppers (Ludmilla Skripkina, Oleg Petrenko), *Bone Marrow,* 1989, mixed media

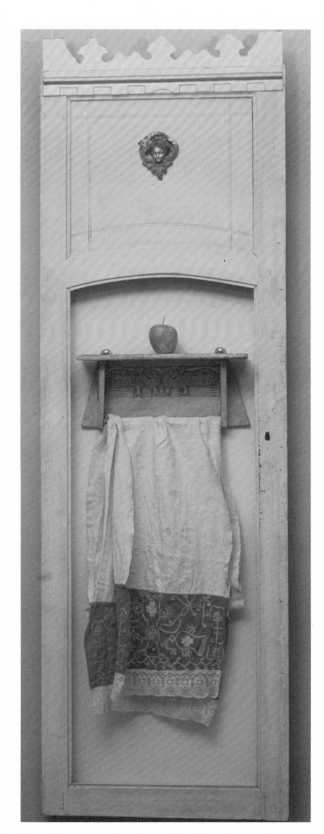

Konstantin
Zvezdochetov,
Towel Holder,
1989, mixed
media

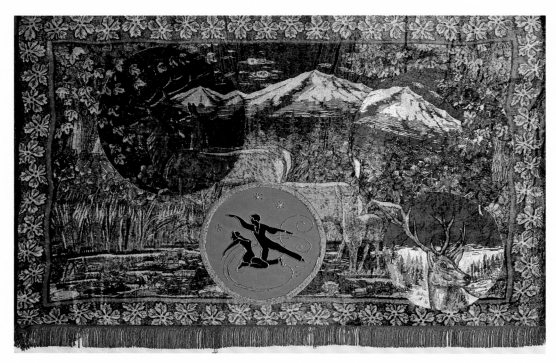

Larisa Zvez-
dochetova,
Skater on Rug,
1989, carpet,
lacquer on wood

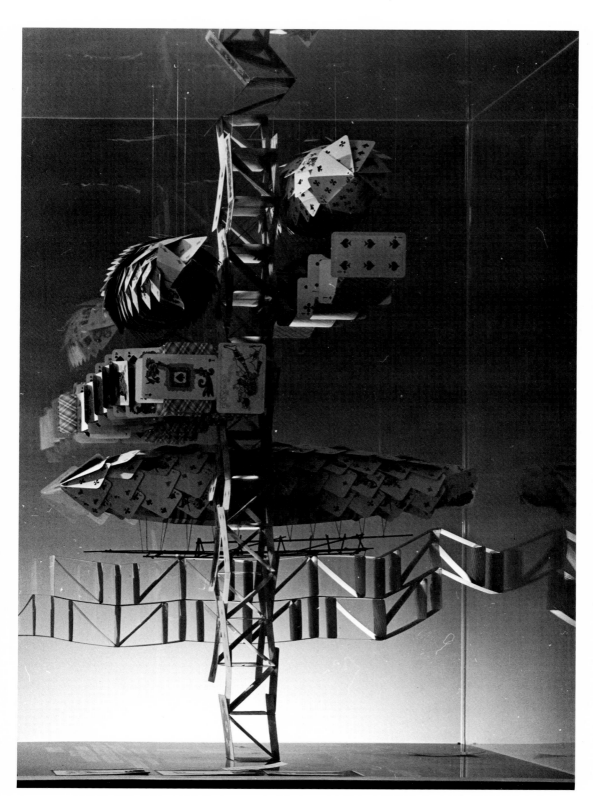

Yuri Avvaku-
mov, *Space
Bridge,* 1989,
mixed media
with playing
cards

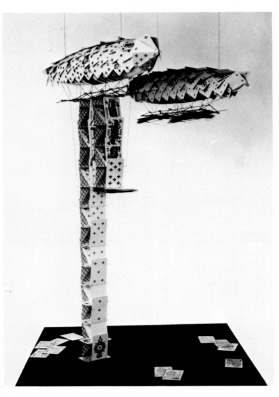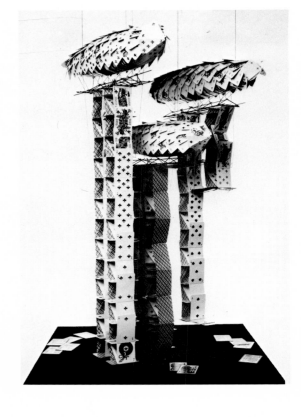

Yuri Avvaku-
mov, *Space
Bridge*, 1989

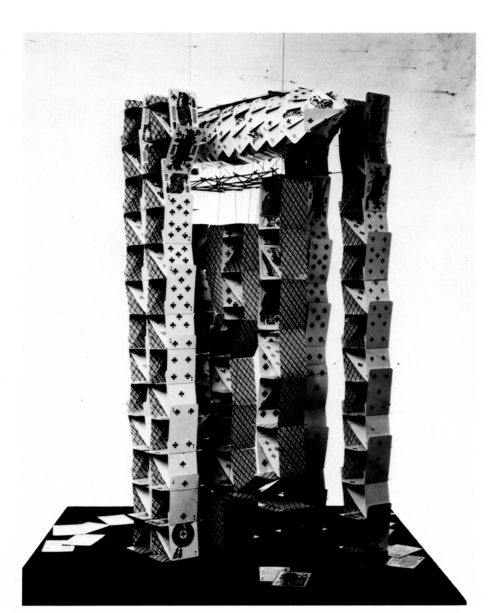

Yuri Avvaku-
mov, *Space
Bridge*, 1989

Yuri Avvaku-
mov/Yuri Kuzin,
*Youth Residential
Complex in
Imaginary City of
Magnitogorsk,*
1987, silkscreen
print

Alexander
Brodsky and Ilya
Utkin, Site
specific installa-
tion, 1990

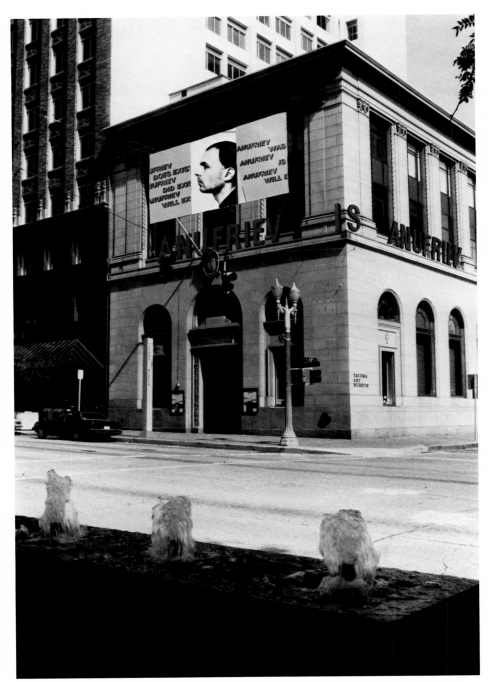

Africa, *The Orthodox Totalitarian Altar in the Name of Anufriev,* 1990, Proposal for Tacoma Art Museum facade, Tacoma, Washington

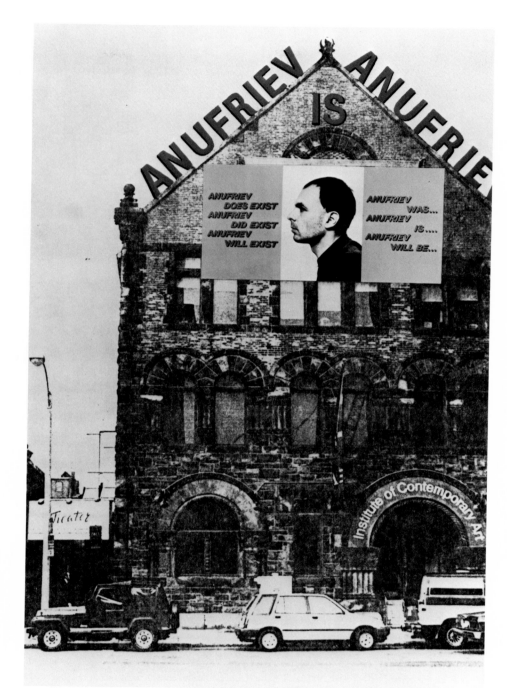

Africa, *The Orthodox Totalitarian Altar in the Name of Anufriev,* 1990, Proposal for The ICA facade, Boston, MA.

Notification No. 55

Africa

There are forms of productivity which allow material gain, and it follows that there are forms which do not allow material gain, such as science or art. The specific immaterial fruits of these forms of productivity are economically equal from the point of view of the goal, which is the more complete satisfaction of the material, social, and spiritual needs in an individual's comprehensive development.

This is why it is currently our view that an economic approach to experimentation in spiritual pursuits is imperative within the context of artistic productivity. Similarly, the experimental connection between material and spiritual productivity depends on the historical precedence set for the forms of material gain, which is the focus of activity within any socio-economic system.

Spiritual productivity falls within an independent sphere of social activity and manifests a special output. Here, in the capacity of productivity, labor is something quite different from material productivity, creating a not quite material product, but a product of a special sort.

At the same time, the connection between material and spiritual productivity is far from simple and uni–dimensional in meaning. As far as art is concerned, it is known that the prescribed periods for its inception are by no means in accordance with the general development of society, but, rather, with the same development of society's material foundation.

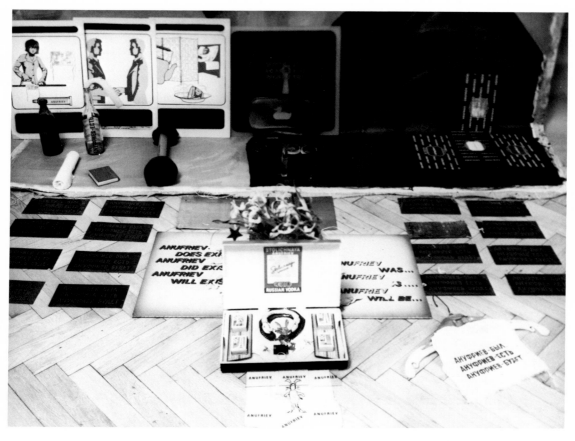

Africa (Sergei
Bugaev), *The
Orthodox Totali-
tarian Altar in
the Name of
Anufriev*, 1990,
mixed media

Collective
Actions, From
the Performance
*Ten Appear-
ances*, 1981,
black and white
photographs

Ten Appearances

Collective Actions

In the middle of a large, snowed-over field surrounded by a forest, together with the action's organizers, strode ten participants, knowing neither the name of that in which they were about to participate, nor what was to happen.

Ten spools on vertical nails were affixed to a board (60 x 90 cm) which was laying upon the snow. Each of the spools was wound with two to three hundred meters of strong, white thread. Each of the participants was required to take the end of a thread from one of the spools and, unraveling the thread from the spool, move in a straight line into the forest surrounding the field. Thus the ten participants were to have dispersed from the center of the field in the following directions:

The participants were instructed to move in a straight line as far as the forest and then, entering the forest, to continue on into the depths of the forest for about another fifty to one hundred meters, or to the point where the field could no longer be seen. Each of the participants traveled three to four hundred meters. Walking in the field and forest entailed a considerable physical effort, as the snow ranged from half a meter to a meter in depth. Having completed his trek, each participant (also according to prior instructions) was to pull to himself the other end of the thread (which was not attached to the spool), to which a piece of paper with factographic text (the last names of the organizers, time and place of the action) was affixed.

Insofar as no further instructions had been given, each participant, having extracted his factography, was left to his own discretion as to further action; they could return to the field's center, where the organizers remained, or, not returning, leave this place behind, moving on further through the forest.

Eight participants came back to the center of the field within an hour, moreover seven of them returned along their own paths, and one (N. Kozlov) along a neighbor's path. Two participants—V. Nekrasov and A. Zhigalov—did not return.

The returning participants received photographs (30 x 40 cm) glued to cardboard from the organizers. Each photograph depicted the portion of

the forest into which the participant receiving that photo had walked at the beginning of the action, and the scarcely distinguishable figure of a man emerging from the forest. The photographs were outfitted with label/ signatures upon which were written the last names of the action's authors, the action's name *Ten Appearances,* and the event "represented" in the photograph, for example, "The appearance of I. Chuikov on the first of February, 1981," and so on. These photographs were taken within the week before the action: the action's organizers photographed in a "zone of indifferentiation" in the very same directions in which the participants had been directed and from whence they had returned.

Thus the name of the action and its full significance became clear to the participants only at the moment when they received the photographs, and not when they pulled the factographic documents, which signified only the completion of the first stage of the action—the distancing of the participants into portions of the forest visually isolated one from another (at the terminal points of their paths out from the center of the field, in the depths of the forest, the participants could not see each other, as the interstices between these points measured no less than four hundred meters). During the action, photographs were taken of the actual appearances from the forest. These photographs could be distinguished from those handed to the participants at the conclusion of the action by the differing conditions of the forest (snow which had covered the branches of the trees a week before the action had melted away), and by the absence of the quotation marks, which on the first photographs had been placed around the names of the events depicted on them, i.e., in the given circumstances the simple appearance of I. Chuikov, I. Kabakov, I. Pivovarova and so on. The figures of the participants emerging from the forest were practically indistinguishable from the figures in the first "metaphorical" photographs, owing to the fact that they were taken from equal distances (in the "zone of indifferentiation"). The function of these "metaphorical" photographs was, in the case of the participants' return, to indicate only the fact of their return (which was utterly volitional, as no instruction to return had been given), without adding any supplementary meaning to their prior acts of walking off and dispersing into the depths of the forest. At the same time these "metaphorical" photographs were signs of time extrademonstrational (for the participants) to the event and were included in the structure of the action and served as its "empty act." In other words, they were signs of the time between the "end" of the action and the moment when they were handed the photographs indicating their appearance (or return) from the forest, which the participants did not recognize and could not have recognized as the signified and culminating event in the structure of the action.

The fact that of the ten possible appearances only eight, and not all ten came to pass, represents in our view not a failing of the action but, on the contrary, underscores the realization of zones of psychic experience of the action as aesthetically sufficient on the plane of the demonstrational field of the action as a whole. This is to say that the planned appearance in reality turned out to lie entirely in the extrademonstrational time of the event—the participant appeared from a non-artistic, non-artificially-constructed space.

February, 1981
Moscow Province, Savel, "Kievi-Gorky"

Andrei Monastyrsky, Georgii Kizevalter, Sergei Romashko, Nikita Alekseev, Igor Makarevich, Elena Elagina, Nikolai Panitkov

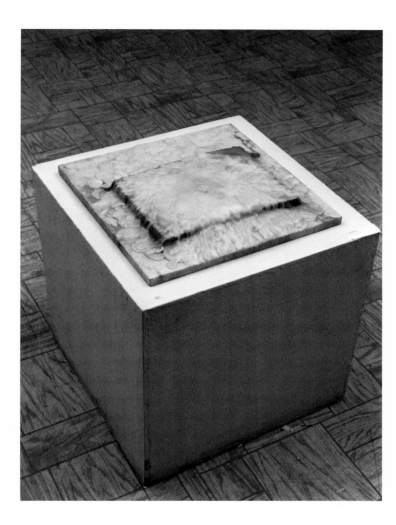

Andrei Filippov,
Old Testament,
1989, mixed
media

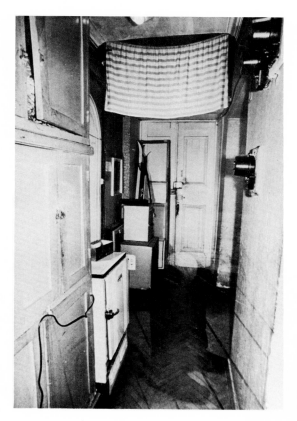

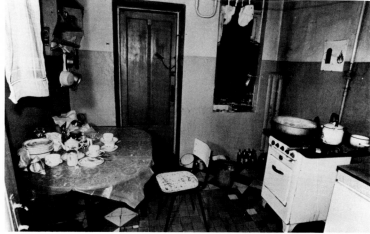

Ilya Kabakov,
*Olga Georgievna,
Something Is
Boiling!* 1984,
Folding album,
64 pages

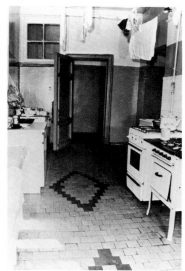

Komar &
Melamid, *God,
New Jersey,
U.S.A.*, 1990

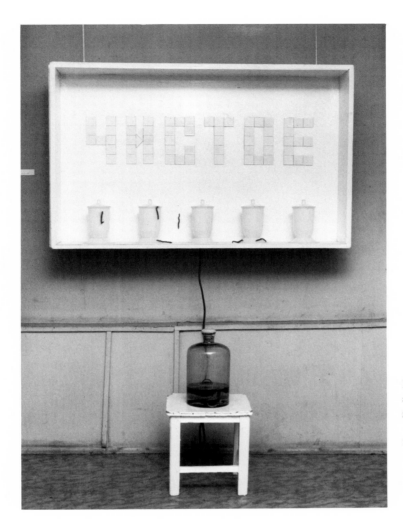

Igor Makarevich
and Elena Ela-
gina, *Pure*,
1989, mixed
media

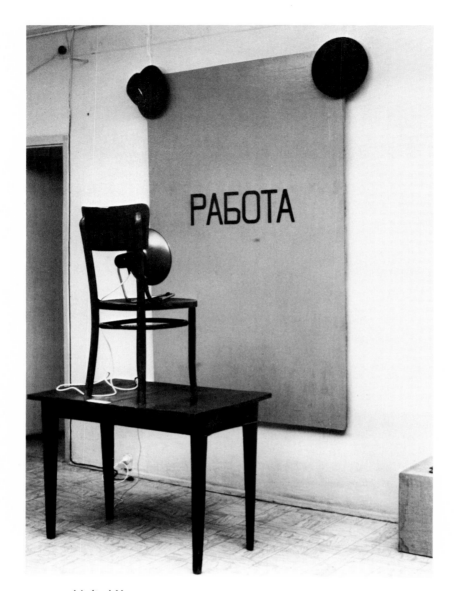

Medical Herme-
neutics (Sergei
Anufriev, Yurii
Leiderman,
Pavel Pepper-
stein), *Work*,
1989, mixed
media

Medical Hermeneutics, *New Year*, 1990, Drawing of site specific installation

Medical Hermeneutics

The inevitable scarcity of usable ideas, independent of quantity or quality, gives the functional sufficiency of an apparatus the opportunity to be realized. The latest work is in the reduction of the clearance between ideas or disciplines; it narrows this clearance by way of translation and converts one of these disciplines into another, for instance, thermotechnology into mechanics, electrode dynamics into electronics, chemistry into geology, geology into chemistry, etc. In this case the apparatus does not belong to the "idioevolution" of any concrete discipline; rather it appears as a product of extrapolation (as a product, the creation of which is the goal of technological ornaments) of one with the methods of the others. Simultaneously, it appears as a plastic functionality, which the designer cunningly places between the partitions of each with gnostic fragments.

In such a manner, the apparatus is positioned at the junction between the real and the ideal, which is that strip of surf, where the waves of ideas strike the shore of organization. The maelstroms, which are manifested under these conditions and are the possible exceptions to the rules, are admitted into the domain of "no works," in which these or any principles and simpler fluctuations stretch and annihilate understanding. The apparatus organizes and divides the surf of ideas, correlating it with needs. Rightly so, because this happens by way of organizing to the greatest advantage the distinctive "comprehensible reservoir within the domain" of certain ideas. We have in mind the design for a technological set up, inside of which any scientific law can be realized in its optimally reduced form, in as much as the facts, which are capable of encompassing and eroding its activities, are taken out of the parentheses of the work environment. In the capacity of examples, it can bring about a vacuous smelting (in the absence of acids, which oxidize metals), and the superconductive instrument is loaded onto a thermostat (the principle of super conduction in its pure form, is only realized at the absolutely lowest temperature.)

Medical Herme-
neutics (Sergei
Anufriev, Yurii
Leiderman,
Pavel Pepper-
stein), *Untitled
Collages (#51)*,
1989, mixed
media

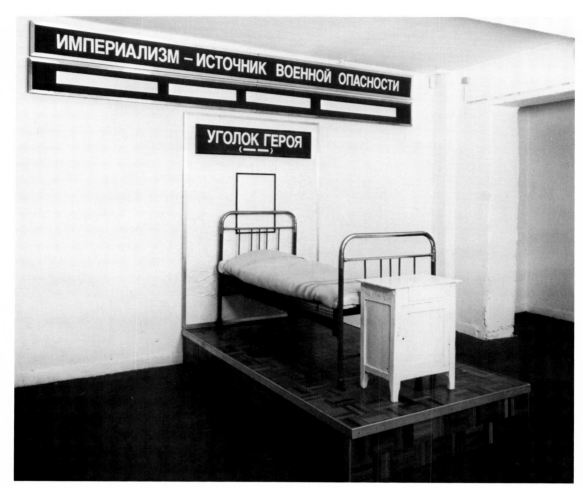

Sergei Miro-
nenko, *Room for
a Hero,* 1989,
mixed media

Andrei Monas-
tyrski, *Finger*,
1978, mixed
media instal-
lation

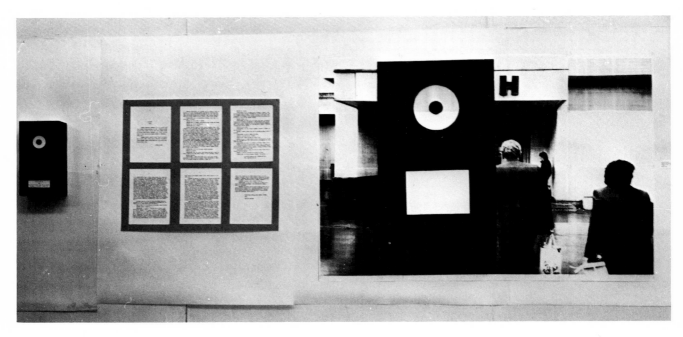

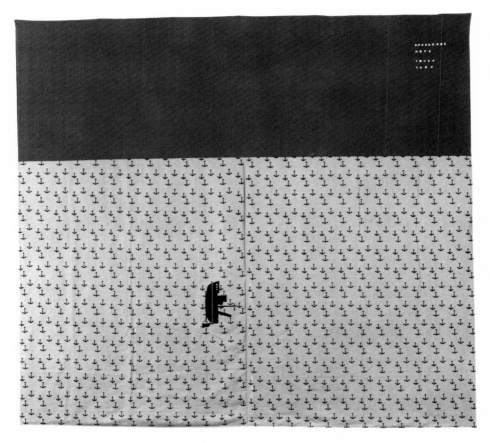

Timur Novikov,
Aral Sea, 1989,
mixed media on
textile, Photo
by Chuck
Mayer, Boston

Peppers (Ludmilla Skripkina, Oleg Petrenko), *Jar*, 1988, mixed media

Andrei Roiter,
Punctuation,
1989, oil and
plaster on
canvas

Andrei Roiter,
*Monument
(Pushkin)*, 1989,
oil and plaster
on canvas

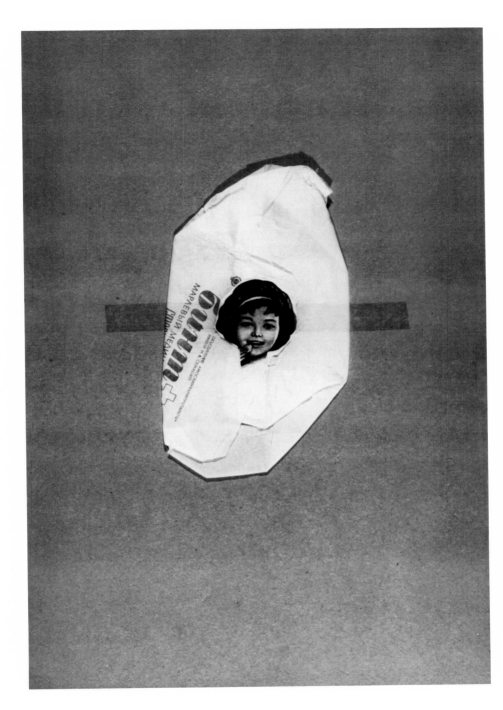

Maria Serebria-
kova, *Untitled
Collages* (#61),
1989, mixed
media

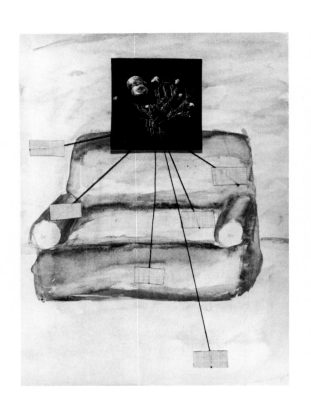

175

Maria Serebria-
kova, *Untitled
Collages* (#61),
1989, mixed
media

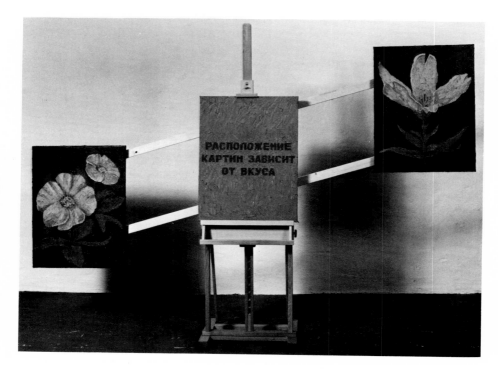

Sergei Volkov, *Taste,* 1989, mixed media, "The arrangement of the paintings depends on taste."

Sergei Volkov, *Thumb,* 1988, oil on canvas

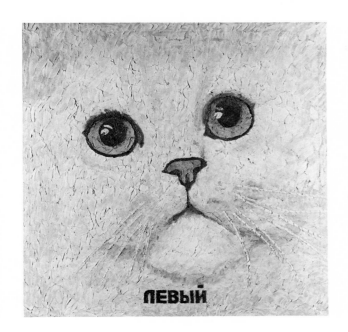

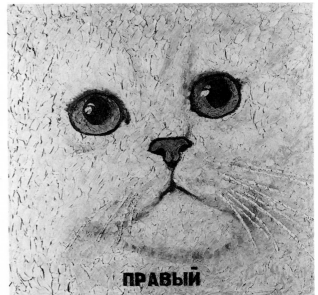

"Stereoscopy is not possible in painting."

Sergei Volkov,
Cat, 1988, oil
on canvas

Vadim Zak-
harov, *After the
Fur,* 1989, plas-
tic, plaster,
paper, cement

Vadim Zak-
harov, *Two Years
Between Hiding
and Infection,*
1989 oil, plas-
ter, paper on
canvas 6 parts

Konstantin
Zvezdochetov,
*Box and Bag
with Sand*, 1990,
drawing of
mixed media
installation

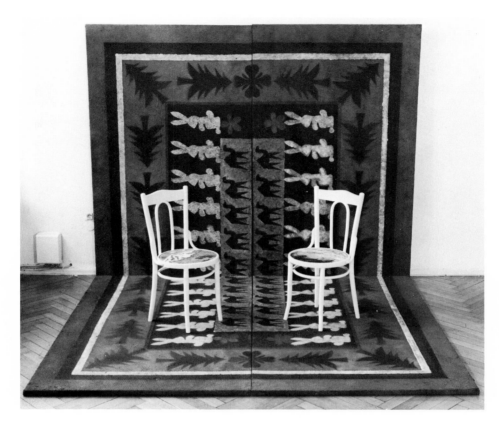

Larisa Zvez-
dochetova,
*Installation with
Two Chairs,*
1989, mixed
media

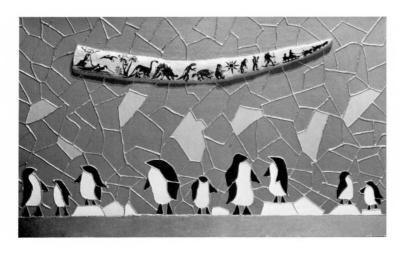

Larisa Zvez-
dochetova,
Chukot Legend,
1988, mixed
media

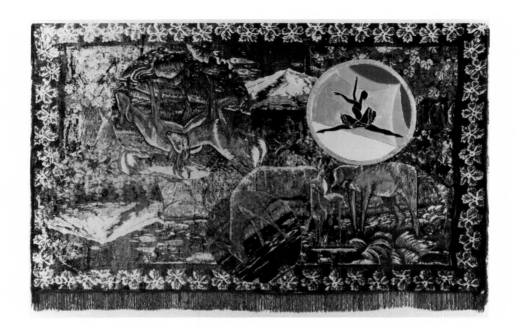

Larisa Zvez-
dochetova,
Skater on Rug,
1989 carpet,
lacquer on wood
4 parts

The Image of Reagan in Soviet Literature

Dmitri Prigov

A new President of the United States
has been elected
The old President of the United States
is damned

But so what—so, a President
So, the United States
Still it's sort of interesting—the President
of the United States

The Chinese attacked Vietnam
Our press condemned it
Still I wouldn't condemn them
They're just poor people too

They're simply a tool in the hands
Of objective historical forces
God has punished them
By turning them into Revisionists—they even make themselves sick

Far off is all-suffering Afghanistan
Nearby are my all-suffering people
From one suffering to another
An airplane is flown as a gift

And in the airplane are military forces
And in the military forces are people
People—perforce they are always lazy
If they weren't sent, they wouldn't hurry there on their own

They don't love us
The way Stalin loved us
They don't destroy us
The way Stalin destroyed us

Without his almost female tenderness
Without his male cruelty
We'll soon feel boredom from feeling bliss
Like some kind of Merican
You and I won't be able to tell them apart

The American President
With all his soul longs for a second term
But the simple Soviet dissident
Doesn't want to be given any term at all

So what attracts him to a term
It's strange—it's what attracts the President:
Each of us in this world is at our post
And it's not in our power to change it

So they were seated
On the same branch
One Lenin Lenin
The other Lenin Stalin
Having a quiet talk
Way above everyone
Their feathers fluttering
On the edge of the land
That eastern land
On the western brink
At the center of the world
Branches on the brink

Once again the Poles have plots for Moscow
One can understand it—it's the capital of the world
In the beginning Solidarity, and a junta
But later—straight off to Moscow

It's like forty-one, but they can't sue and win now
The land is immemorially Russian
Nope, dear comrade Jaruzelsky
You will never see the conquest of Moscow!

According to reports from the foreign press
And press reports from Tass
In the capital of Islamic Iran
Militant reactionary students
Breaking international laws
And bilateral agreements took hostage
The Soviet Embassy personnel
All attempts through diplomatic channels
To gain release of the Soviet citizens
Have been unsuccessful

Then a barely audible voice in the midst of the enemy ranks
The voice of Morse code wafted from Teheran
Triumphant and sorrowful:
We call the fire down on ourselves:

One day Dostoevsky spotted Pushkin:
Little bird, fly into sight
And then I will tell you what to do
So that in our exile together we'll be happier

But Pushkin replied: get out of here, damn it!
A poet's free! Nothing bugs him!
What's he need your boring suffering for!
Wherever God wants him—there he sits pretty!

Into the cosmos the Americans have sent
Their supernew cosmic ship
So that from out there, from God's own spot
They can destroy us with lasers—Fuck!

It'd be o.k. with swords or point blank
Or from the water or from the ground or from tanks
But from the cosmos, where there are only God and the stars!
I'm sorry but there's nothing sacred!—
Fuck!

Shostakovich—our Maxim
Fled to the German nation
Jesus, what kind of madness
To flee not to us but to them
And not only that but to Germany

And if one considers it rightly
Then his father's symphony
The Leningrad is directed right
Against the bastard, his son
That's what happens

He's not Chinese, kind of
Not Merican, kind of
Not a Jew, kind of
But not Soviet, kind of
So just who is he going to be?
Giscard d'Estaing, kind of
Or Mitterand, kind of
All in all, something of that kind
One of those French kind of people

So, the Mericans don't want
To complete an agreement with us
Obviously, they want to
Cheat us and to put us in prison

Everything their way; they'll gear up
And bend us with iron
Well they seem to gear up from the outside
But one has to gear up from within

In the beginning it's always the same
With these Pollacks
There they promoted Lech
Walesa in the beginning

But there are different Chopins
Stern Mitskevichs
And Pushkin-Suvorovs
And the brothers Karamazov
On our side

Anyone who wants to very much will see
A Russian—what he is
The thing is, anyone who sees him
As he is, that's how he is
Let's take Lenin—he saw
A Communist
But Solzhenitzyn—he saw
A Christian
So what—so it goes
Only the thing is—who's got the power

In order to establish a military regime
One has to shut down the sewer system
Not one civilized nation
Could survive

When feces float past
Since the proud spirit of struggle is noble by nature
It would suffocate in this shit
And completely die in the people

Reagan doesn't want to feed us
So what—he'll miscalculate
Since it's only there that they calculate
That one has to eat to live

But we don't need his bread
We will live on our own idea
He'll suddenly wake up: Where are they?
And we'll be already inside!

Who is that semi-nude
He stands among the branches
And sings powerfully
Like a winter nightingale

Well, pay no attention!
We have one like that
Alexander Pushkin—
The Russian androgyne

Let's say the Chinese wage
War on us—what would happen?
Who would win?
Probably the Chinese would win
But maybe our side would win
But all in all—friendship will triumph
We are brother nations

I propose to fight for peace against the U.S.
And against Chile and China
Appearing in Paris before Congress
To expose them, exuding greatness

And to advance the Communist cause
Invincible and almost mystical
Which doesn't even need proof
Being already deep in their hearts, the creeps

The case for peace is essentially lost
Because God doesn't want us
To settle down with enemies in the distance
So he settles us in our neighborhoods

Let's say we make friends with Argentinians
In order to settle down side by side
Ah, you see, he settles us down with Chinese—
So where's the peace and happiness

They live without thinking
The reactionary way
So what, it's understandable
But forgivable—no way

Or more precisely, they are forgivable
But understandable—no way:
Those reactionaries
They live the life of ease

Reagan doesn't want to give us
His pipes so that Soviet gas
Could flow as our representative
Through these pipes to the West
So what
Let this thread be cut
But in essence it's as invincible
As life, as light, as songs for them
All by itself, it will break forth without pipes
Our gas

Well we can ask if the Lithuanians
The Latvians different Estonians
Can take Russia as their mother
Land deeply into their hearts
So that love can be vast
Of course they can—who's stopping them

Well, clearly Reagan is a crazy beast
But he's not cut off
From truth—inside him, quiet and holy
There's a tiny bud
Of our objective idea, and when
The bud blossoms into consciousness
Then his heart will bloom like a rose
And this beast will lie down like a lamb
And he won't bite

So Reagan enticed them over to himself
Seduced them with golden embraces
But God wouldn't permit it
Because we ourselves are the brothers of the Chinese

We've become their kin with our flesh and myths
We share our native shambal
Because with the Chinese we are Scythians
And you—whores and the evil integral

Friends—they're complicated people
Here for example we've got the Chinese
Impossible to imagine how they injured us
And nevertheless they are friends, our friends

And then enemies too are complicated people
Here for example we've got the Mericans
They send us all kinds of goods
And nevertheless they are our enemies, the motherfuckers

Now there's our representative to the U.N.
He has stayed in America again
And clearly he imagines
What now he has given up forever
Or rather he imagined it before
When he properly represented
Us to the U.N.

There's a little house in Rostov
Within a little garden
And what does Reagan need here?
Why does he disrupt peace here?
Why does he completely disrupt peace?
This little house, this little garden
It's simply like this—for the sake of being
Irrational

In the West there are Communists
And we have lots of Communists too

In the West there are Soshulists
And we have lots of Communists too

In the West there are Christians
And we have lots of Communists too

In the West there are God knows what
And we have lots of Communists too

Uncle Reagan, help!
Here they are—the Communists
I'm just a poor little kid
I can barely make a squeak

Wait, my child
I'll take a neutron bomb
Everything will go to hell, I'll smash
It all, and they won't trouble
You
Little corpse

Translated by Lyn Hejinian and Elena Balashova

Artists' Chronologies

Sergei Anufriev, (member of Medical Hermeneutics)

Born 1964 in Odessa. Lives in Moscow.

1989
The Green Show, Exit Art, New York, catalogue.
Moskau-Wien-New York, Wien Messepalast, Vienna, catalogue
Expensive Art, Palace of Youth, Moscow
Perspectives of Conceptualism, Third Exhibition of Avantgardists' Club, Exhibition Hall at Avtozavodskaya, Moscow.

1988
Iskunstvo: Berlin-Moskau, Bahnhof Westend, West Berlin, catalogue.
Second Exhibition of Avantgardists' Club, Exhibition Hall at Avtozavodskaya, Moscow.

1987
First Exhibition of Avantgardists' Club, Exhibition Hall at Avtozavodskaya, Moscow.
17th Youth Exhibition, House of Artists, Exhibition Hall at Kvznetsky Most, Moscow.

1986
Aptart, New Museum of Contemporary Art, New York, Catalogue.

1985
Aptart, Washington Project for the Arts, Washington, D.C., Catalogue.

1983
Aptart en Plein Air, Aptart Open-Air Exhibition, Moscow

Yurii Avvakumov

Born 1952 in Moscow. Lives in Moscow.

1989
Architecture and Imagination, Fort Asperen, The Netherlands, catalogue.
Concepts in Soviet Architecture: 1917-1988, West Berlin, catalogue.
Paper Architecture: New Projects from the Soviet Union, Deutsches Architektumuseum, Frankfurt am Main, Germany, catalogue.
Inventor '89, Paris.

1988
Nostalgia of Culture, Architectural Association, London, catalogue.
Paper Architecture from the USSR, La Grande Halle de la Villette, Paris, catalogue.

1986
Paper Architecture, SKVC Gallery, Ljubljana, Yugoslavia.

Alexander Brodsky and Ilya Utkin

Born 1955 in Moscow. Live in Moscow.

Selected Awards

1988
First Prize (architecture), *East Meets West in Design Competition,* Jacob K. Javits Convention Center, New York

1987
Honorable Mention, *Central Glass Competition,* The Intelligent Market, Tokyo

1986
Second Prize, *Central Glass Competition: A Glass Monument to the Year 2001,* Tokyo

1985
Second Prize, *Shinkenchiku Competition: Bulwark of Resistance,* Tokyo

1984
Second Prize, *Central Glass Competition: A Glass Tower,* Tokyo

1983
Third Prize, *Shinkenchiku Competition: A Dwelling with Historicism and Localism,* Tokyo

1982
First Prize, *Central Glass Competition: Crystal Palace,* Tokyo

1978
Second Prize, *OISTT Competition: Theater for Future Generations,* Paris

Solo Exhibitions

1990
Ronald Feldman Fine Arts, New York

1989
Alexander Brodsky and Ilya Utkin, University Art Gallery, San Diego State University, San Diego

Selected Group Exhibitions

1989
Architecture and Imagination, Fort Asperen, The Netherlands; catalogue
Soviet Architecture: 1917-1987, Amsterdam, The Netherlands; catalogue
Concepts in Soviet Architecture: 1917-1988, West Berlin; catalogue
Paper Architecture, Antwerp, Belgium
Paper Architecture: New Projects from the Soviet Union, Deutsches Architekturmuseum, Frankfurt am Main; catalogue
East Meets West in Design, Jacob K. Javits Convention Center, New York; catalogue
Exhibition Diomede, The Clocktower, New York

1988
The City of the World and the Future of the Metropolis, 17th Trienalle, Milan, Italy; catalogue
Inventor '89, Paris, France
Present Tensions: 25 Years of Irreverence in Architecture, The Clocktower, New York
Nostalgia of Culture, Architectural Association, London; catalogue
Paper Architecture from the USSR, La Grande Halle de la Villette, Paris; catalogue

1986
Paper Architecture, SKVC Gallery, Ljubljana, Yugoslavia

Sergei Bugaev ("Africa")

Born 1966 in Novorossisk. Lives in Leningrad.

1988
After a meeting with John Cage in Leningrad, was selected as designer for new Merce Cunningham Dance Company production which premiered in New York, 1990

1987
Stage designer and performer with the group Popular Mechanics, an experimental orchestra which has performed in Russia and Europe. One of their performances included Sergei Anufriev, Nikita Alexeev, Sergei Volkov, et al.

1983/1986
Exhibits in Leningrad, Moscow and the Baltic states

1983
With Timur Novikov he helped to organize ASSA in Leningrad, an underground organization of unofficial artists, musicians and filmmakers.

1982
First showing of paintings at an apartment exhibition at the studio of Timur Novikov.

"Africa" and Novikov

Joint Exhibitions

1989/1990
Green Show, Exit Art, New York

1989
Red Wave, Sawtelle Gallery, Los Angeles
Afrika & Timur Novikov, The Raab Gallery, London and Berlin
Soviet Art from Leningrad, The Tate Gallery, Liverpool
The First North American Exhibition of the Friends of Mayakovsky Club, P.A.J. Gallery, New York
Live from Leningrad, Galerie Kaj Forsblom, Turku, Estonia and Helsinki, Finland
The Friends of Mayakovsky Club, The Russian Museum Leningrad

1988
The New Ones from Leningrad, The Culture House, The Central Huset, Stockholm
Friends of Mayakovsky Club Exhibition, Amsterdam, The Netherlands

1987
United Museum of Creative Community, Leningrad
New Artists from Leningrad, Young Unknown Gallery, London

1986
New Forms, Group Exhibition of the New Artists, Vodocanal Club, Leningrad
New Artists Exhibition, 17th Youth Festival, Artists' House, Moscow

Collective Actions Group

(Georgii Kisevalter (b. 1955), Andrei Monastyrsky (b. 1949), Nikolai Panitkov (b. 1952), Igor Makarevich (b. 1943), Elena Elagina (b. 1951), Sergei Romashko (b. 1952) All live in Moscow.)

Group Exhibitions

1989
The Green Show, Exit Art, New York, catalogue.

1989
Expensive Art, House of Youth, Moscow

1988
Ich Lebe, Ich Sehe: Kunstler der Achtziger Jahre in Moskau, Kunstmuseum, Bern, catalogue.

1988
Second Exhibition of Avantgardists' Club, Exhibition Hall at Avtozavodskaya, Moscow

1987
First Exhibition of Avantgardists' Club, Exhibition Hall at Avtozavodskaya, Moscow

1983
Come Yesterday and You'll Be First, City Without Walls, Newark, New Jersey, catalogue.

1982
Russian New Wave, Contempoary Russian Art Center of America, New York, catalogue.
First Aptart Exhibition, Aptart Gallery, Moscow

1980
Nonconformists: Contemporary Commentary From the Soviet Union, Art Gallery, University of Maryland, College Park, Maryland, catalogue.

1977
La Nuova Arte Sovietica: Una Prospettiva Non Officiale, Venice Biennale, catalogue.

Andrei Filippov

Born 1959 in Petropavlovsk-Komchatsky. Lives in Moscow.

1989
Perspectives of Conceptualism, Third Exhibition of Avantgardists' Club, Exhibition Hall at Avtozavodskay Moscow
Expensive Art, Palace of Youth, Moscow
Momentaufnahme: Junge Kunst aus Moskau, Altes Stadtmuseum, Munster, Germany, catalogue
Mosca: Terza Roma, Sala I, Rome, Italy, catalogue

1988
Labyrinth, Palace of Youth, Moscow
20 Years, Hermitage Society, Moscow
Second Exhibition of Avantgardists' Club, Exhibition Hall, at Avtozavodskaya, Moscow

1987
First Exhibition of Avantgardists' Club, Exhibition Hall, at Avtozavodskaya, Moscow
17th Youth Exhibition, House of Artists, Exhibition Hall, Kuznetsky Most, Moscow

1986
Aptart, New Museum of Contemporary Art, New York, catalogue.

1983
Aptart en Plein Air, Aptart Open-Air Exhibition, Moscow
Aptart Beyond the Fence, Aptart Open-Air Exhibition, Moscow

Ilya Kabakov

Born 1933 in Dniepropietrovsk. Lives in Moscow.

Selected Solo Exhibitions

1990
Peter Pakesch Gallery, Vienna, Austria
Neue Galerie, Aachen, W. Germany
Selections from Ten Characters, Hirshhorn Museum, Washington, D.C.
The Rope of Life & Other Installations, Fred Hoffman Gallery, Santa Monica, California
He Lost His Mind, Undressed, Ran Away Naked, Ronald Feldman Fine Arts, New York

1989
Communal Apartment - The Ship, Kunsthalle, Zurich
Ten Characters, Institute of Contemporary Art, London

1988
Ten Characters, Ronald Feldman Fine Arts, New York
Berne Kunstmuseum, Berne, Switzerland

1987
Museum of Modern Art, (with Ivan Chuikov) Basel, Switzerland

1986
Centre National des Art Plastiques, Paris

1985
Am Rande (Along the Margins), Kunsthalle, Berne, Switzerland

Selected Group Exhibitions

1990
Sydney Biennale 1990, Sydney, Australia
Soviet Art, Museo d'arte Contemporanea, Prato, Italy
The Green Show, University Museum at Berkeley, California

1989
The Green Show, Exit Art, New York
Behind the Ironic Curtain, Phyllis Kind Gallery, New York
Post Utopia: Paintings and Installations by Soviet Conceptualists: Bulatov, Kabakov, Komar & Melamid, S.E. Massaachusetts University, N. Dartmouth, Massachusetts

1988
Biennale, Venice, Italy
10 Characters, Portikus, Frankfurt, W. Germany

1982
Contemporary Russian Painting 1971-1981, Gorky Galleries, Paris

1979
Twenty Years of Independent Art from the Soviet Union, Bochum Museum, Germany
Light, Form, Space, 28 Malaya Gruzinskaya, Moscow

1977
New Soviet Art, An Unofficial Perspective, Biennale, Venice, Italy

1968
Exhibition together with E. Bulatov in the "Blue Bird Cafe," Moscow

1966
Exhibition of Sixteen Moscow Artists, Sopot - Poznan, Poland

Komar & Melamid

Vitaly Komar born 1943 in Moscow. Lives in Bayonne, New Jersey.
Alexander Melamid born 1945 in Moscow. Lives in Bayonne, New Jersey.

Selected Joint Exhibitions

1990
Grand Lobby Installation, Brooklyn Museum, New York

1989
Komar & Melamid, Recent Work, Mandeville Gallery, University of California, La Jolla, California
Bergen Point Brass Foundry, Bayonne, Ronald Feldman Fine Arts, New York

1988
Kicken Pauseback, Cologne, West Germany

1987
Artspace, Sydney, Australia

1986
Van Straaten Gallery, Chicago, Illinois

1984
Saidye Bronfman Center, Montreal, Canada

1978
MATRIX 43, Wadsworth Atheneum, Hartford, Connecticut

1976
Ronald Feldman Fine Arts, New York

1967
Blue Bird Cafe, Moscow

Selected Group Exhibitions

1990
Image World: Art and Media Culture, Whitney Museum of American Art, New York
Images of Death in Contemporary Art, Haggerty Museum of Art, Marquette University, Milwaukee, Wisconsin

1989
Post-Utopia: Painting and Installations by Soviet Conceptualists Eric Bulatov, Ilya Kabakov, Komar & Melamid, Southeastern Massachusetts University, N. Dartmouth, Massaachusetts
Endangered Industries, Mary Ryan Gallery, New York

1988
The Social Club, Exit Art, New York

1987
Documenta 8, Kassel, West Germany

1986
Sots Art, New Museum of Contemporary Art, New York
Avant-Garde in the Eighties, Los Angeles County Museum of Art, Los Angeles

1985
The Anticipated Ruin, The Kitchen, New York
Content: A Contemporary Focus, 1974-1984, Hirshhorn Museum and Sculpture Garden, Smithsonian Institution Washington, D.C.

1983
Subculture, organized by Group Material, New York City Subway

1982
The Atomic Salon, Ronald Feldman Fine Arts, New York

1977
Dissident Art, Biennale, Venice, Italy

1974
Outdoor exhibition, Beljaevo, Moscow
Outdoor exhibition, Izmailovsky Park, Moscow

Yurii Leiderman, (member of Medical Hermeneutics)

Born 1963 in Odessa. Lives in Moscow.

1989
The Green Show, Exit Art, New York, catalogue.
Moskau-Wien-New York, Wien Messepalast, Vienna.
Perspectives of Conceptualism, Third Exhibition of Avantgardists' Club, Exhibition Hall at Avtozavodskaya.
Expensive Art, Palace of Youth, Moscow.

1988
Second Exhibition of Avantgardists' Club, Exhibition Hall at Avtozavodskaya, Moscow.

1987
First Exhibition of Avantgardists' Club, Exhibition Hall at Avtozavodskaya, Moscow.

1986
17th Youth Exhibition, House of Artists, Exhibition Hall at Kuznetsky Most, Moscow.

1984
Moscow-Odessa, Aptart Gallery, Moscow.

1983
Aptart Beyond the Fence, Aptart Open-Air Exhibition Moscow.

Igor Makarevich

Born 1943 in Tbilisi. Lives in Moscow.

1989
The Green Show, Exit Art, New York, catalogue.
Perspectives of Conceptualism, Third Exhibition of Avantgardists' Club, Exhibition Hall at Avtozavodskaya, Moscow.

1987
Twenty Years, Hermitage Society, Moscow

1983
Russian Samizdat Art, Franklin Furnace, New York

1982
Russian New Wave, Contemporary Russian Art Center of America, New York, catalogue

1980
Nonconformists: Contemporary Commentary from the Union, Art Gallery, University of Maryland, College Park, Maryland, catalogue.

1979
Abramov, Chuikov, Makarevitch, Centre Georges Pompidou, Paris.
20 Yahre Unabhaneige Kunst aus Sovjetunion, Museum Bochum, Bohum, Germany catalogue.

Sergei Mironenko

Born 1959 in Moscow. Lives in Moscow.

1989
Momentaufnahme: Junge Kunst aus Moskau, Altes Stadt-museum, Munster, Gemany, catalogue.

1988
Labyrinth, Palace of Youth, Moscow.

1986
Aptart, The New Museum of Contemporary Art, New York, catalogue.

1985
Aptart, Washington Project for the Arts, Washington, D.C., catalogue.

1983
Come Yesterday and You'll Be First, City Without Walls, Newark, New Jersey, catalogue.
Aptart en Plein Air, Aptart Open-Air Exhibition, Moscow.

1982
First Aptart Exhibition, Aptart Gallery, Moscow.

1978
Experiment, Exhibition Hall at Malaya Gruzinskaya, Moscow.

Timur Novikov

Born 1958 in Leningrad. Lives in Leningrad.

1986
The Works of Leningrad Painters, October Palace of Culture, Yarva, Estonia
Art Days Exhibition Festival, Cafe Allegro, Riga, Latvia
Group Exhibition at Valdai Cafe, Moscow

1985
Rock Festival Exhibition, Rock Club, Nevsky Palace of Culture, Leningrad
Glory to the Soil of Leningrad, Central Exhibition Hall, Leningrad

1984
The Facets of Portrait Art, Kirov Palace of Culture, Leningrad

1983
Library of the Academy of Sciences, Leningrad
Group exhibition of Leningrad Arts, Palace of Culture Chkalov State Farm, Crimea

1982
Society of Experimental Art Exhibitions, Palace of Youth, Kirov Palace of Culture, Leningrad
Helped organize ASSA and the group Popular Mechanics and participated in concerts as actor, musician, and stage designer.
Exhibited with artists like Oleg Kotelnikov, Boris Koshelohov, and Ivan Sotnikov, who were then known as the "New Artists."

1981
Of Time and Self, Youth Palace Group Exhibition of Leningrad Artists, Tartu, Estonia University

1980
Olympic Exhibition, Youth Palace, Leningrad

1979
Exhibit of the Tenth, LDKhS, Leningrad

1978
Kirill and Methodius Exhibit.

1977
First exhibition of "Letopis" group, Leningrad

**The Peppers
(Oleg Petrenko and
Mila Skripkina)**

Petrenko born 1964 in Odessa.
Skripkina born 1965. Lives in
Odessa. They live in both
Moscow and Odessa.

1989
The Green Show, Exit Art, New
York, catalogue.
Moskau-wien-New York, Wien
Messepalast, Vienna.
*Perspectives of Conceptualism,
Third Exhibition of
Avantgardists' Club,* Exhibition
Hall at Avtozavodskaya,
Moscow
Expensive Art, Palace of Youth,
Moscow.

1988
*Second Exhibition of
Avantgardists' Club,* Exhibition
Hall at Avtozavodskaya,
Moscow.

1984
Moscow-Odessa, Aptart Gallery,
Moscow.

**Pavel Peppershtein,
(member of Medical
Hermeneutics)**

Born 1966 in Moscow. Lives in
Moscow.

1989
The Green Show, Exit Art, New
York.
Moskau-Wien-New York, Wien
Messepalast, Vienna.
*Perspectives of Conceptualism,
Third Exhibition of
Avantgardists' Club,* Exhibition
Hall at Avtozavodskaya,
Moscow.
Expensive Art, Palace of Youth,
Moscow.

1988
*Second Exhibition of
Avantgardists' Club,* Exhibition
Hall at Avtozavodskaya,
Moscow.

Dmitri Prigov

Born 1940 in Moscow. Lives in
Moscow.

1989
Struve Gallery, Chicago
Institute of Contemporary Art,
London
Galerie Krings-Ernst, Cologne,
W. Germany

1988
Geometry in Contemporary Art,
organized by Boris Orlov,
Moscow
Labyrinthe, Moscow

1987
Artists and Contemporaneity,
Kashyrskaya Prospect, Moscow
Object, Avantgardist's Club,
Moscow
Documenta, Kassel, West
Germany

Andrei Roiter

Born 1960 in Moscow. Lives in Moscow.

Solo Exhibition

1990
Kunsthalle, Basel.

Group Exhibitions

1989
The Green Show, Exit Art, New York, catalogue
Momentaufnahme: Junge Kunst aus Moskau, Altes Stadtmuseum, Munster, Germany, catalogue.
10 + 10, Modern Art Museum of Fort Worth, Fort Worth and San Francisco Museum of Modern Art, San Francisco, catalogue.
Expensive Art, Palace of Youth, Moscow.

1988
Labyrinth, Palace of Youth, Moscow.
Geometry, Exhibition Hall at Kashirskaya.

1987
20 Years, Hermitage Society, Moscow.

1986
17th Youth Exhibition, House of Artists, Exhibition Hall at Kuznetsky Most, Moscow.

Maria Serebriakova

Born 1965. Lives in Moscow.

1989
Moskau-Wien-New York, Wien Messepalast, Vienna
Exhibition of Small Objects, First Gallery, Moscow
Expensive Art, Palace of Youth, Moscow

1988
Labyrinth, Palace of Youth, Moscow

1987
20 Years, Hermitage Society, Moscow

Sergei Volkov

Born 1956 in Kazan. Lives in Moscow

Solo Exhibition

1989
Galerie Folker Skulima, West Berlin, catalogue

Group Exhibitions

1989
The Green Show, Exit Art, New York, catalogue
Perspectives of Conceptualism, Third Exhibition of Avantgardists' Club, Exhibition Hall at Avtozavodskay, Moscow

1988
Iskunstvo: Berlin-Moskau, Bahnhof Westend, West Berlin, catalogue.
Ich Lebe, Ich Sehe: Kunstler der Achtziger Jahre in Moskau, Kunstmuseum, Bern, catalogue.

1987
First Exhibition of Avantgardists' Club, Exhibition Hall at Avtozavodskaya, Moscow.
Object, Malaya Gruzinskaya Exhibition Hall, Moscow.

1986
17th Youth Exhibition, House of Artists, Exhibition Hall at Kuznetsky Most, Moscow

Vadim Zakharov

Born 1959 in Dushanbe. Lives
in Moscow.

Solo Exhibitions

1990
Galerie Sophia Ungers,
Cologne, Germany. With
Victor Skersis.

1989
Galerie Peter Pakesch, Vienna,
Austria.
Galerie Sophia Ungers,
Cologne, Germany.
*Perspectives of Conceptualism,
Third Exhibition of
Avantgardists' Club,* Exhibition
Hall at Avtozavodskaya,
Moscow.
Expensive Art, Palace of Youth,
Moscow.
10 + 10, Modern Art Museum
of Forth Worth, Fort Worth and
San Francisco Museum of
Modern Art, San Francisco,
catalogue.
*Momentaufnahme: Junge Kunst
aus Moskau,* Altes Stadt-
museum, Munster, Germany,
catalogue.

1988
Iskunstvo: Berlin-Moskau,
Bahnhof Westend, West Berlin,
catalogue.
*Second Exhibition of
Avantgardists' Club,* Exhibition
Hall, at Avtozavodskaya,
Moscow.
Ich Lebe, Ich Sehe: Kunstler der
Achtziger Jahre in Moskau,
Kunstmuseum, Bern, catalogue.

1987
Direct from Moscow, Phyllis
Kind Gallery, New York.
20 Years, Hermitage Society,
Moscow.
*First Exhibition of
Avantgardists' Club,* Exhibition
Hall at Avtozavodskaya.

1986
17th Youth Exhibition, House of
Artists, Exhibition Hall at
Kuznetsky Most, Moscow.
Aptart, The New Museum of
Contemporary Art, New York,
catalogue.

1985
Aptart, Washington Project for
the Arts, Washington, D.C.,
catalogue.

1983
*Come Yesterday and You'll Be
First,* City Without Walls,
Newark, New Jersey, catalogue.
*Aptart en Plein Air, Aptart
Open-Air Exhibition,* Moscow.
*Aptart Beyond the Fence, Aptart
Open-Air Exhibition,* Moscow.

1982
First Aptart Exhibition, Aptart
Gallery, Moscow.

Konstantin Zvezdochetov

Born 1958 in Inta. Lives in
Moscow.

1989
Expensive Art, Palace of Youth,
Moscow.
10 + 10, Modern Art Museum
of Fort Worth, Forth Worth and
San Francisco Museum of
Modern Art, San Francisco,
catalogue.
*Momentaufnahme: Junge Kunst
aus Moskau,* Altes Stadt-
museum, Munster, Germany,
catalogue.

1988
Iskunstvo: Berlin-Moskau,
Bahnhof Westend, West Berlin
catalogue.
Ich Lebe, Ich Sehe: Kunstler der
Achtziger Jahre in Moskau,
Kunstmuseum Bern, catalogue.
Labyrinth, Palace of Youth,
Moscow.
*Second Exhibition of
Avantgardists' Club,* Exhibition
Hall at Avtozavodskaya,
Moscow.

1987
20 Years, Hermitage Society,
Moscow.
*First Exhibition of
Avantgardists' Club,* Exhibition
Hall at Avtozavodskaya,
Moscow.

1986
Aptart, New Museum of
Contemporary Art, New York,
catalogue.

1985
Aptart, Washington Project for
the Arts, Washington, D.C.,
catalogue.

1983
Come Yesterday and You'll Be First, City Without Walls, Newark, New Jersey, catalogue.
Aptart en Plein Air, Open-Air Aptart Exhibition, Moscow.
Aptart Beyond the Fence, Open-Air Exhibition, Moscow.

1982
First Aptart Exhibition, Aptart Gallery, Moscow.

1978
Experiment, Exhibition Hall at Malaya Gruzinskaya, Moscow.

Larisa Zvezdochetova

Born 1958 in Odessa. Lives in Moscow.

Solo Exhibitions

1990
Galerie Avant-Garde, West Berlin

1989
First Gallery, Moscow

Group Exhibition

1989
Odessa Artists, Galerie Krings-Ernst, Cologne
Perspectives of Conceptualism, Third Exhibition of Avantgardists' Club, Exhibition Hall at Avtozavodskaya, Moscow

1984
Moscow-Odessa, Aptart Gallery, Moscow.

1983
Aptart Beyond the Fence, Aptart Open-Air Exhibition Moscow

Select Bibliography

Anufriev, Sergei. "Sergei Volkov." *Flash Art,* Russian Edition, No. 1 (1989): 128–129.

Aptart: Moscow Vanguard in the 80's. Norton Dodge, ed. Mechanicsville, MD: Cremona Foundation, 1985.

"L'Art au Pays des Soviets, 1963–1988." 9–article anthology; with catalog of Soviet artists, exhibitions, articles, and books. *Les Cahiers du Musée National D'Art Moderne,* No. 26 (Winter 1988): 4–110, supplement 1–69.

Bown, Mattew Cullerne. *Contemporary Russian Art.* Great Britain: Phaidon Press, 1989.

Burnham, Jack. "Komar & Melamid—Post USSR—Get Religion." *Art in America* 67 (February 1979): 13.

Caley, Shaun. "To Russia With Love." *Flash Art,* No. 137 (November–December 1987): 86–87.

Davis, Douglas. "Red Diary." *Village Voice* (April 18, 1989): 37–45.

Dodge, Norton, and Alison Hilton. *New Art from the Soviet Union.* Washington D.C.: Acropolis Books Ltd., 1977.

Fields, Marc. "Komar and Melamid and the Luxury of Style." *Artforum* 16 (April 1982): 58–63.

Gambrell, Jamey. "Notes on the Underground." *Art in America* 76 (November 1988): 126–36 +.

–––––– . "Perestroika Shock." *Art in America* 77 (February 1989): 124–34 +.

Gookin, Kirby. "Ilya Kabakov." *Artforum* 27 (September 1988): 135–36.

Groys, Boris. "Ilya Kabakov." *A-Ya,* No. 2 (1980): 17–22.

–––––– . "L'Oeuvre d'Art Staline." *Les Cahiers du Musée National d'Art Moderne,* No. 23 (Spring 1988): 94–99.

Heartney, Eleanor. "Ilya Kabakov at Ronald Feldman Fine Arts." *Art in America* 76 (September 1988): 179.

–––––– . "Sots Art." *Art News* 83 (March 1984): 212 +.

Hughes, Robert. "Canvases of Their Own." *Time* 133 (April 10, 1989): 116–118.

Ilya Kabakov. Catalogue. Bern: Kunsthalle, 1985.

Indiana, Gary. "Komar & Melamid Confidential." *Art in America* 73 (June 1985): 94–101 + and cover.

Jolles, Claudia, and Viktor Misiano. "In Conversation with Eric Bulatov and Ilya Kabakov." *Flash Art,* No. 137 (November–December 1987): 81–83.

Kabakov, Ilya. "Discussion of the Three Layers." *A-Ya,* No. 6 (1984).

———. "Kitchen Series." *A-Ya,* No. 6 (1984).

Kimmelman, Michael. "An Allowance for Wit and Human Foible." *The New York Times* (October 8, 1989): H35–36.

Klotz, Heinrich, and Alexander Rappaport. *Paper Architecture.* Munich: Oktagon Verlag, 1989.

Komar, Vitaly, and Alexander Melamid. "In Search of Religion." *Artforum* 18 (May 1980): 36–46.

———. "We Love N.J." *Artforum* 27 (April 1989): 133–35 and cover.

Levin, Kim. "The Man Who Flew Into Space." *Village Voice* (May 31, 1988): 93.

Lichtenstein, Terry. "Aptart in Tribeca." *Arts* 59, (March 1984): 39.

Misiano, Viktor. "Back in the USSR." *Contemporanea* 1 (May–June 1988): 96–107.

———. "Review: Moscow." *Contemporanea* 1 (May–June 1988): 96–107.

Morgan, Stuart. "Kabakov's Albums." *Artscribe* 75 (May/June 1989): 57–59 and cover.

Newman, Amy. "The Celebrated Artists of the End of the Second Millennium A.D." *Artnews* 75 (April 1976): 43–46.

Oliva, Achille Bonito. "Neo-Europe (East)." *Flash Art,* No. 140 (May–June 1988): 61–64.

Peschler, Eric A. "Kunstler in Moskau, Die Neue Avantgarde." *Schaffhausen* (1988): 110–117.

Ryklin, Mikhail. "Medical Hermeneutics." *Flash Art,* Russian Edition, No. 1 (1989): 115–116.

Schjeldahl, Peter. "Komar & Melamid." *Flash Art,* No. 125 (Dec. 1985–Jan. 1986): 64–65. Interview.

10 + 10: Contemporary Soviet and American Painters. I. Bulgakova, P. Freeman, M. Price, T. Abalova, and J.E. Bowlt, eds. New York: Harry N. Abrams, and Leningrad: Aurora Publishers, 1989.

Tupitsyn, Margarita. "Back in the USSR." *Flash Art,* No. 141 (1988): 121–123.

———. "From Sotsart to Sovart." *Flash Art,* No. 137 (Nov.–Dec. 1987): 75–80.

———. *The Green Show.* New York: Exit Art, 1989.

———. "Ilya Kabakov." *Flash Art,* No. 126 (Feb.–March 1986): 67–69.

———. "Ilya Kabakov." *Flash Art,* No. 142 (October 1988): 115.

———. *Margins of Soviet Art.* Milan: Giancarlo Politi Editore, 1989.

———. *Sots Art.* New York: New Museum of Contemporary Art, 1986.

———. "Veil on Photo: Metamorphoses of Supplementarity in Soviet Art." *Arts* 64, No. 3 (November 1989): 79–84.

Tupitsyn, Victor. "Expensive Art." *Flash Art,* No. 146 (May–June 1989): 132.

———. "Ideology Mon Amour." *Flash Art,* No. 137 (November–December 1987): 84–85.

———. "Ilya Kabakov." *Flash Art,* No. 151 (March–April 1990).

———. "The Inspection of Inspectors." *Flash Art,* No. 147 (Summer 1989): 133–135.

Tupitsyn, Victor and Margarita. "Six Months in Moscow." *Flash Art,* No. 137 (October 1989): 115–117.

———. "The Studios on Furmanny Lane in Moscow." *Flash Art,* No. 142 (October 1988): 103, 123–125.

———. "Timur and Africa." *Flash Art,* No. 151 (March–April 1989): 122–125.

Volkov, Sergei. *Ausstellung.* Berlin: Galerie Folker Skulima, 1989.

Von Tavel, Hans Christoph, and Markus Landert. *Ich Lebe-Ich Sehe.* Bern: Kunstmuseum Bern, 1988.

Wollen, Peter. *Komar & Melamid.* Edinburgh: Fruitmarket Gallery, 1985.

Checklist of the Exhibition

**Yuri Avvakumov/
Sergei Podyomschikov**

Space Bridge, 1989
mixed media with playing cards
107 x 71 x 71cm
Courtesy of the artists

**Yuri Avvakumov/
Michael Belov**

*Sepulchral Skyscraper or Self-
Elevating Metropolitan
Columbarium,* 1983
silkscreen print
84 x 60cm
Courtesy of the artists

**Yuri Avvakumov/
Yuvi Kuzin**

*Youth Residential Complex in
Imaginary City of Magnitogorsk,*
1987
silkscreen print
84 x 60cm
Courtesy of the artists

**Alexander Brodsky and
Ilya Utkin**

Site specific installation, 1990
Courtesy of Ronald Feldman Fine
Arts, Inc., New York

Africa (Sergei Bugaev)

Anufriev is Anufriev, 1990
oil on canvas
3 parts; 2 x 3 m each
Courtesy of Paul Judelson Arts,
New York

*The Orthodox Totalitarian Alter in
the Name of Anufriev,* 1990
mixed media
2 1/2m x 3m x 80cm
Courtesy of Paul Judelson Arts,
New York

Collective Actions

(Nikita Alekseev, Elena Elagina,
Georgii Kizevalter, Igor
Makarevich, Andrei Monastyrsky,
Nikolai Panitkov, Sergei Romashko)
From the Performance "Ten
Appearances", 1981
black and white photographs
Collection of Igor Makarevich

Andrei Filippov

Old Testament, 1989
mixed media
43 x 43 x 5cm
Courtesy of the artist

The Last Supper, 1989
mixed media
installation: 80 x 650 x 74cm
Courtesy of the artist

Ilya Kabakov

Sixteen Strings, 1983
mixed media with audio
roomsize installation
Courtesy of Ronald Feldman Fine
Arts, Inc., New York

*Olga Georgievna, Something is
Boiling,* 1984
folding album, 64 pages, each page
66 × 46 cm
Courtesy of Ronald Feldman Fine
Arts, Inc., New York

Komar & Melamid

Bergen Point Brass Foundry, 1988
oil and brass leaf on canvas
3 panels: 121″ × 181″
Courtesy of Ronald Feldman Fine
Arts Inc., N.Y.

Labor, 1988
oil, marker on paper, bronze
object, brass leaf, pencil on paper
4 panels: 25″ × 74 5/8″
Courtesy of Ronald Feldman Fine
Arts Inc., N.Y.

Portrait of Worker I, 1988
mixed media
3 panels in welded steel frame
25″ × 93″
Courtesy of Ronald Feldman Fine
Arts Inc., N.Y.

Sketch #4, 1989
4 panels, total 24″ × 90 1/4″
Courtesy of Ronald Feldman Fine
Arts Inc., N.Y.

Sketch #8, 1989
4 panels in frame
24″ × 90 1/2″
Courtesy of Ronald Feldman Fine
Arts Inc., N.Y.

Two Worker's Heads, 1988
pen on paper, oil, brass leaf and
charcoal dust on canvas,
lithograph stick on paper
4 panels: 25″ × 118 5/8″
Courtesy of Ronald Feldman Fine
Arts Inc., N.Y.

Room Size Installation, 1990
Courtesy of Ronald Feldman Fine
Arts, Inc., New York

**Igor Makarevich and Elena
Elagina**

Children's, 1989
mixed media
3 parts: 80 x 190 x 4cm; 80 x 190 x
4cm; 60 x 50 x 50cm
Courtesy of the artists

Pure, 1989
mixed media
3 parts: 90 x 140 x 30cm; 60 x 50 x
50cm; 30 x 20 x 20cm
Courtesy of the artists

Igor Makarevich

*"Graphics" (Astrology and Human
Science),* 1990
mixed media collage on aluminum
6 parts: 64 x 82cm each
Courtesy of the artist

**Medical Hermeneutics
(Sergei Anufriev,
Yurii Leiderman,
Pavel Peppershtein**

Work, 1989
mixed media
3 parts: 180 x 120cm; 100 x 100 x
60cm; 50cm3
Courtesy of Yurii Leiderman

Frenchmen, 1989
mixed media
65 x 105 x 7cm
Courtesy of Yurii Leiderman

Third Variant, 1989
mixed media
45 x 81 x 10cm
Courtesy of Yurii Leiderman

Black Elsa, 1989
wood, aluminum
60 x 44 x 43cm
Courtesy of of Yurii Leiderman

He has not gone to Rozenlau, 1989
mixed media
2 parts: 85 x 85 x 3cm each
Courtesy of Yurii Leiderman

New Year, 1990
mixed media
room size installation
Courtesy of the artists

Untitled Collages (#51), 1989
mixed media
approximately 28 x 21 1/2cm
Courtesy of Sergei Anufriev

Sergei Mironenko

Room for a Hero, 1989
mixed media
350 x 400 x 220cm
Courtesy of Galerie Krings-Ernst,
Cologne

Andrei Monastyrsky

Finger, 1978
mixed media installation
100 x 300 x 30cm
Courtesy of the artist

Timur Novikov

Untitled, 1988
mixed media on textile
186 x 191cm
Courtesy of Raab Galerie, Berlin

Untitled, 1988
mixed media on textile
186 x 191cm
Courtesy of Raab Galerie, Berlin

Untitled, 1988
mixed media on textile
186 x 191cm
Courtesy of Raab Galerie, Berlin

Aurora, 1988
mixed media on textile
164 × 136cm
Courtesy of the artist

Aral Sea, 1989
mixed media on textile
236 × 270cm
Courtesy of the artist

**Peppers
(Ludmila Skripkina,
Oleg Petrenko)**

Jar, 1989
mixed media
16 x 11 x 11cm
Courtesy of Ronald Feldman Fine
Arts, Inc., New York

Shoe Form, 1989
enamel on wood and lens
2 parts each/9 x 26 x 9cm
Courtesy of Ronald Feldman Fine
Arts, Inc., New York

Bone Marrow, 1989
mixed media
apron 109 × 38cm, peas (6 parts)
8 × 8 × 25cm
Courtesy of Ronald Feldman Fine
Arts, Inc., New York

*Types of Discharge According to
Mandelshtam/Chromodiagnosis
According to Schiller,* 1989
Diptych enamel on plywood, found
objects
169 x 120cm each panel
Courtesy of Ronald Feldman Fine
Arts, Inc., New York

Andrei Roiter

Monument (Pushkin), 1989
oil and plaster on canvas
150 x 200cm
Courtesy of the artist

Punctuation, 1989
oil and plaster on canvas
150 x 200cm
Courtesy of the artist

Monument, 1989
oil and plaster on canvas
200 x 150cm
Courtesy of the artist

Maria Serebriakova

Untitled Collages, (#61) 1989
mixed media
approximately 28 x 36 cm unframed
Courtesy of the artist

Untitled, 1989
mixed media
30 x 30 x 80 cm
Courtesy of the artist

Sergei Volkov

Palm, 1988
oil on canvas
200 x 150 cm
Courtesy of Galerie Folker
Skulima, Berlin

Thumb, 1988
oil on canvas
200 x 140cm
Courtesy of Galerie Folker
Skulima, Berlin

Taste, 1989
mixed media
3 parts: 80 x 60cm each
Installation: 200 x 280cm
Courtesy of Galerie Folker
Skulima, Berlin

Cat, 1988
oil on canvas
3 parts: 180 x 180cm; 180 x
180cm; 65 x 100cm
Collection of Dr. Ludwig, Germany

Vadim Zakharov

Two Years Between Hiding and Infection, 1989
oil, plastic, paper on canvas
6 parts: 200 x 150cm each
Courtesy of Galerie Sophia Ungars,
Cologne

After the Fur, 1989
plastic, plaster, paper, cement
6 parts
Courtesy of Galerie Sophia Ungars,
Cologne

Konstantin Zvezdochetov

Towel Holder, 1989
mixed media
195 x 57 x 10cm
Courtesy of the artist

Box and a Bag with Sand, 1990
mixed media
210 x 75 x 75cm
Courtesy of the artist

Larisa Zvezdochetova

Chukot Legend, 1988
mixed media
122 x 202 x 3cm
Courtesy of the artist

Installation with Two Chairs, 1989
mixed media
2m x 2 1/2m x 5cm
Courtesy of Avantgarde Galerie,
Berlin

Skater on Rug, 1989
carpet, lacquor on wood
4 parts: 130 x 201cm each
Courtesy of Galerie Krings-Ernst,
Cologne

Notes on Contributors

Joseph Bakshtein lives in Moscow. He holds a doctorate in the sociology of art. His publications include articles on the Moscow avant-garde in Soviet and Western publications. He recently curated several important small exhibitions of conceptual art in Moscow.

Ilya Kabakov was born in Moscow and graduated from Surikov Art Institute. He is the founder of the Soviet version of conceptualism and has had a profound influence on a number of important Soviet artists of the younger generation. Since glasnost his work has been widely exhibited in Europe and the USA.

Richard Lourie lives and works in Boston. He is the author of three novels, most recently, *Loyalty* and *Zero Gravity*. He has translated more than thirty books from Russian and Polish, including Andrei Sakharov's *Memoirs*. He is currently completing *Russia Speaks,* an oral history from the Revolution to the present.

Alexander Rappaport lives in Moscow and graduated from the Moscow Institute of Theory and History of Architecture. He works in the all-union Institute of Theory of Architecture in Moscow. He has written extensively about architecture, the theater, the city, style and the environment.

David A. Ross is Director of The Institute of Contemporary Art in Boston. He is the author of many essays on the subject of contemporary art and has organized numerous exhibitions over the last twenty years. He has been traveling to the Soviet Union over the last decade and has had extensive conversations and studio visits with Soviet artists.

Mikhail Ryklin is a philosopher who lives in Moscow. He is a senior researcher at the Institute of Philosophy. His main interest is in the "margins" of philosophy and art, and their site of convergence. He is the author of over fifty publications.

Elisabeth Sussman is Deputy Director for Programs at The Institute of Contemporary Art in Boston. She has organized exhibitions and written extensively about American and Western European art of the last decade.

Margarita Tupitsyn is a Soviet-born art historian and independent curator. She is the author of *Margins of Soviet Art: Socialist Realism to the Present* and has organized a number of important exhibitions of contemporary Soviet art. She is currently working on a book *Soviet Photography and Photomontage Before Socialist Realism.*

Victor Tupitsyn is a Soviet-born poet, critic, and theorist. He is a professor of mathematics at Pace University, New York. He is the editor of Russian Edition of *Flash Art* and a frequent contributor to this magazine's international edition.

Peter Wollen is a filmmaker and teacher in the Cinema Studies Program at the University of California, Los Angeles. His latest film is *Friendship's Death* and he has written widely on art, film and semiotics.